TESTAMENT
CHRIS HONDROS

—

POWERHOUSE BOOKS
GETTY IMAGES

TESTAMENT

Published in the United States by powerHouse Books,
a division of powerHouse Cultural Entertainment, Inc.
37 Main Street, Brooklyn, NY 11201-1021
telephone 212.604.9074, fax 212.366.5247
e-mail: info@powerHouseBooks.com
website: www.powerHouseBooks.com

First edition, 2014

Library of Congress Control Number: 2013956138

ISBN 978-1-57687-673-2

Printed in China by Everbest Printing Company
through Four Colour Imports, KY.

Editors: Alexandra Ciric, Francisco P. Bernasconi, Christina Piaia
Contributing Word Editors: Christina Larson and Preeti Aroon
Book Design: Triboro

10 9 8 7 6 5 4 3 2 1

BROOKLYN, NEW YORK

TESTAMENT
CHRIS HONDROS

—

EDITED BY ALEXANDRA CIRIC,
FRANCISCO P. BERNASCONI, AND
CHRISTINA PIAIA

INTRODUCTION BY JONATHAN KLEIN
FOREWORD BY RÉGIS LE SOMMIER
AFTERWORD BY GREG CAMPBELL

—

For you, Chris.

We, too, walk among many things as we begin to discover how much remains untranslatable. Then, we return to you: your images, words, and unsparing heart — and find ourselves among the world you longed for us to see.

INTRODUCTION

JONATHAN KLEIN IS
CO-FOUNDER AND CHIEF
EXECUTIVE OFFICER OF
GETTY IMAGES.

Chris was never short of words, stories, or anecdotes, yet my most powerful memory of him occurs whenever I look at the overall body of his work and also at an image of Chris himself that sits on my desk. It is impossible for me to choose a "favorite" Chris image as the essence of the man and his humanity, and deep warmth always came through no matter how terrible the situation or the circumstances in which he found himself.

I was fortunate to count Chris as a friend, to have shared stories, drinks, music, and laughs with him for more than a decade. I smile when I think about his stories of his encounters with Liberian rebels and government forces, who would ask, among other questions, why Chris was there. Chris knew exactly why he was there and, for that matter, in every other place he went to capture the story on the ground.

Chris was one of the first photographers we hired when we decided to invest in and support photojournalism. His insights and ethics helped form the foundation of our news organization, and he took tremendous pride in what we were able to achieve since those early days.

Chris' death in Libya was a seismic event for every one of us who had come to know and love him over the years. He is the first Getty Images photographer to be killed while on assignment. Only a few weeks before Chris' death, our colleague, the photographer Joe Raedle, was captured and tortured by Moammar Gadhafi's forces in Libya. Through the efforts of the international journalism community, Joe was released. Chris felt strongly that it was important for him to be there to greet Joe when he crossed the border to safety. This was typical of the man.

When they arrived in New York, the three of us, together with Pancho Bernasconi, our director of photography, met in my office and discussed the risks of going back into Libya at that time. Chris was resolute that the story had to be told. This is the challenge and dilemma at the core of conflict photography. We know and understand the risks; we stress that no picture is worth a life. Yet Chris, like so many in photojournalism, believed that it is critical to cover stories in depth, educate society about the wider world, and, if necessary, be at the front line.

Chris' life taught me so much about photojournalism; his passing taught me even more. The competition, while intense, is greatly outpaced by collaboration. There is incredible dedication and integrity within the people who have chosen this life and career. I am humbled to work alongside this remarkable community, with long-standing bonds that make them seem less like colleagues and more like a family.

We held a memorial service for Chris in Brooklyn at the church where he was to be married a few months later. There was a profound sense of loss — many of us still in a state of shock and disbelief — as well as a sense of a community coming together. A couple of days later, we all went to Chris' hometown in North Carolina for his funeral. The contrast between the two places could not have been starker — busy, noisy, cosmopolitan Brooklyn and the small military town of Fayetteville near Fort Bragg. There was no difference, however, in the love, regard, and esteem that people felt for Chris.

People from all parts of the world and all walks of life mourned Chris' death. Several senior military friends of his traveled to Fayetteville to pay their respects and attend his funeral. Tributes came from the White House, the chairman of the Joint Chiefs of Staff, and major politicians, as well as from those who had known Chris since he was a child. They all admired him and recognized that the work that Chris had chosen was important and that he was one of the best in the world.

Since that devastating day in April 2011, Chris' indelible spirit and influence have sparked needed conversations about the importance of protecting journalists in conflict zones, inspired emerging and veteran photojournalists alike, and affirmed the importance of a free press in society. I am personally committed to ensuring that this impact endures.

Chris believed that his work could and would make a difference. He dedicated and ultimately lost his life in pursuit of that belief. I have no doubt that Chris was correct. Images can and do influence public opinion, galvanize people and societies, and force governments to change. They bring much-needed focus and attention to the suffering of people who are otherwise unable to communicate their plight.

Chris' deep well of empathy and humanity have had a lasting impact on me. We at Getty Images are lucky to be a small part of his legacy and are proud to have supported him and made sure that his work was seen around the world.

I heard from Chris a couple of days before he died. He was happy, focused, motivated, and, as his work on the morning of his passing shows, at the top of his craft. Our conversation, as well as the knowledge that Chris died while doing what he loved, provides a small measure of comfort.

I miss him, his stories, the twinkle in his eye, his warmth, his smile, his encyclopedic knowledge, and the pictures that he had yet to make.

RÉGIS LE SOMMIER IS
ASSOCIATE EDITOR-IN-
CHIEF OF PARIS MATCH.

When Chris Hondros died in Misurata, Libya, on April 20, 2011, he had in his bag a copy of French philosopher Jean-Paul Sartre's book "Nausea." At one point in this existentialist manifest, the main character muses: "My entire life is behind me. I can see it completely; I can see its shape and the slow movements that have brought me this far." Above and beyond the premonitory nature of these words, the fact that Chris was reading Sartre when he died speaks volumes about the figure this internationally recognized photographer had become over the years.

When I met Chris in Ohio, seven years before his tragic death, he was a genuine young American. What struck me was that he was also an intellectual. Chris was in a world of his own and not like the other photographers. He had a vision beyond the frame of his lens. He liked to write and did it well. Our friendship was immediate. We had much downtime in the field together. War, the Iraq war particularly, can be excitingly dangerous, brutal, and terrifying, but it can also be boring. Which was the case, most of the time. In Iraq, two time frames came together to slow things down: military time and Middle Eastern time. Much space remained for us to talk, reflect, think deeply. Chris and I worshipped those moments so much that when we would start talking, nothing else seemed to matter. He often took language-learning CDs into the field. During our first trip to Iraq, in March 2006, he tried convincing me to learn Arabic: "rajul," "emra'ah," "siarra zarka" (man, woman, blue car). I clearly remember those words, having pronounced them out loud, often annoying the grunts with our attempt to speak the language of the "hajjis" (military slang for Iraqis). Although I am rather gifted at languages, I wasn't terribly serious about learning Arabic. Chris, on the other hand, had no gift for languages, surprising for someone so musically skilled, but he was serious. On our next trip, his selected language had shifted to French. Without much success, he would nevertheless continue trying, in his bunk bed, headset on, moving his lips soundlessly, into the thick of the night.

I think he enjoyed hearing me switch from French to English, sharing a breath of the world he had taken task to discover. France fascinated him; so did the Arab world. But most of all, in the great adventure of humankind, he liked contrasts. He didn't especially like Iraq as an exotic place shaped in a halo of Babylonian mysteries and the extravagancies of a dictator. He didn't especially like the military as an institution, full of commitment, rigor, and history. I would often hear him say, "Régis, you do the talking; I take the pictures." He had noticed my ability to make friends and keep relations with soldiers and officers beyond our embeds. The U.S. military's occupation of Iraq intrigued him in much the same way he would have been intrigued by the occupation of Vietnam in 1968 or of France in 1944. People of two nations adjusting to each other, forced to live in the same streets, breathe the same air, for a long time, with little in common. Through his lens, he tried to uncover their common humanity, explain their contrasts, catch human moments. The picture featuring a RoboCop wearing night-vision goggles, breaking into the home of an Iraqi in sandals, scaring his toddlers in pajamas, featured screams, awe, sweat, pain, and blood — the brutal contrasts vital to Chris' pictures. One day in Baghdad, an Iraqi soldier stepped on an improvised explosive device at the entrance to the outpost where we were stationed. With a few soldiers and a medic, we helped bring the soldier to an operating table in an otherwise rehabilitated kitchen. From the U.S. Army cook to the Iraqi onlookers to us journalists, everyone helped. So much blood had flowed onto the floor that the soldiers had to use rolls and rolls of toilet paper to absorb it. I had no idea a man could lose so much blood and remain alive. Albeit not for long. A Shiite soldier from the Iraqi army, he then had to be transported via ambulance through the entire Sunni neighborhood of Ghazaliya in order to reach a hospital ruled by Shiites. Presumably he didn't make it. Chris' goal was to show that even in the world's darkest corners, there are enough values, compassion, and common ground to forge humanity. On the surface, the people in his pictures seem so different, but in the end, they are not that different.

Wherever you go, children remain children, with their dreams, hopes, and innocence. Mothers share similar pains, and soldiers bleed the same red blood.

When taking pictures, Hondros, as he liked to be called, knew exactly where to stand. When the action ceased, he'd disappear, crouching in a corner of a forward operating base or in whatever space he could find, headset on, laptop on his thighs. Sometimes you'd find him crawling on a rooftop, trying to set up his BGAN satellite dish in order to transmit pictures. He could spend hours fixing his computer with the cellophane tape and countless wires he carried. Wherever he went, he took pictures. He could shoot photos without anyone noticing. One day, at the Balad field hospital in Iraq, I was trying to figure out how the environment differed from an average emergency ward in an average big American city. Indeed, the closer you would get to the operating room, the fewer military traces you would see. The medical personnel wore colorful blouses and funky hats. Nurses would chew gum and listen to R&B. The wounds you witnessed, from men peppered with AK bullets to those burned by bombs, as awful as they were, were no different from the gang-related wounds from violence or arson in Chicago, Los Angeles, or New York. However, when a wounded insurgent would come rushing in, the picture would change. Surgeons would push the door open with M-16s on their backs. War would enter the operating room in a split second. This would make Chris smile. Although he might have been casually talking with a nurse only minutes prior, he would have already seized his camera and taken the picture. This surgeon perfectly displayed the contrasts so essential to Chris' work. What kind of job could you be doing if you were entering the operating room ready to shoot the very person you were supposed to save?

Hondros knew well that covering a conflict is not an invitation to embrace a cause or take a side. His goal was merely to provide witness as a journalist, not as some cool guy hoping to forge lifelong bonds with the people he was meeting or join the combat through his pictures. You are there, but you don't belong there. You are there to witness man's created chaos, otherwise referred to as History. Chris was not the type of person who would find purpose in other people's suffering. He had no identity problems or any dilemma about who he was.

Nearly two years after his death, I traveled to Fayetteville, North Carolina, to visit where he grew up. He never really talked about his hometown and childhood, though he spoke extensively about his loving mother, Inge, and his mixed German and Greek roots. It was his way of coming closer to Europe and the big world, away from the small-town America he had left behind. Chris grew up in an average middle-class American home, a towering tree in the yard, a basketball hoop mounted over the garage door, and a playground around the corner. Nothing much happened other than the occasional snow storm, heat wave, or annual neighborhood Halloween mischief. Life was punctuated by graduation ceremonies, football playoffs, fireworks, cheerleaders, and July 4th parades. This was a place where you could hear ice-cream trucks ringing and freight trains howling in the distance – and, with the sunset, feel the infinite solitude of America's vastness. He must have met soldiers in his youth. After all, North Carolina prides itself on being the most military-friendly state, and Fayetteville is tied to one of America's most important bases, Fort Bragg. It is more of a town near a base than Fort Bragg is a base near a town. But I doubt this environment influenced his choice of becoming a war photographer, the way my military family background played into my wanting to see war. Chris Hondros was a civilian with a life more bohemian than disciplined. His approach to clothing, caring for his shoes, his books, his health – pretty much everything was disheveled. He was even messier about how he took care of his cameras, tossing them into car trunks already filled with junk. On the other hand, he was always precise about his vision, the intellectual touch he would put on things, his attention to detail. I remember a picture he took of a man holding a Purple Heart medal in his hand. The soldier had just awakened from a four-hour surgery when an officer presented him with the award. In the picture, you couldn't see the face, just the medal and the hand, but on the lower part of the wrist, a stain of blood. No need for words, not even to explain what the medal stood for. One detail told it all.

Which takes us to the picture of the little girl covered in the blood of her parents freshly killed by U.S. soldiers at a checkpoint in Tal Afar, Iraq. With this picture, Chris Hondros achieved what Nick Ut's picture of a napalmed girl screaming naked on a road achieved in Vietnam. Ut had a trigger effect on the pacifist movement back home. Chris' picture helped influence Americans' attitude toward the Iraq war. People began wondering, what exactly was happening over there? What could possibly justify so much horror by the U.S. military? Chris told me three things about that picture. First, the officer leading the patrol that day was aware of

the devastating impact the incident would have on the U.S. effort in Iraq and on his own career. So he kept Chris under supervision for a day or two before officially kicking him out of the embed. Surprisingly, in the end, he didn't oppose the picture's release. It would not have changed anything, as Chris had sent the pictures to Getty Images shortly after they were taken. Second, a few weeks later, he received a phone call from Paul Wolfowitz. The Pentagon's second in command knew all too well how the picture could have an impact, but was eager to get a sense of who took it. So Chris was invited to lunch with Wolfowitz in the Pentagon. Wolfowitz admired Chris. "What was it like being out in the field like that?" he asked, feverish like a child meeting his idol. It was a strange moment, Chris later told me, meeting this man, one of the toughest hard-liners of George W. Bush's administration, in awe of the photographer who was partially destroying his reputation by revealing the disaster that he and the rest of the administration had created. Thirdly, Chris was disappointed to discover, several years later, that his Tal Afar picture had been brandished at anti-war demonstrations at the White House. For him, a photographer should remain as neutral as possible. Chris had no desire to serve propaganda of any kind.

Chris was comfortable speaking about his pictures. Every assignment was an adventure, another key to his understanding of the world. Between assignments, he had New York, where he could rest, relax, and feel at home. The city had a great impact on him. Living there was proof of his achievement as a photographer. In the early 2000s, New York had replaced Paris as the world capital of photojournalism. When we first met, he was living on Tillary Street in Brooklyn, in a transformed warehouse featuring high-ceilinged apartments. He would throw memorable parties at his place, gathering many friends of diverse origins and backgrounds. International columnists would toast with NGO members, while photojournalists might be drinking cocktails with U.N. representatives of various nations. Over the years, he invented a new type of party: live classical music combined with slideshows of his war pictures. He had read somewhere that Johann Sebastian Bach was inspired by war when composing. It never really clicked in my mind, nor did I fully understand his love of music. To me, classical music was related to childhood when I played the piano several hours a day before dropping it at age 16, mostly as an act of rebellion toward my parents. Chris was a natural. He discovered classical music on his own. I remember hearing him play a

keyboard in the suite occupied by Getty Images at the Hamra hotel in Baghdad. It was odd, listening to Bach in a place filled with Iraqi interpreters and drivers, in the middle of a city convulsing under explosions day and night. At intervals, the vibrations of Black Hawk helicopters flying above covered the sound of Bach … Later, he gifted that instrument to my children, Tristan and Madenn. He was undoubtedly hoping it would trigger in them a desire to learn music. The keyboard disappeared during my family's move out of New York and our catastrophic return to France that resulted in my separation from my first wife. The day he made that gift was one of the last times I saw Chris in New York. Before I left, I gave him my 19th-century living room table and chairs. I took his car to my storage place in Harlem, fixed the table on the roof, stuffed the chairs inside — and then drove back to his loft. That night we dined with two photographers, Todd Heisler and Spencer Platt. As we were leaving the restaurant, Chris told me to always remember that I was becoming the associate editor-in-chief of Paris Match, the world's best magazine. It may have been true, but I was slowly losing my grip on the fieldwork and adventures that had paved my life over the years. The sad dilemma of our job is that as you climb the ladder, you cease doing what you do best. We reunited twice in 2010, both times in Afghanistan. Helmand, then Kandahar, were our last embeds together with the U.S. Army and the last stories we worked on together. Our last chance to encounter history together. Out of the many pictures he took during those assignments, one stands above all. Three Afghan elders filling Hesco bags with dirt to build a police checkpoint on the outskirts of a town only recently run by the Taliban. With the outline of the mountains behind them, the image is almost biblical.

When the Arab Spring broke out in January 2011, Chris suggested I join him. We already had a team on the ground, so I declined his offer. We spoke again on April 18. With my wife, Charlotte, I was scheduled to visit him and his fiancée, Christina Piaia, in New York the following weekend. "Man, I don't think I'm going to be back!" he answered by email. "I'm on a boat off the coast of Misurata now, waiting to go in … I'm really sorry to miss you, I was really looking forward to catching up." We never caught up. Chris was killed in Misurata by a mortar round two days later.

—

FROM A SEPTEMBER 2010
PHOTOGRAPHY EXHIBITION
IN FAYETTEVILLE, N.C.:

—

Looking over nearly 10 years of photographs from the wars in Iraq and Afghanistan since 2001, I'm amazed by the sheer volume of pictures I've amassed over the course of nearly 20 trips. I haven't counted precisely, but I must have hundreds of thousands of images. Some of them I barely remember taking. And they come from diverse situations in the theaters of war: taken on both embedded and unembedded trips, in crowded cities and rural villages, during quiet reflective moments and amid cacophonous firefights.

Some pictures now merge together in my mind, but many I can date easily with a glance. The initial American force that invaded Iraq in March 2003 was charged with eliminating all monuments and images of Saddam Hussein. This mission was mostly complete by the end of May 2003, so I know my photo of an American Marine removing a picture of Saddam from a classroom must date from before then. (In fact, it was shot on April 16, 2003.) The look of a Humvee also provides clues, since the combat vehicle used by U.S. troops in Iraq gained various pieces of additional armor over the course of nearly 10 years, like an evolving species of dinosaur. A photograph of troops riding confidently in a thin-skinned, unarmored Humvee must have been taken that first summer after the invasion in 2003. If a gunner is standing exposed in the turret, that's from 2004 at the latest, before troops started building metal boxes around the gunners, who had frequently suffered grievous injuries in roadside bomb blasts. But the initial design meant the gunners couldn't see out, so by 2005 thick bulletproof windows sprouted up from these boxes. And so on to the current day. Now Humvees have mostly been retired in favor of mine-resistant ambush-protected vehicles.

Always I try to keep my work focused on the people most impacted by these conflicts: the Iraqis and Afghans themselves, caught in the cauldron of post-9/11 geopolitics, and the American servicemen and servicewomen sent into harm's way in unfamiliar lands. Many of my photographs are portraits: focused on the probing eyes of an Afghan village boy, or the playful gaze of rambunctious Iraqi schoolgirls enjoying their precious few years of relative freedom before aging into more restricted adulthoods, or the piercing stare of an American Marine looking back at me through a small mirror on an unadorned wall. There are also moments of raw searing grief, such as the open-mouthed cry of an Iraqi 5-year-old crouching next to an American soldier moments after her parents were killed in a horrible combat-zone mistake.

ALWAYS I TRY TO KEEP MY WORK FOCUSED ON THE PEOPLE MOST IMPACTED BY THESE CONFLICTS: THE IRAQIS AND AFGHANS THEMSELVES, CAUGHT IN THE CAULDRON OF POST-9/11 GEOPOLITICS, AND THE AMERICAN SERVICEMEN AND SERVICEWOMEN SENT INTO HARM'S WAY IN UNFAMILIAR LANDS.

I.

"One of the ongoing themes
in my work, I hope, and one of
the things I believe in, is a sense
of human nature, a sense
of shared humanity above the
cultural layers we place on
ourselves. ... We place these
layers of ethnicity and culture on
ourselves, and it really doesn't
mean that much compared to
the human experience."

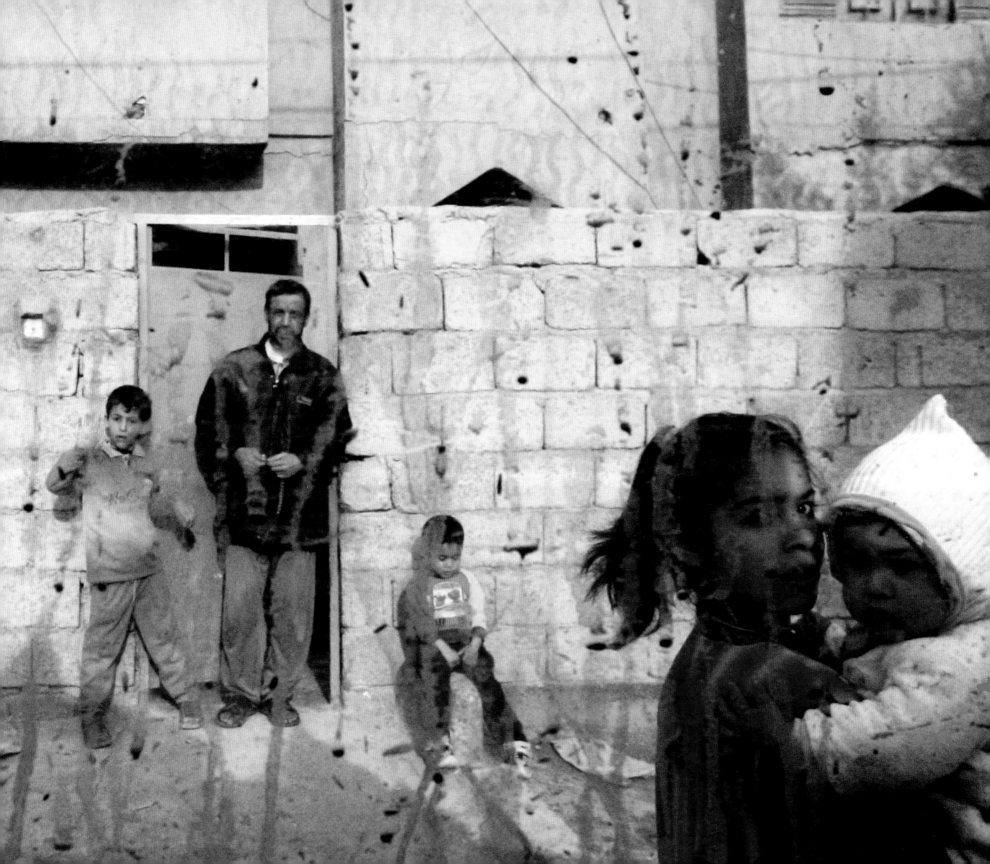

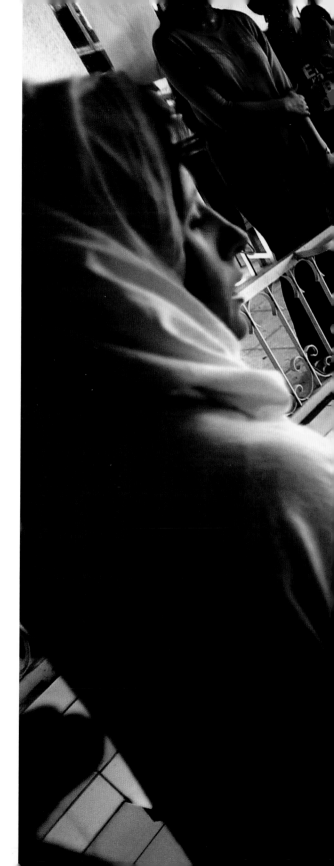

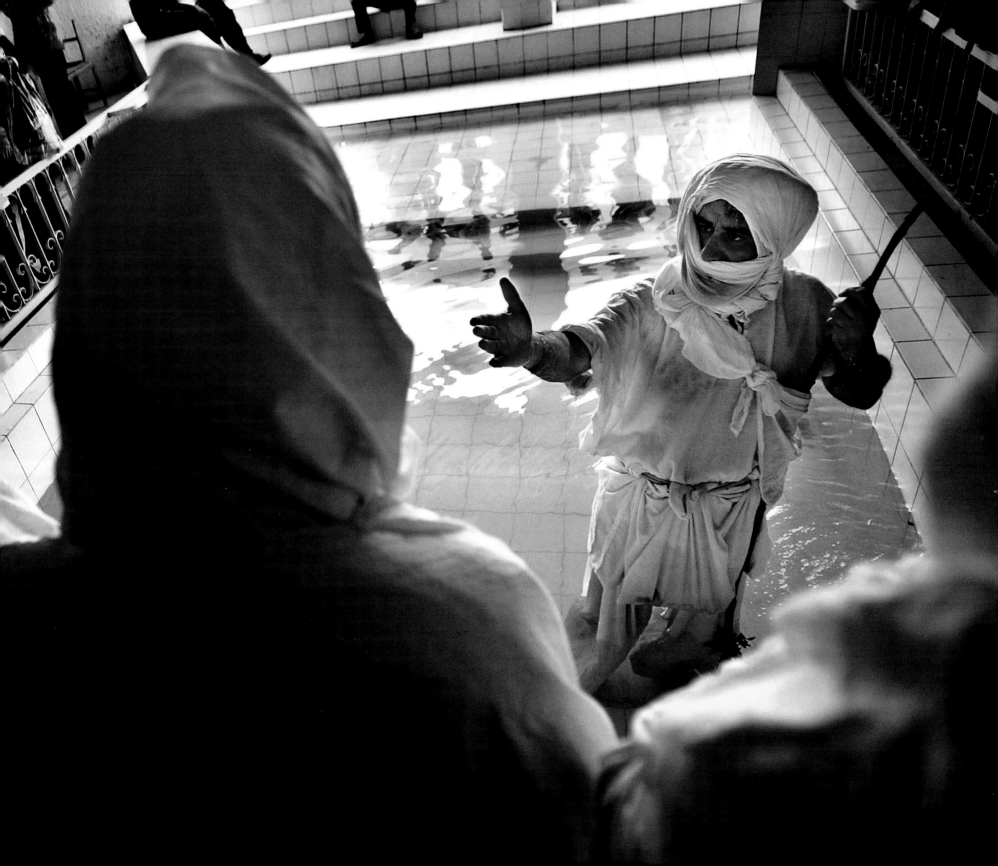

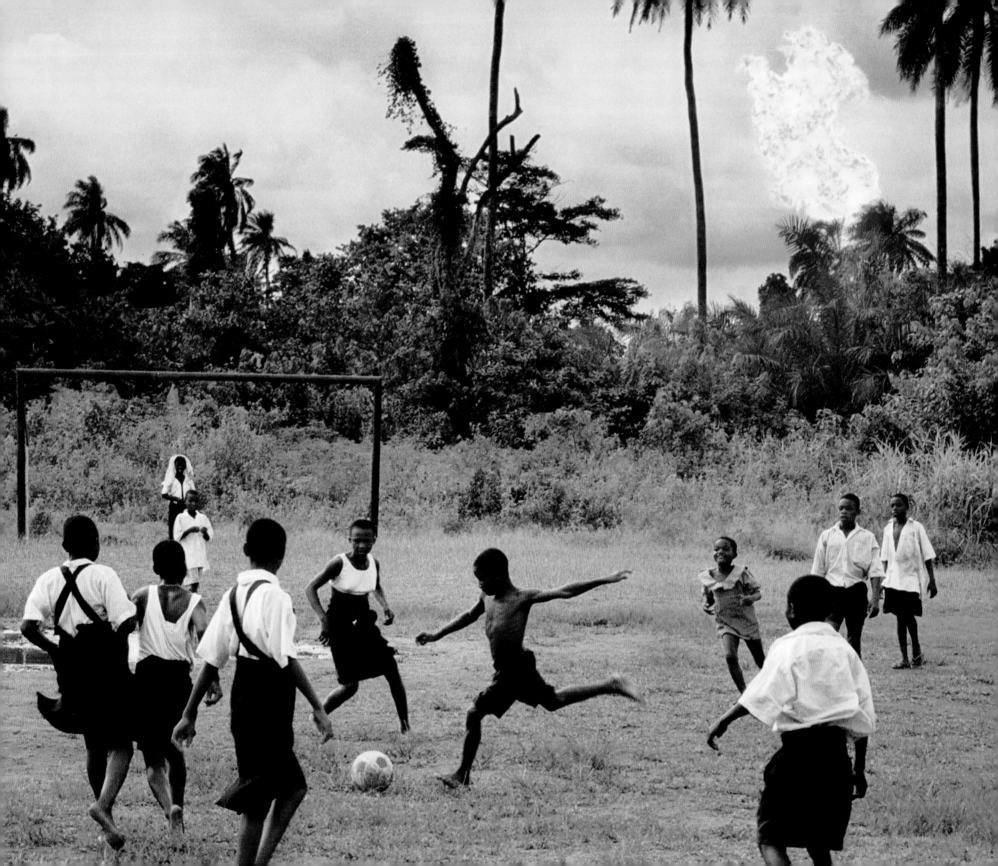

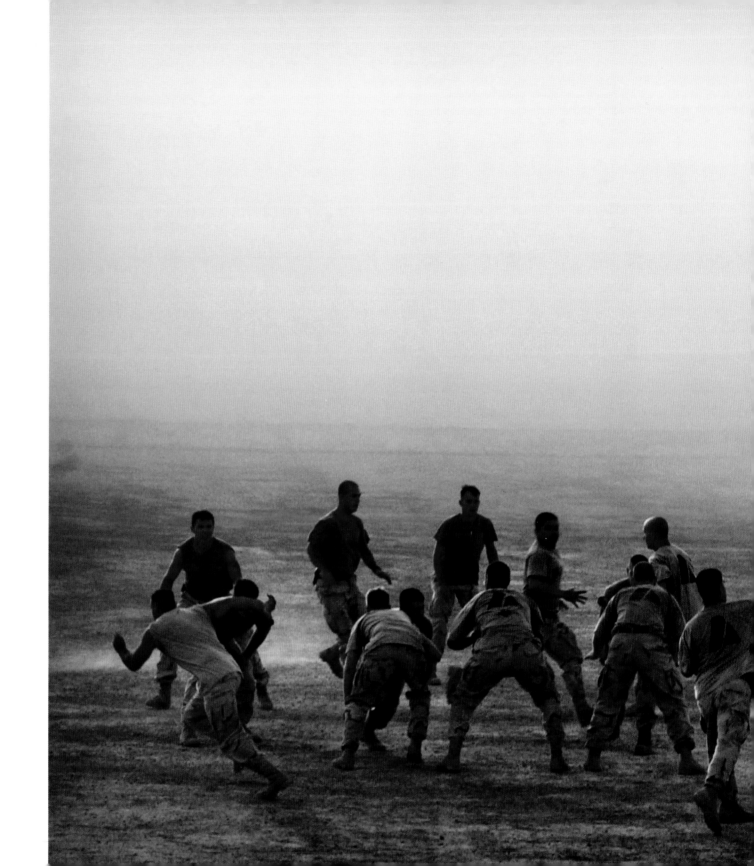

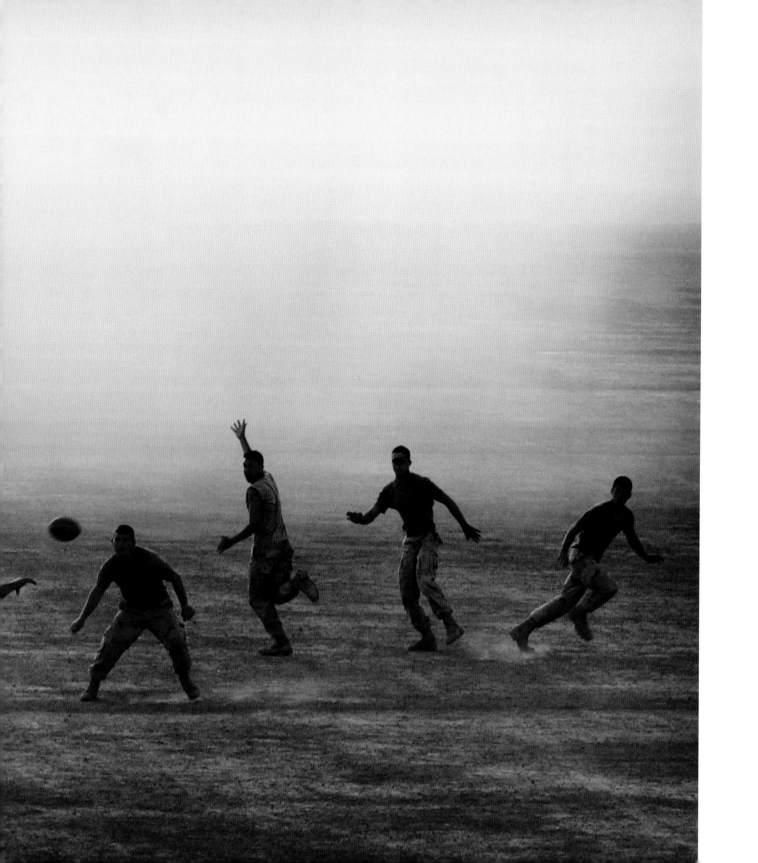

—

A VERSION OF THIS ARTICLE
WAS ORIGINALLY PUBLISHED
ON THE GETTY IMAGES
BLOG, OCT. 9, 2009.

—

It's now 2009, and everyone is asking me if things have changed in Afghanistan since 2002, when I was last here. Well, they have, and they haven't.

Kabul is still dirty and exotic, full of tan old sheepherding men with white beards and wrinkled faces. Of course, now they might be chatting on cellphones as they guide their flocks around town with long sticks. Some new buildings have gone up, but not that many.

On the military side, the U.S. Army is still stocked with an endless parade of energetic young men and women. Now as ever, they are fitness fanatics and will work out every day, even if they have to run laps through some muddy field on the edge of their base as the sun rises. But they're more jaded now than they were in 2002, after so many tours in both Iraq and Afghanistan.

The central military hub in Afghanistan is Bagram Air Base, an hour's drive from Kabul across a spectacular plateau nestled between mountains. When I stayed at Bagram in 2002, all the press slept in one large tent located next to the barbed-wire perimeter of a now-infamous detention facility. Opportunistic Afghans had set up impromptu bazaars just outside the front gates, and we'd discreetly purchase incredibly bad Uzbek vodka and other supplies for our nightly rabble-rousing party in the press tent. (Sometimes off-duty soldiers would walk by, peek in, and find themselves downing a quick beer and flirting with reporters for a few minutes — then dashing off into the night again.)

Those days are long gone. Bagram today has evolved and changed in spirit; everything is far more organized and uptight, and the base has spread out, like a California town exploding into a tangle of urban sprawl. Troops now stay in long rows of stacked housing units that look more like apartment complexes than tents. MPs hand out tickets to drivers who are speeding or not wearing a seat belt. I once saw a flier touting free swing dancing classes.

One recent morning, I laced up my shoes and went for a run with the troops along Bagram's broad main boulevard. The street ends after a few kilometers and opens up onto a broad flat plain. From there, I stopped and watched all manner of military aircraft taxi down a runway and then roar into the sky: stately C-130 workhorses, massive C-17 cargo carriers, strange Russian-looking planes, and the incredible fighter jets, lithe wedges of physics-defying magic that scream overhead louder than a train thundering by.

Bagram is a small city with a big airport, all built from scratch in the middle of this inhospitable countryside, for billions upon billions of dollars. And there are hundreds of other bases, more or less like it, across Afghanistan. The scope of it all is staggering. If there's anything I wish I could convey to the general American public who will never visit this place, it is the enormous scale of the undertaking being done here in our name — photos never seem to quite capture it.

THOSE DAYS ARE LONG GONE.
BAGRAM TODAY HAS EVOLVED AND
CHANGED IN SPIRIT; EVERYTHING
IS FAR MORE ORGANIZED AND UPTIGHT,
AND THE BASE HAS SPREAD OUT,
LIKE A CALIFORNIA TOWN EXPLODING
INTO A TANGLE OF URBAN SPRAWL.

A VERSION OF THIS ARTICLE
WAS ORIGINALLY PUBLISHED
ON THE GETTY IMAGES
BLOG, NOV. 2, 2009.

The Army had this elaborate plan to drop soldiers via helicopter into a valley in Taliban country, with each man carrying supplies for days of marching in search of caves that had been reconnoitered by air. It sounded fun, so I tagged along and jumped off the helicopter and onto the muddy field. Almost before we hit the soil, the Black Hawk lurched up, the rotors' roar fading away. Soon it was quiet. The sun began to peek over the horizon.

Led by Steven Caldwell, an ebullient, witty staff sergeant from Indiana, the platoon comprised young men from across America. They irreverently cracked jokes while marching, mostly banter about girlfriends back home. Also along were Staff Sgt. Justin Schwartz, an Air Force dog handler, and his pride and joy, Bleck, a German shepherd trained to sniff out explosives.

The first day was for finding the first two caves. After a short walk, it turned out they weren't caves, just ridges resembling caves from the air. Caldwell shrugged and entered the information into a GPS-type device he used to find targets. We continued in search of the rest.

As we passed through villages, Pashtun tribalists stared curiously. A few hours of hiking brought us to a road hugging the base of an imposing cliff. Caldwell glanced down at his computer and back up at the mountainside.

"Looks like the next few caves are right up there," he said, pointing to a spot far above. He looked at his men. "Who's coming with me?"

No volunteers. Caldwell rolled his eyes and muttered several unprintable things. Then he dropped his pack onto the dirt.

"Fine. Just watch the road. I need the K-9 though." He started clambering up the mountain, and Schwartz and Bleck scrambled after him. Soon they were over the ridge, out of sight.

I hesitated, trying to convince myself I could productively photograph right where I was, without venturing up. The platoon resumed joking. I sighed, slung my camera over my shoulder, and headed up the mountain.

It was dangerous. The route ranged from steeply inclined to nearly vertical, and the shale tended to disquietingly disintegrate as I searched for footholds. Eventually, I caught up with Caldwell, Schwartz, and Bleck. They were barely sweating.

"Caldwell, you're from Indiana," I said, panting. "Where did you learn how to climb mountains?" He smiled without looking up from his computer.

"Man, I've been stationed in Alaska for five years. We do this stuff all day." He bolted off and crossed the base of the long vertical crack that wound down the cliff. Schwartz and Bleck gamely followed.

This route seemed impossible, so I hiked up, looking for a better place to cross. Before long, I couldn't go up anymore. The sides were nothing but a slope of loose pebbles. I was stuck.

After minutes of self-pity, I lunged leftward and quickly danced across the crumbly slope like a barefoot teenager bouncing on the hot sands of a vertical beach. I made it to the crevasse, awkwardly landed on my rear, and instantly started sliding down. But inside the crack I could slow myself with my feet, and it was kind of fun, like a water slide. (My shredded pants would disagree. An Afghan tailor later laboriously repaired them.) Finally, I tumbled to a stop at the bottom, landing with a cloud of dust next to Caldwell.

"Hey there," he said. "Man, this ain't no cave here either. You about ready?"

"Whenever you are."

Moments like these prompt me to get philosophical: Why am I here? How did this happen? Why am I hanging on the side of an Afghan mountain? I'm not in the Army; I didn't sign up for this. I should be back home, watching TV or canoodling in bed or having an espresso.

But in the end, things usually work themselves out, and the satisfaction of photographing our era's most important issues far outweighs any discomfort, or even fear.

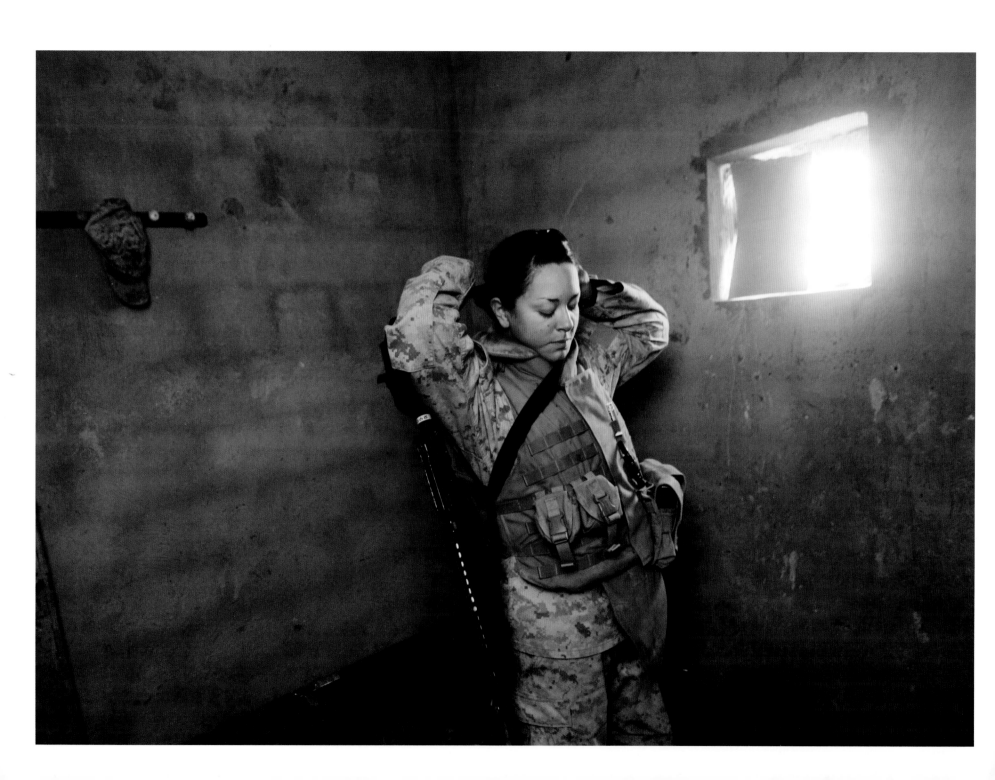

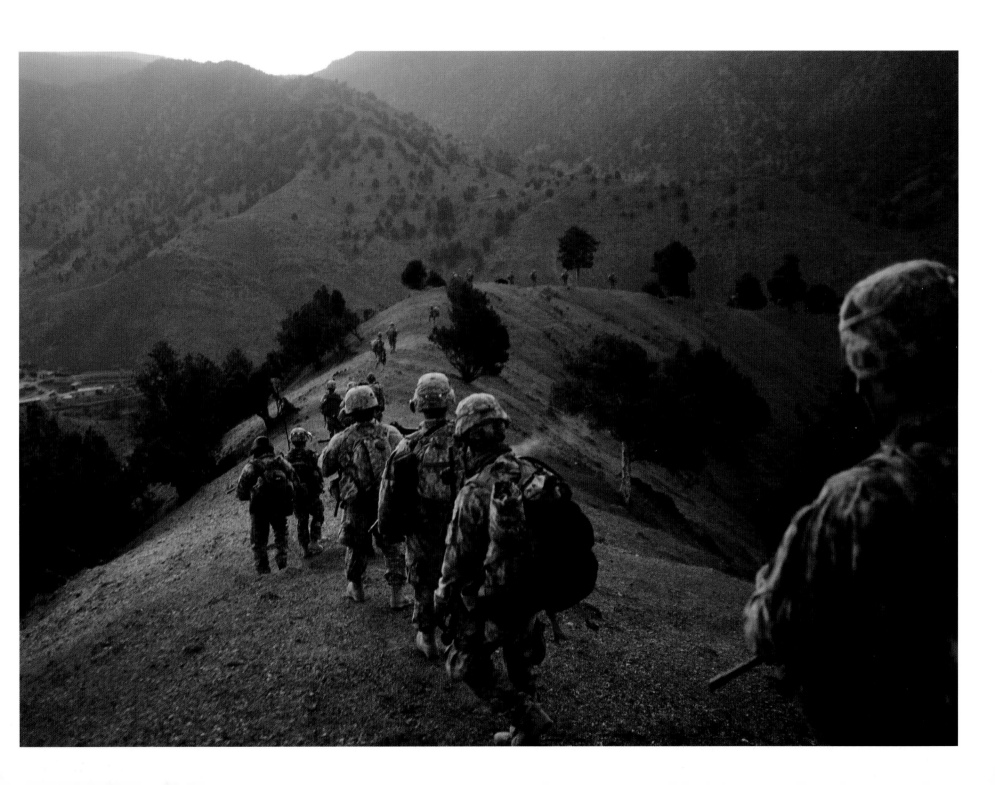

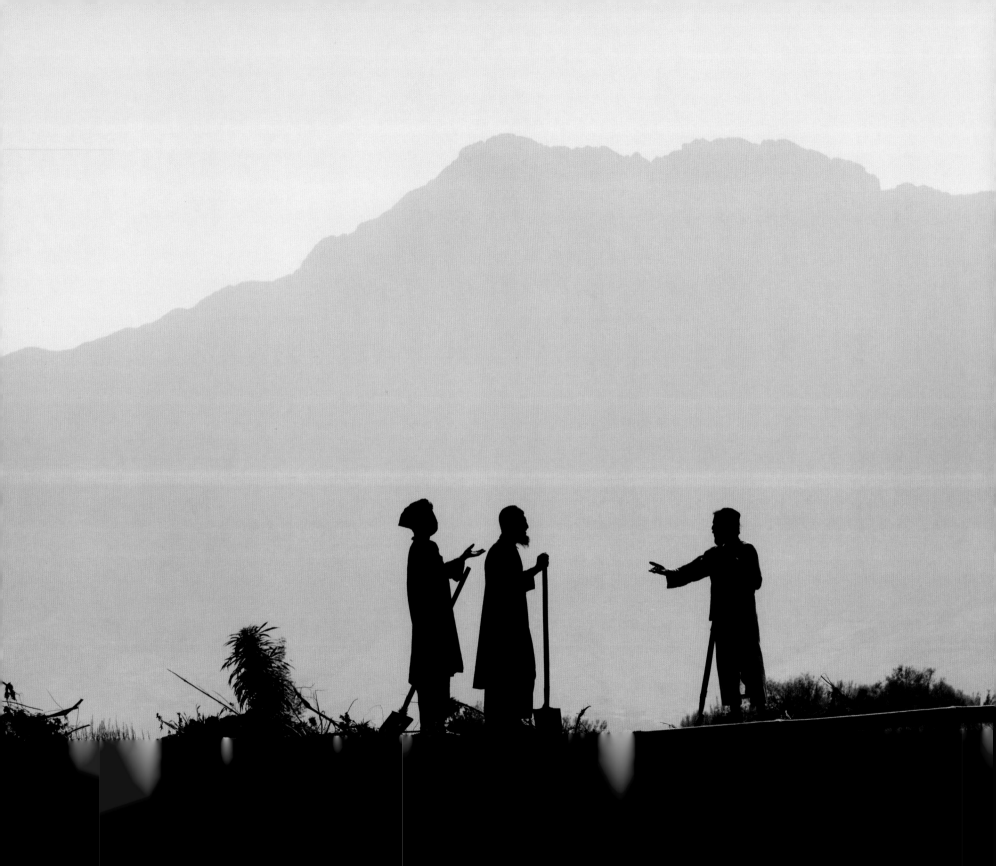

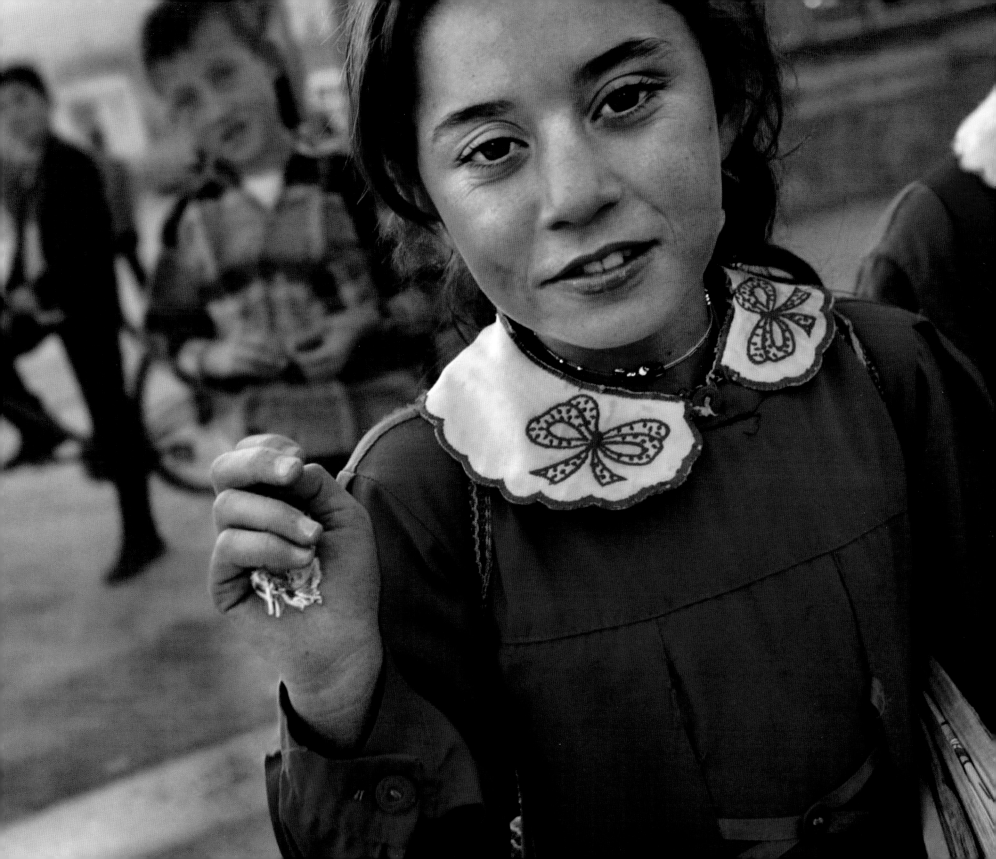

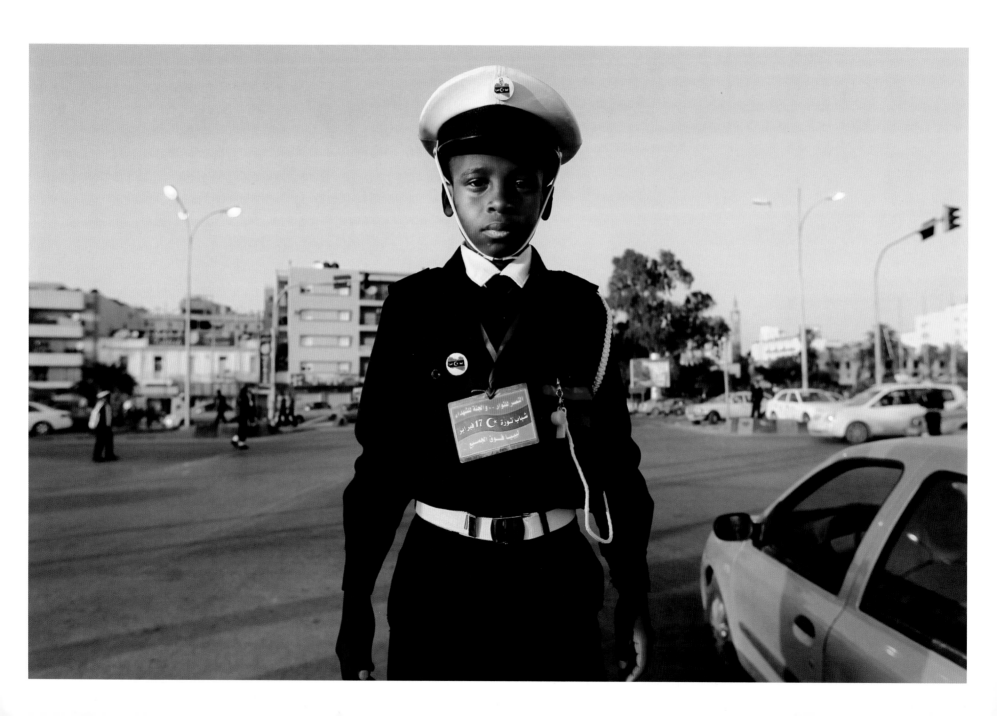

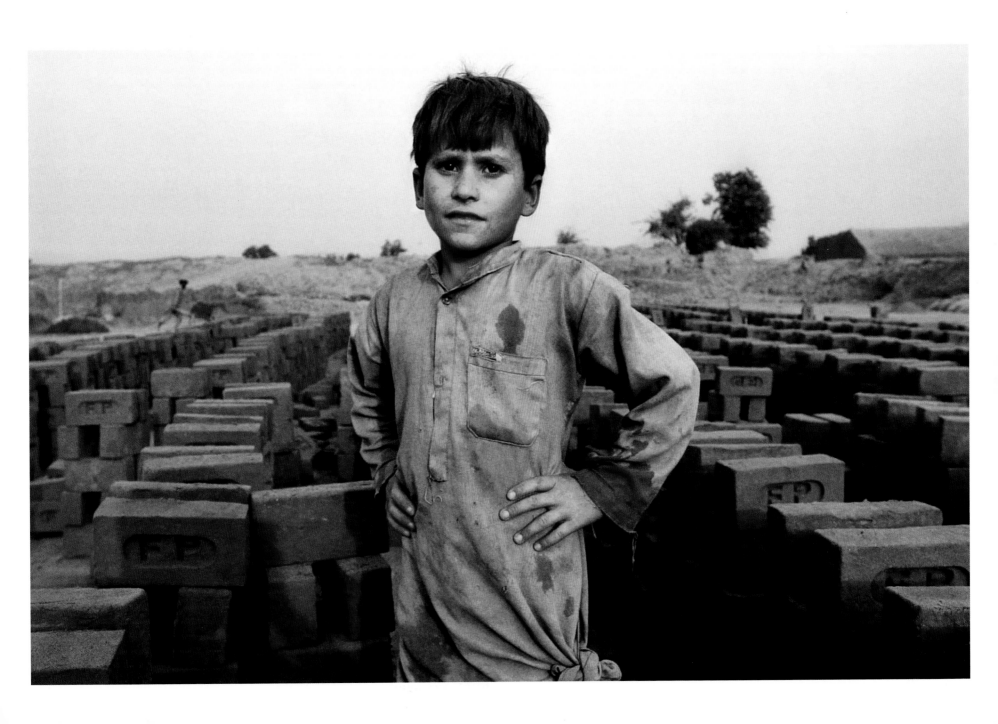

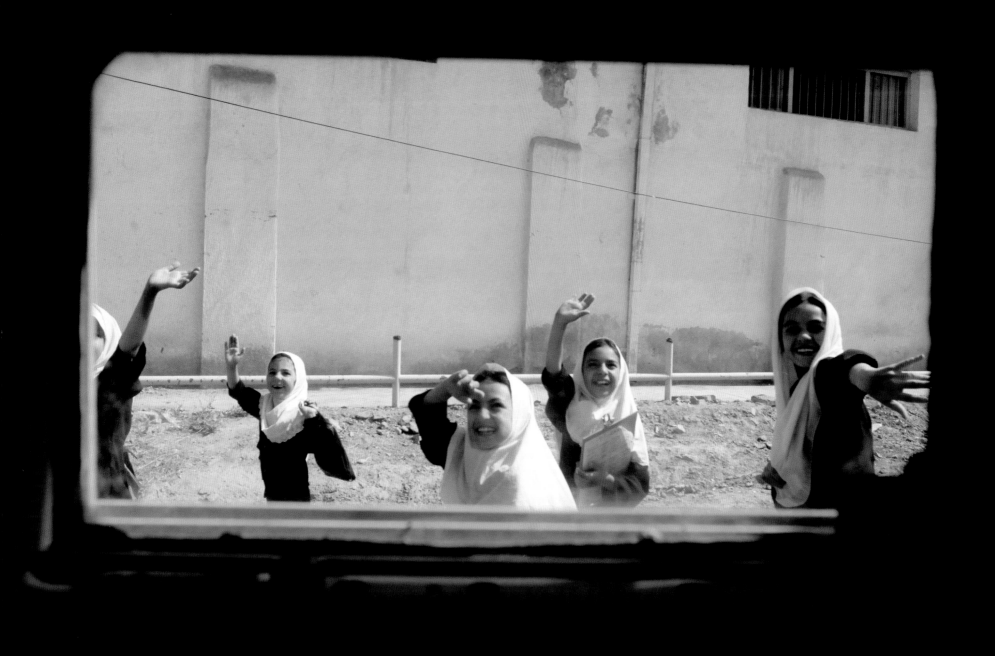

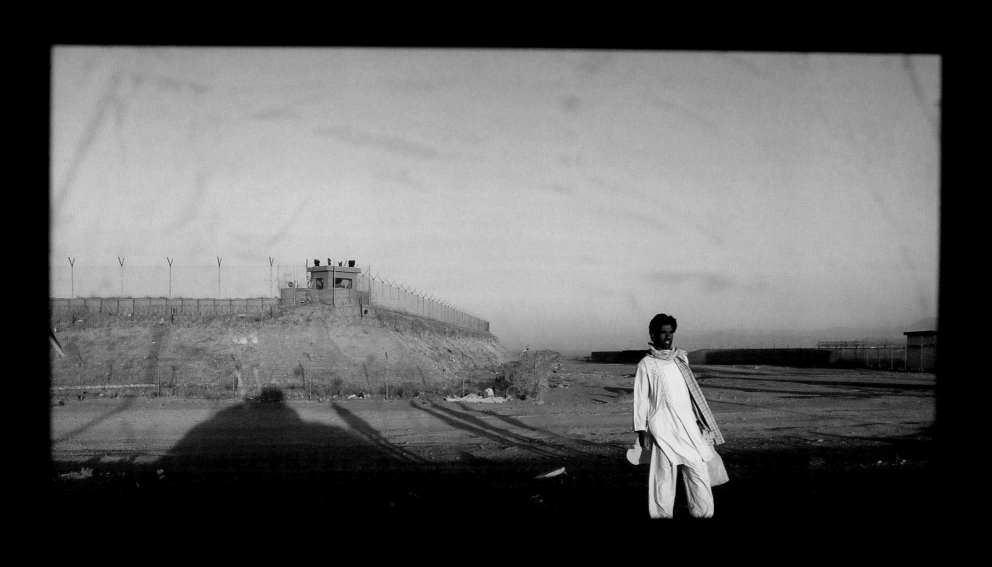

—

A VERSION OF THIS ARTICLE
WAS ORIGINALLY PUBLISHED
IN THE VIRGINIA QUARTERLY
REVIEW, SUMMER 2007.

—

The window of a Humvee rolling through Baghdad's dangerous streets is essentially a television, watched in the dark. The glass is dirty and 3 inches thick, and everything has a hazy, muted look. Humvees are dim inside, even on sunny days. You can see out, but Iraqis can't see in, any more than sitcom characters can see you watching. And these screens show, for the American soldier-viewers gazing through them, glimpses of the daily lives of 7 million souls: Iraqi children walking to school, middle-aged men lounging in chairs outside businesses, a food seller grilling meats, women swathed in black abayas (so rarely worn before the U.S. invasion, yet so common today) shuffling through bombed-out streets. And tall concrete blast walls, everywhere.

Moving through the city in a Humvee is the ubiquitous Iraq experience for U.S. soldiers. And if there's anything that Iraqis are inured to by now, four years into the war, it's the sight of Humvees rumbling down their roads. Often, they barely look up when the armored vehicles thunder by. Sometimes men in tea shops will still shoot angry stares. Sometimes children will still wave. But for the most part, Iraqis have mastered the art of practiced indifference. This means it's possible to watch as people simply go about their daily routines, a rare opportunity for a war journalist.

Of course, the view from a Humvee window, for all its apparent intimacy, provides a limited look at a complex country. Vignettes of street life give some understanding of any society, but an incomplete and ephemeral one. Anyone watching "Humvee TV" knows Iraqi society no better than visitors taking in Manhattan from tour buses understand New York. These scrolling screens don't provide any real information about why Iraq is the way it is. What are those students learning after they arrive at school? Is that woman a Sunni or Shiite — and is she content, or really longing to be somewhere else? Who ordered a road crew to repair that street? What are those men laughing about, and what's even funny to Iraqis nowadays? Where does that man selling appliances get all his washing machines from, and who buys them? And who put up that new billboard for cigarettes — is Baghdad still considered a prime market for selling smokes, perhaps now more than ever?

OF COURSE, THE VIEW FROM A HUMVEE
WINDOW, FOR ALL ITS APPARENT INTIMACY,
PROVIDES A LIMITED LOOK AT A COMPLEX
COUNTRY. VIGNETTES OF STREET LIFE GIVE
SOME UNDERSTANDING OF ANY SOCIETY,
BUT AN INCOMPLETE AND EPHEMERAL ONE.

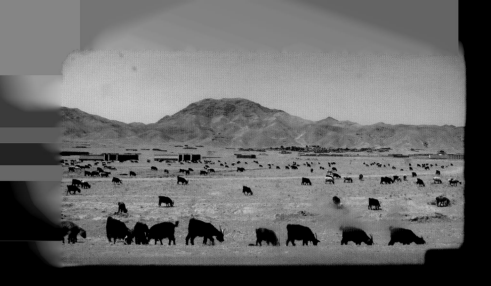
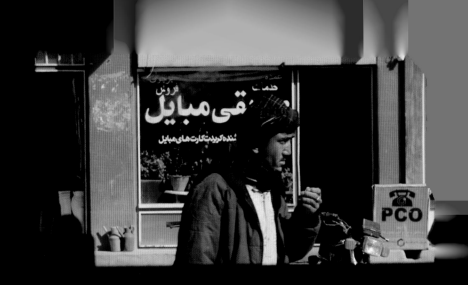
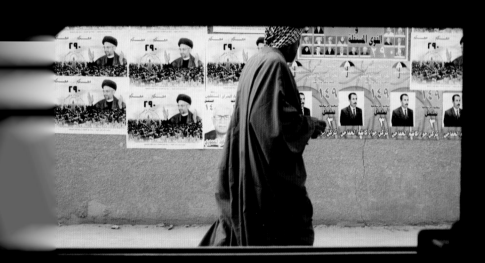
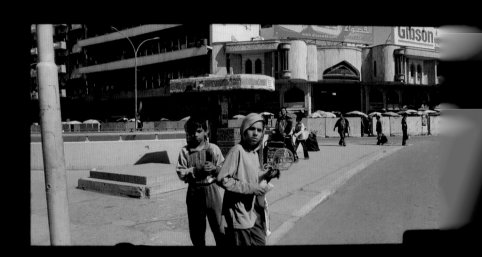

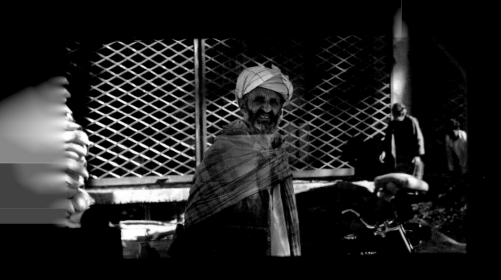

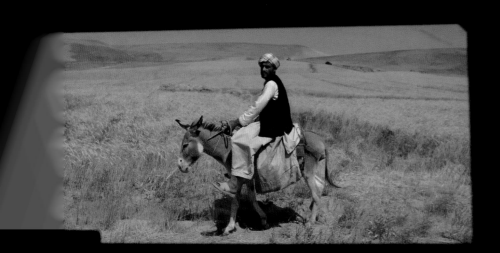
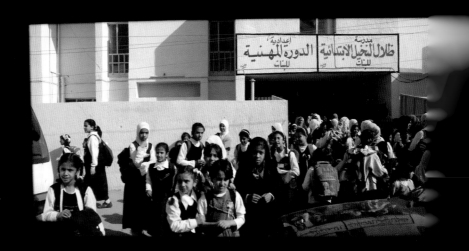
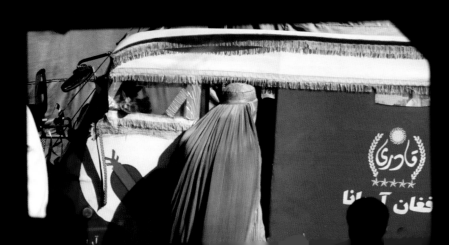
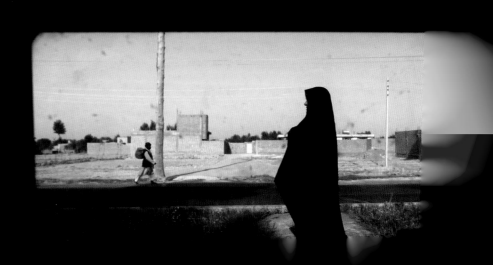

II.

"Always I try to keep my work focused on the people most impacted by these conflicts. ... Many of my photographs are portraits: focused on the probing eyes of an Afghan village boy, or the playful gaze of rambunctious Iraqi schoolgirls ... or the piercing stare of an American Marine looking back at me through a small mirror on an unadorned wall."

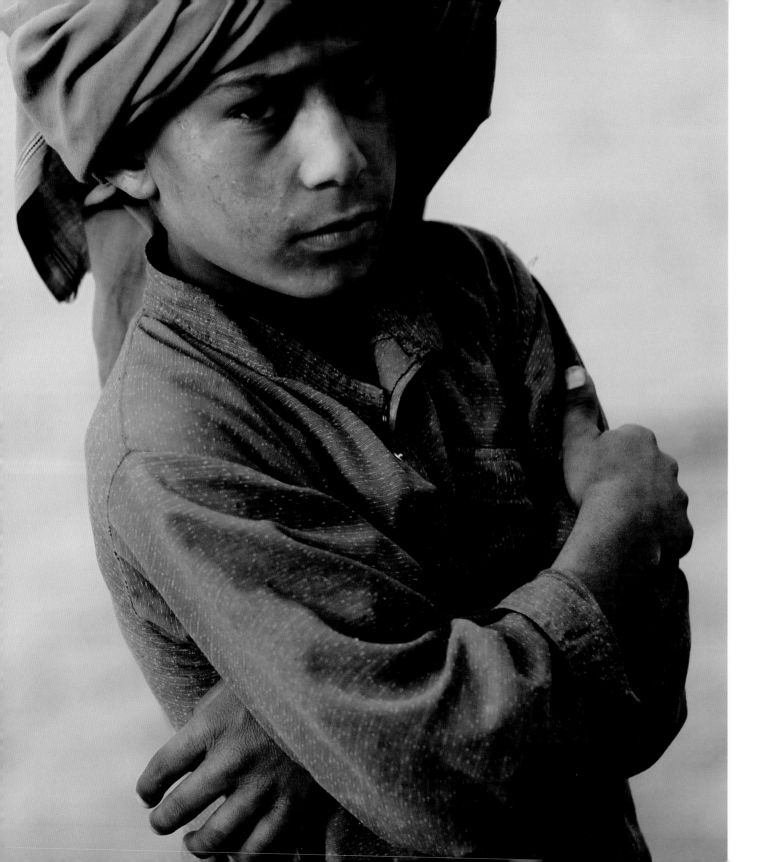

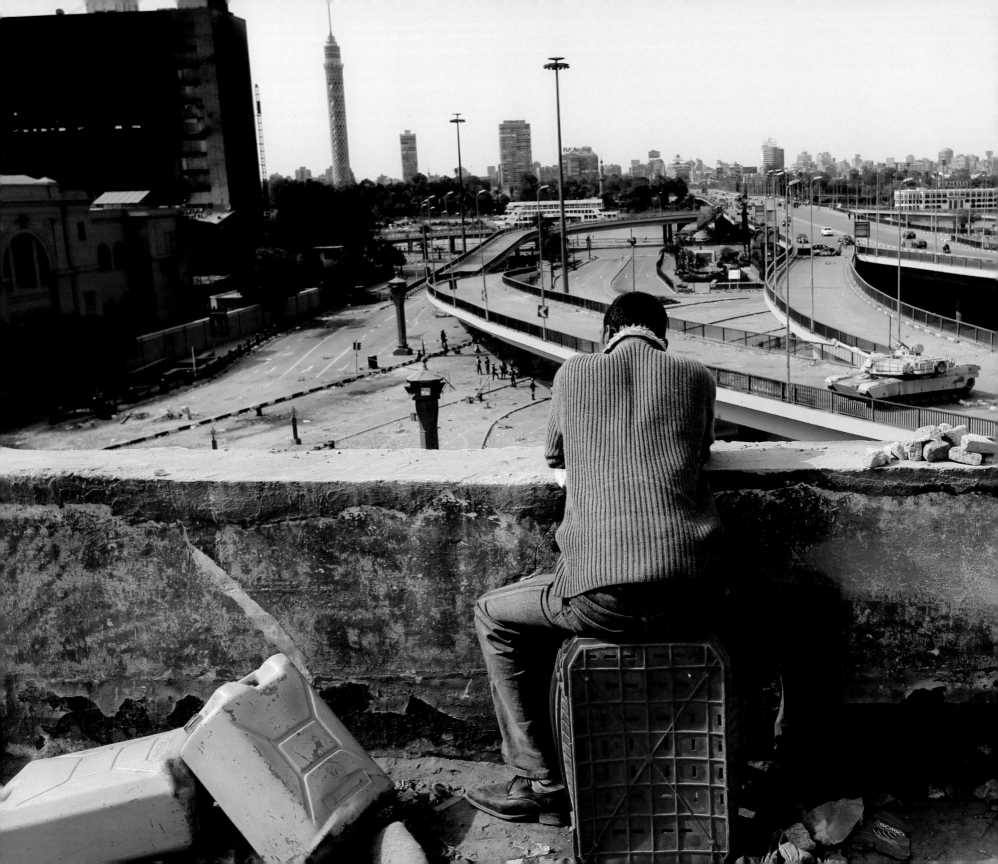

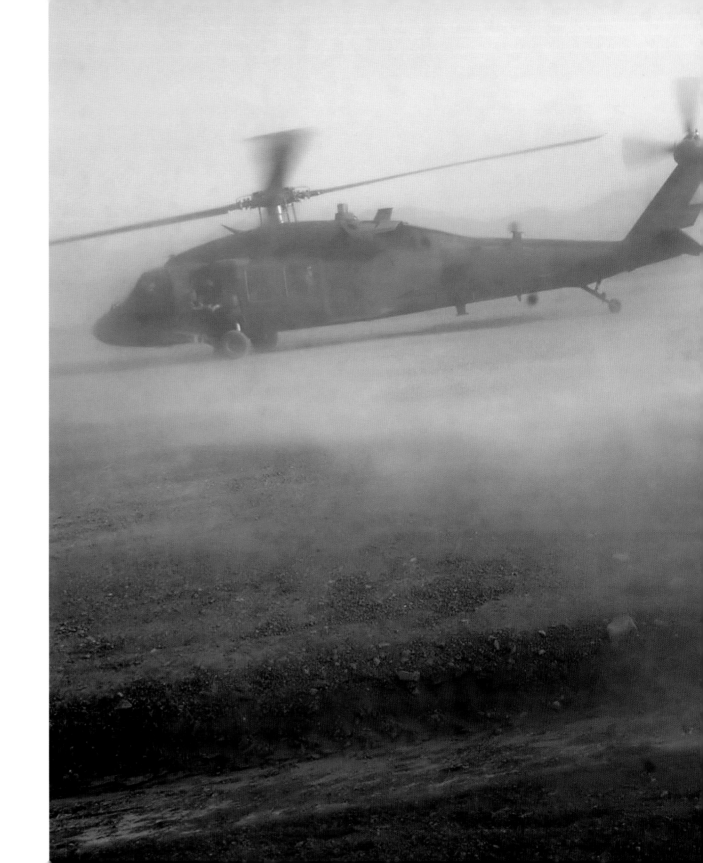

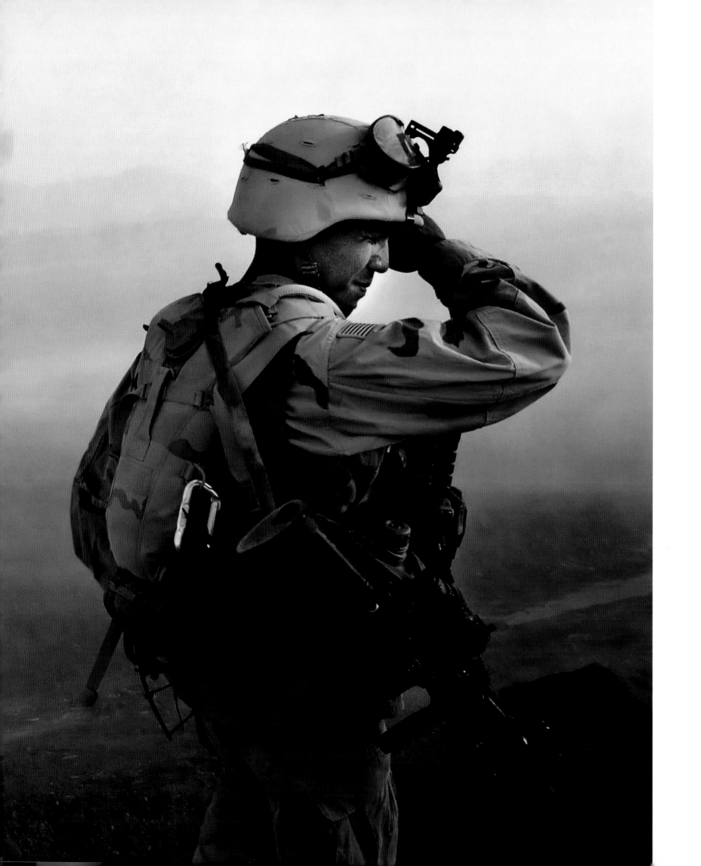

—

A VERSION OF THIS ARTICLE
WAS ORIGINALLY PUBLISHED
IN THE FORT COLLINS
WEEKLY, APRIL 18, 2003.

—

When I arrived in Baghdad in April 2003, the city was on fire. The looting and wanton destruction took most of us veteran foreign correspondents by surprise. One day, I went to the nine-story Iraqi Foreign Ministry. Or, rather, what was left of it. A records room had been totally gutted; the files on the shelves were just ash. When I poked them, cascades of powder came whooshing down. Even the janitor's closet had been looted; papers and books were littered on every floor — everything from Saddam Hussein's vanity press offerings to guides on English business correspondence. Safes had been pried open. One behemoth iron lockbox, 8 feet high, was breached neatly on its side by what must have been a blowtorch.

In Baghdad today, gunfire is so common that it's easy to ignore it unless it's very close. While I was driving around one day with Mohammed, my driver and interpreter, a ferocious series of bursts broke out somewhere in front of us. Traffic slowed, hesitant to continue. The bullets sounded very near, so drivers pulled their vehicles over to the sidewalk and we all got out and crouched behind a low wall, waiting for the exchange to end. Two men next to me used the opportunity to nonchalantly exchange friendly pleasantries.

"This is nuts," I told Mohammed, while peering over the brick wall.

"You know the Wild West, in America? This is like that." He just shrugged. "It is dangerous now."

Times like this bring out the best, as well as the worst, in ordinary people. One group that deserves some medal of honor is Baghdad's traffic police. They're just regular Iraqi men, all wearing white shirts, blue pants, and brimmed hats. Despite the chaos and the lack of government, they've been showing up for work anyway — directing traffic in a city of 4 million people that has no working traffic lights. They aren't even being paid. American troops took away their Kalashnikovs, so they walk their beats without weapons or, at best, with an old personal revolver. Several have been shot while trying to prevent blatant looting. Still, they come to work every morning, manning the large intersections in town and doing their part to keep Baghdad moving. "What else can we do?" one told me. "It's only a small thing, but there is no other choice but to go on."

There are other minor heroes in this ongoing tragedy. Like Dr. Omar, a wily hospital director who armed his team of doctors with assault rifles and put them on guard duty to

fend off any would-be looters who came near the hospital. As a result, his hospital was probably the only one in Baghdad spared looting.

In one ward of the hospital, I met the family of 15-year-old Sakina Jalila, who had been shot in the head by a stray bullet. The girl's head was bandaged and her eyes were grotesquely swollen; an X-ray revealed that the bullet was lodged firmly in the center of her brain. Her mother, father, and uncle sat by her side, their eyes red with tears. Her uncle, Mohammed Jalila, holding her hand, told me, "She is my favorite; she's always been my favorite since she was a little girl. If she dies, then I may die too."

While there are psychic wounds, they haven't set in for everyone yet. Safaa Ahmed, an ebullient 11-year-old, has a perfect face, lips covered with fruity gloss, and beautiful straight black hair. She sits up on her bed, chatting happily with her family. At first, it's easy to miss that her right leg is gone, blown off by shrapnel during the bombing campaign and replaced by a bandaged stump 6 inches long. "She hasn't cried. She does nothing but sing and laugh," Dr. Omar said, a lit cigarette wagging between his lips. "I don't think what's happened to her has sunk in just yet."

My trip is over, for now. I've had enough: two months of uncertainty, near-death experiences, and grim scenes. I'm not alone — many journalists are similarly exhausted and are leaving. "The story is winding down," we often say to each other or to our bosses to justify our exodus. But it may be too much to hope for. I cover wars and unrest for a living — and, I fear, it won't be long until I'm back in Iraq.

Unfortunately, this story isn't winding down. Not even close. It's not over for the U.S. troops who will be in the region for months or years more, and it's certainly not over for Iraq's 24 million citizens. Thousands will bear the literal scars of war for the rest of their lives; millions of others will carry forever marks of the horrors they've witnessed.

MY TRIP IS OVER, FOR NOW. I'VE HAD ENOUGH: TWO MONTHS OF UNCERTAINTY, NEAR-DEATH EXPERIENCES, AND GRIM SCENES. I'M NOT ALONE — MANY JOURNALISTS ARE SIMILARLY EXHAUSTED AND ARE LEAVING. "THE STORY IS WINDING DOWN," WE OFTEN SAY TO EACH OTHER OR TO OUR BOSSES TO JUSTIFY OUR EXODUS. BUT IT MAY BE TOO MUCH TO HOPE FOR. I COVER WARS AND UNREST FOR A LIVING — AND, I FEAR, IT WON'T BE LONG UNTIL I'M BACK IN IRAQ.

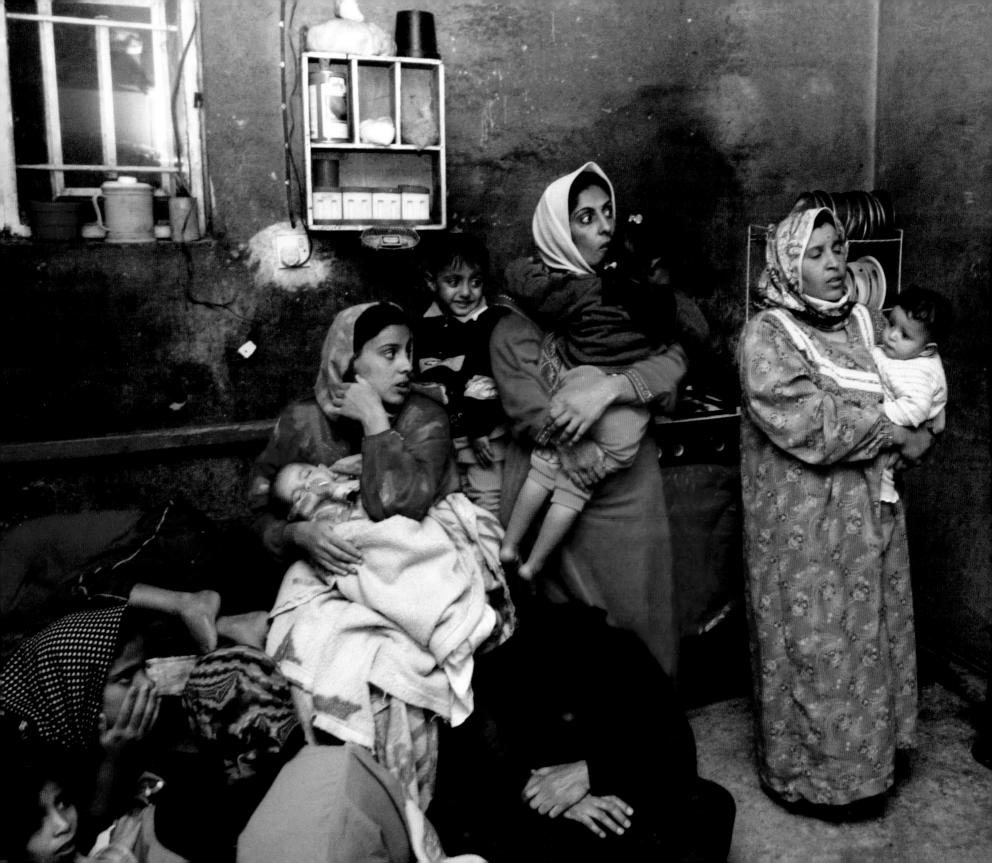

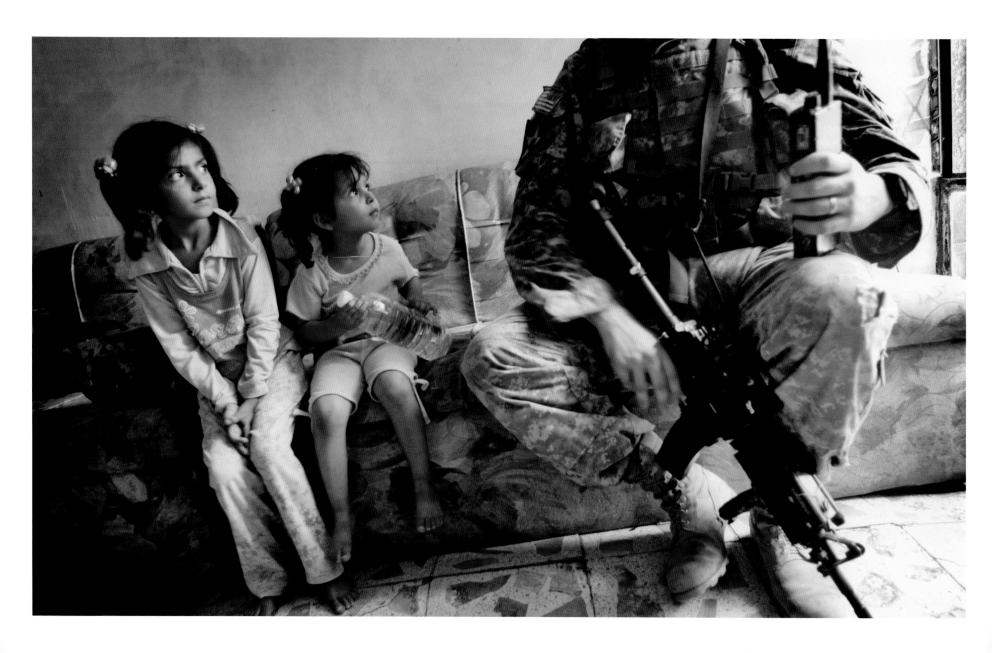

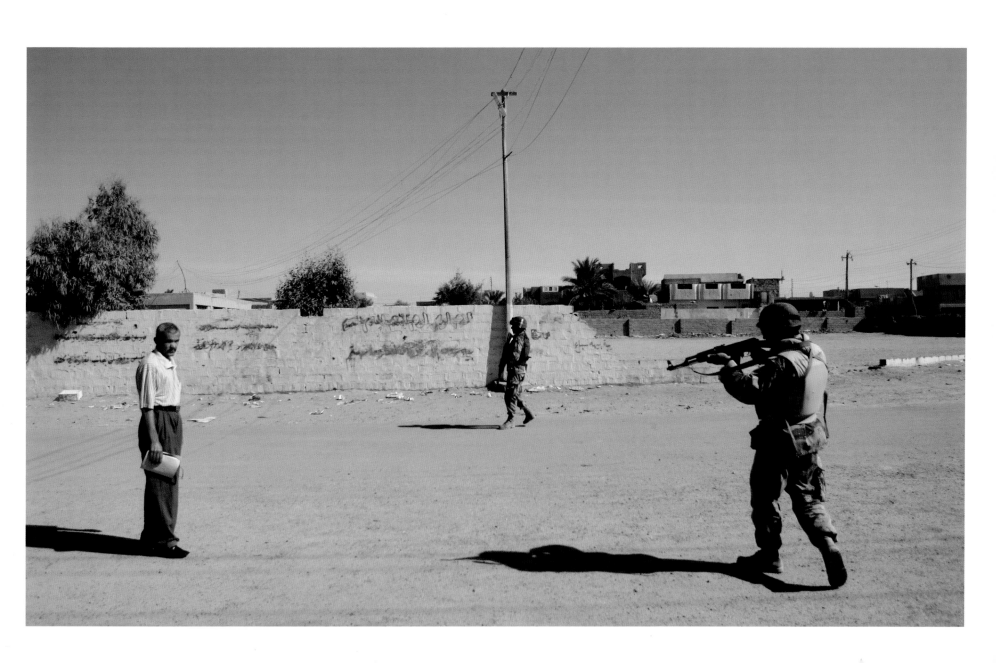

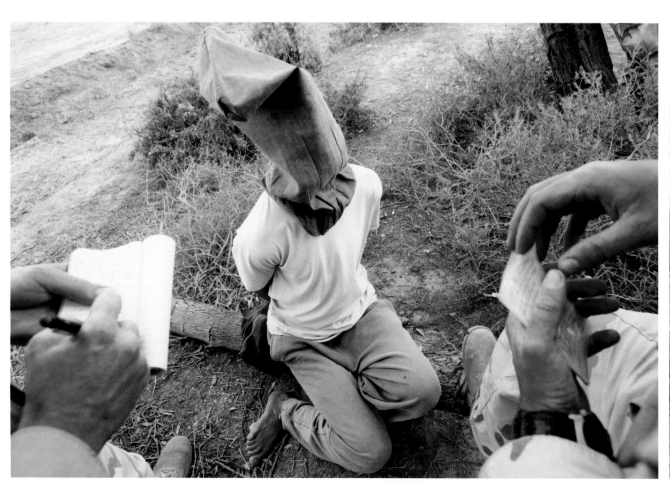

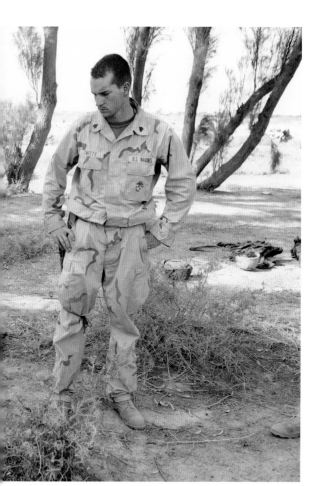

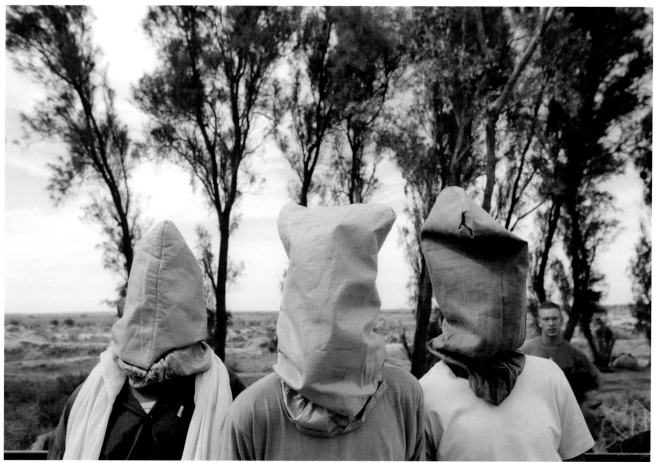

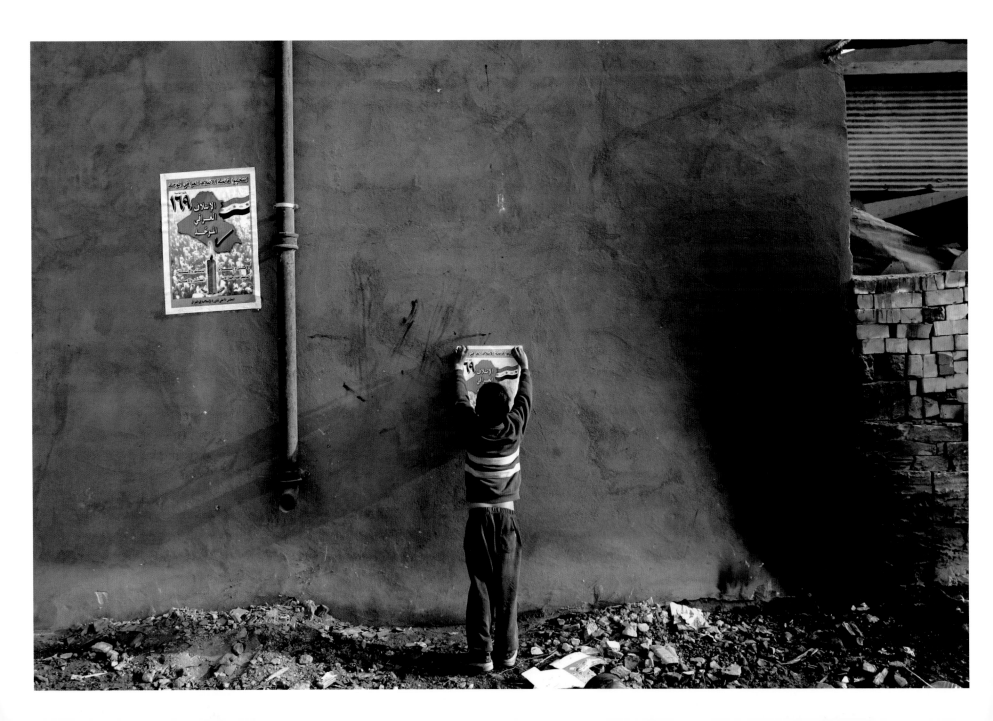

—

A VERSION OF THIS ARTICLE
WAS ORIGINALLY PUBLISHED
IN THE RALEIGH HATCHET,
JUNE 20, 2005.

—

I'm looking for the music that best conveys the tragedy of Iraq. This isn't a theoretical question, writing, as I am, from a dusty Marine base on the edge of Fallujah, in 120 degree heat and surrounded by madness. I'm fingering my iPod at night, while mortars crunch all around, searching for the songs that can help make sense of it all.

Once I thought the answer self-evident: the compositions of Gustav Mahler. Mahler's symphonies, with their grim marches and bombastic brass, might reflect Iraq's epic chaos. Especially his Sixth Symphony, which might almost be a soundtrack for armies on the move, tanks rolling, and fighter jets swooping through the sky. But now I think there isn't really much Mahler in Iraq. This war is too ambiguous for Mahler. Mahler wrote in the first decade of the 20th century and died in 1911, but the mood of his music foretold the world wars before they happened. Mahler's world was one of uneasy nationalism and firm absolutes, of conventional armies squaring off on titanic battlefields. And that world, long gone, was nothing like the confusing later battlefields of Vietnam, Algeria, and now this mess in Iraq. (Well, maybe Mahler hinted at it in his Ninth Symphony. If you had to look for the smoking ruins of Fallujah in Mahler, you'd find it best in the finale of the Ninth Symphony.)

So I'm searching elsewhere on my iPod dial. Bartok? Perhaps. Maybe some of the more nihilistic Stravinsky?

Almost. Shostakovich would seem like another natural match, but there's an apprehensive quality to his music that's not quite right — it better fits the Cold War era than our own.

Perhaps the answer is the late Beethoven string quartets. Certainly the relentlessness of the Grosse Fuge works as well as anything to recall the swirling fury of urban battle (believe me), while the sonorous harmonies of the sixth movement of the profound Opus 131 quartet used to run through my mind, unbidden, whenever I photographed one of Saddam Hussein's exhumed mass graves. And the long, ambiguous, introspective elegies so characteristic of these late quartets — like the lento assai movement of the F major or the lovely cavatina of the B flat — oddly, in their stillness and intimacy, might come as close as we can get to comprehending the madness of war.

Probably this quest is hopeless: finding the right music for Iraq, as the war is still raging and the outcome unknown.

But one night last week, I was out with the Marines before an offensive in an utterly remote desert of Anbar province, sleeping in the open on the sand, my flak vest spread under me as a pillow. The moon had set and it was ethereally dark and quiet, and I listened to Beethoven's cavatina as I stared up into a black sea sprinkled liberally with the lights of the cosmos. And I felt, for just a moment, that I almost understood why I was there and what it all meant.

AND THE LONG, AMBIGUOUS, INTROSPECTIVE ELEGIES SO CHARACTERISTIC OF THESE LATE QUARTETS — LIKE THE LENTO ASSAI MOVEMENT OF THE F MAJOR OR THE LOVELY CAVATINA OF THE B FLAT — ODDLY, IN THEIR STILLNESS AND INTIMACY, MIGHT COME AS CLOSE AS WE CAN GET TO COMPREHENDING THE MADNESS OF WAR.

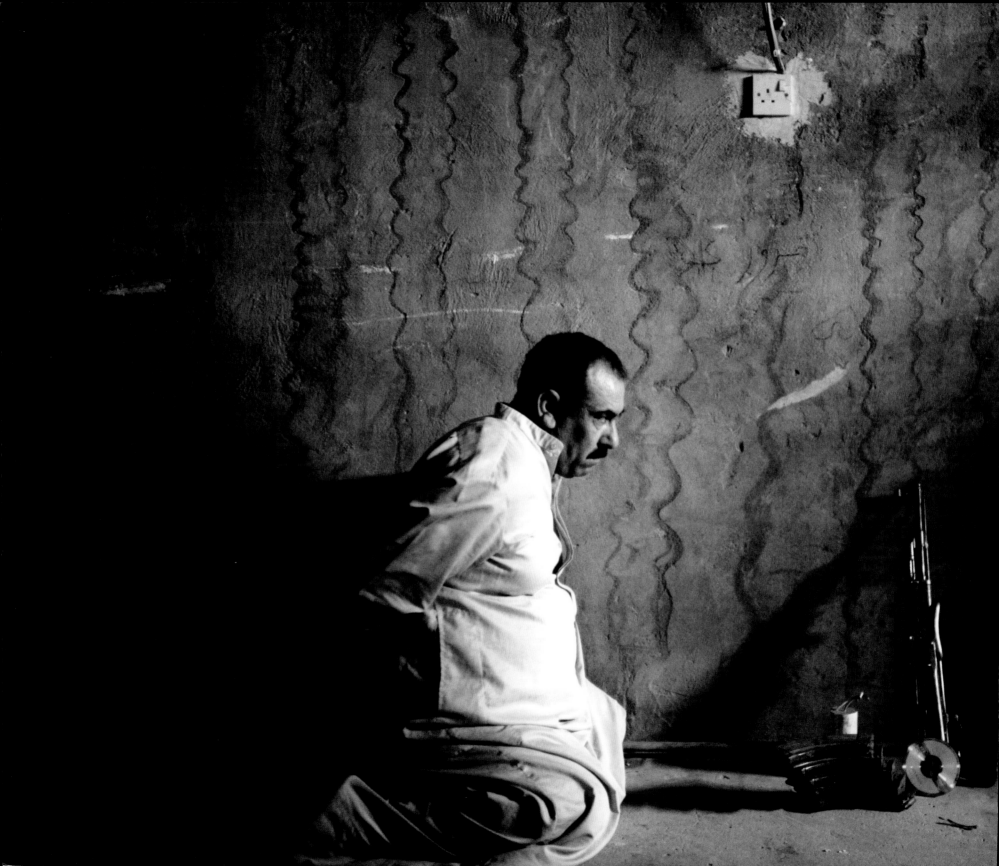

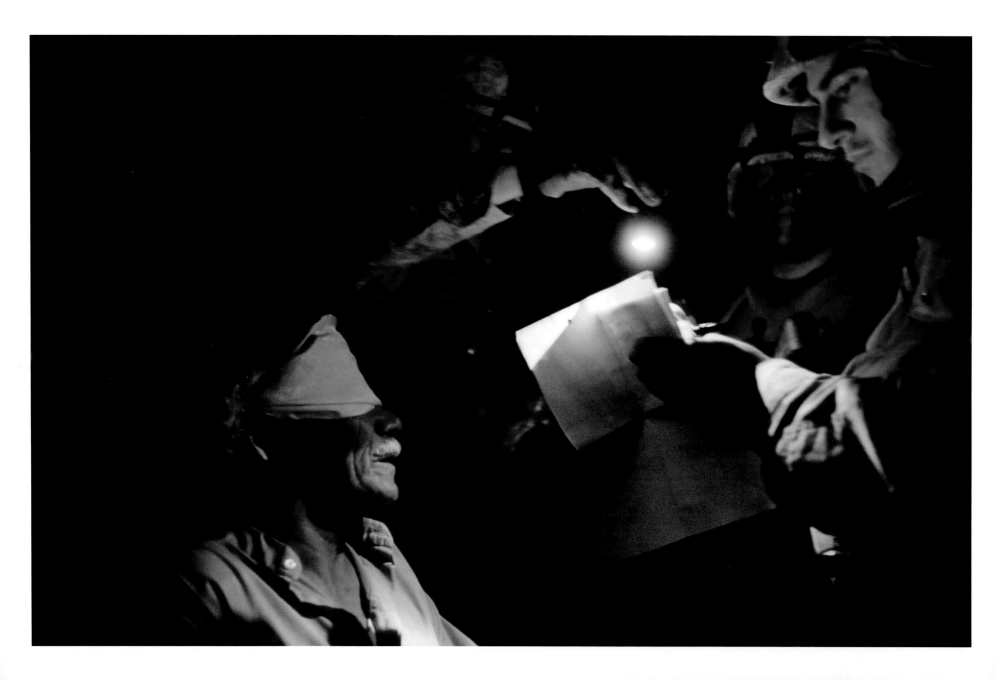

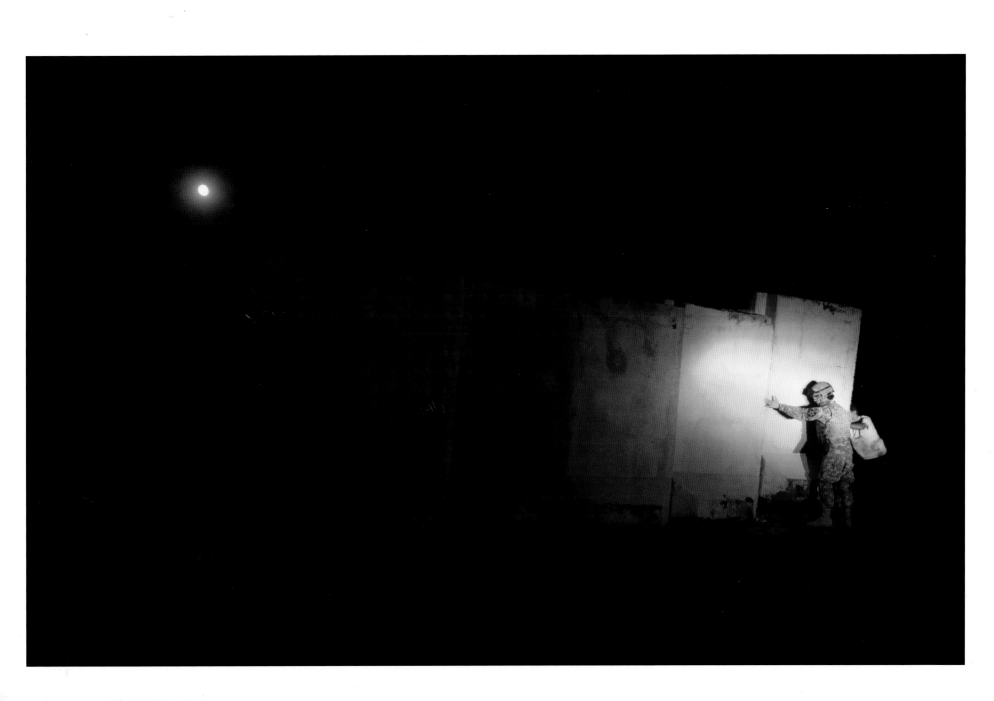

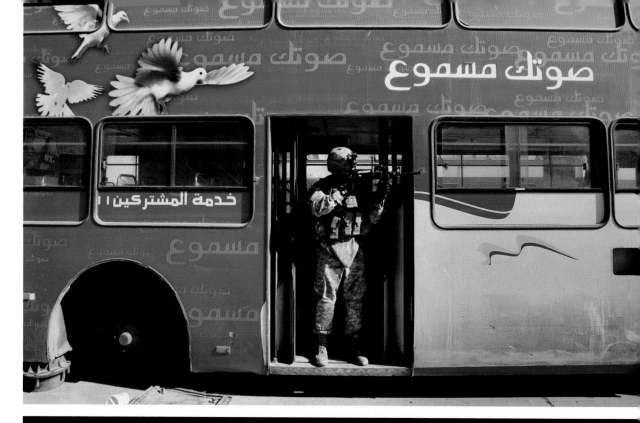

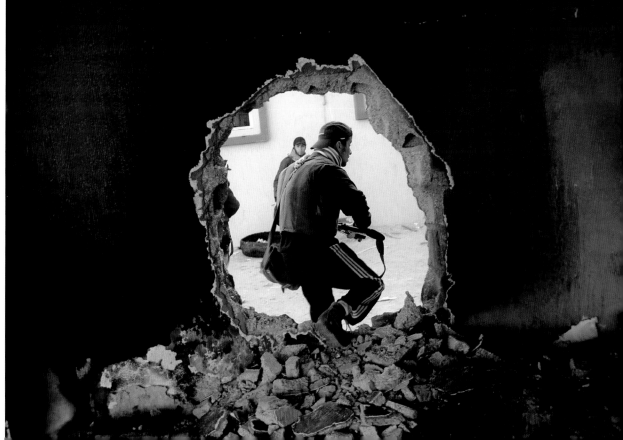

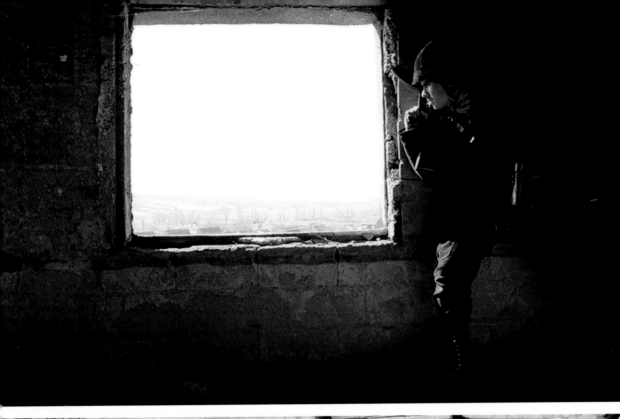

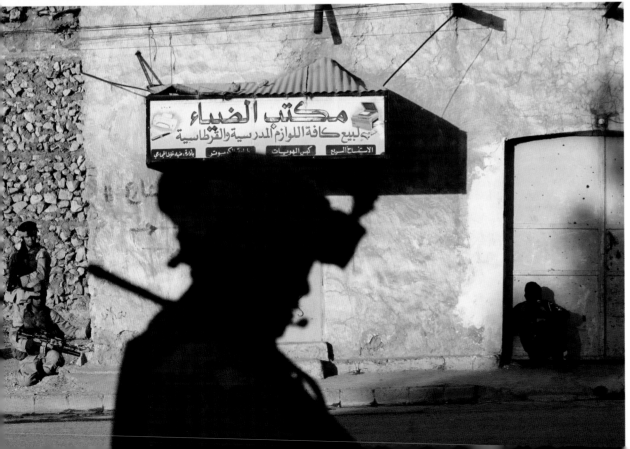

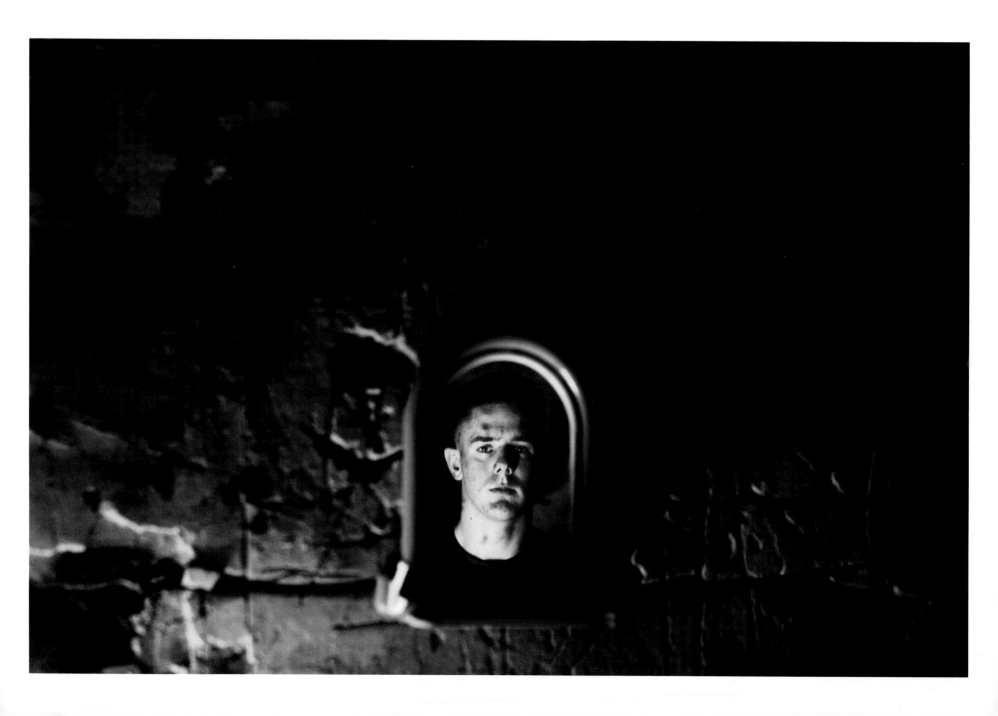

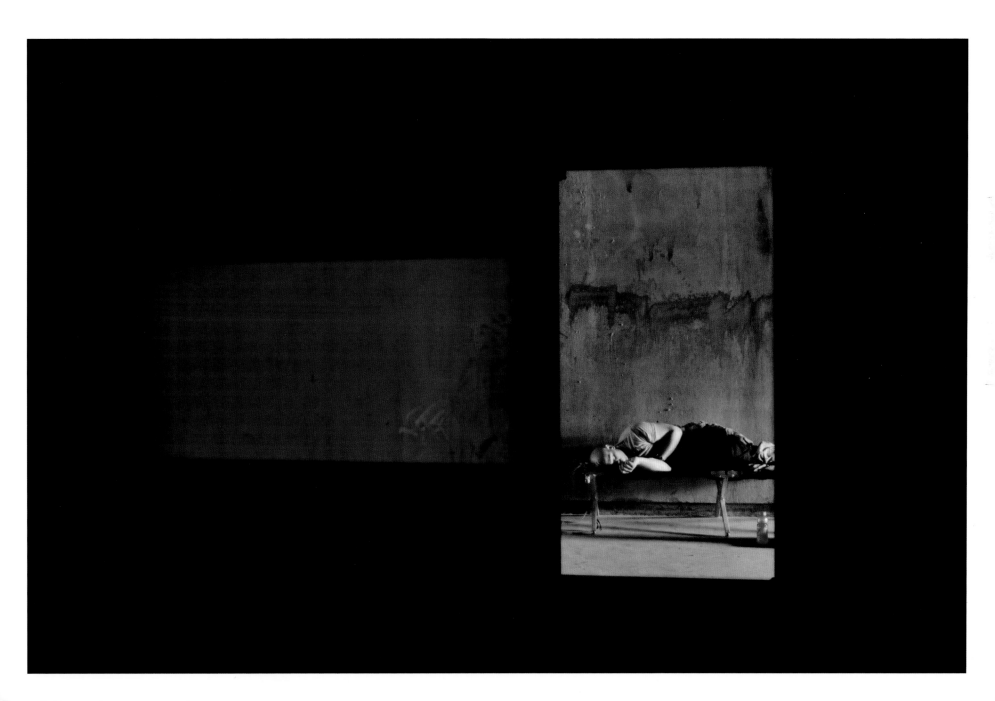

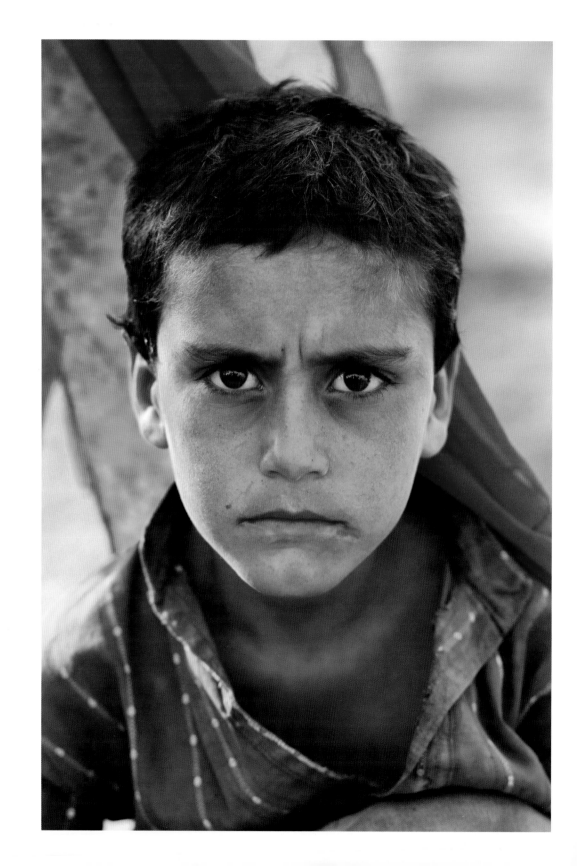

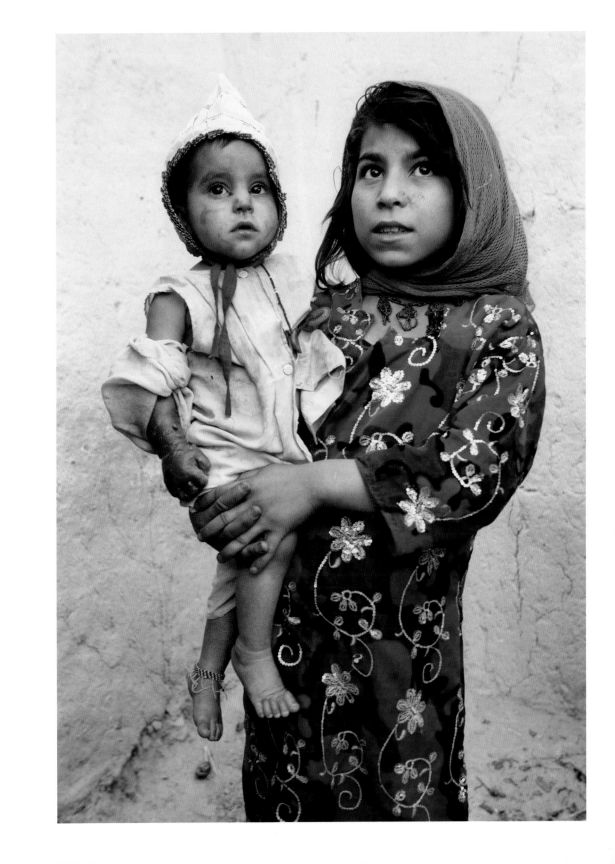

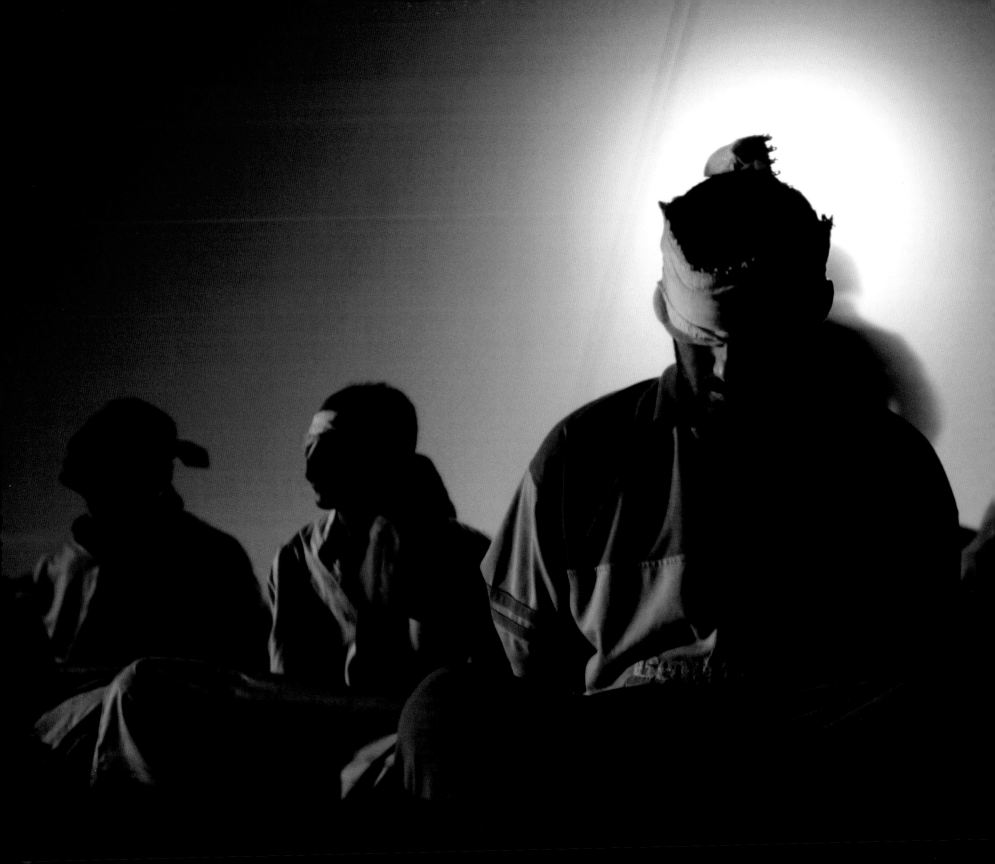

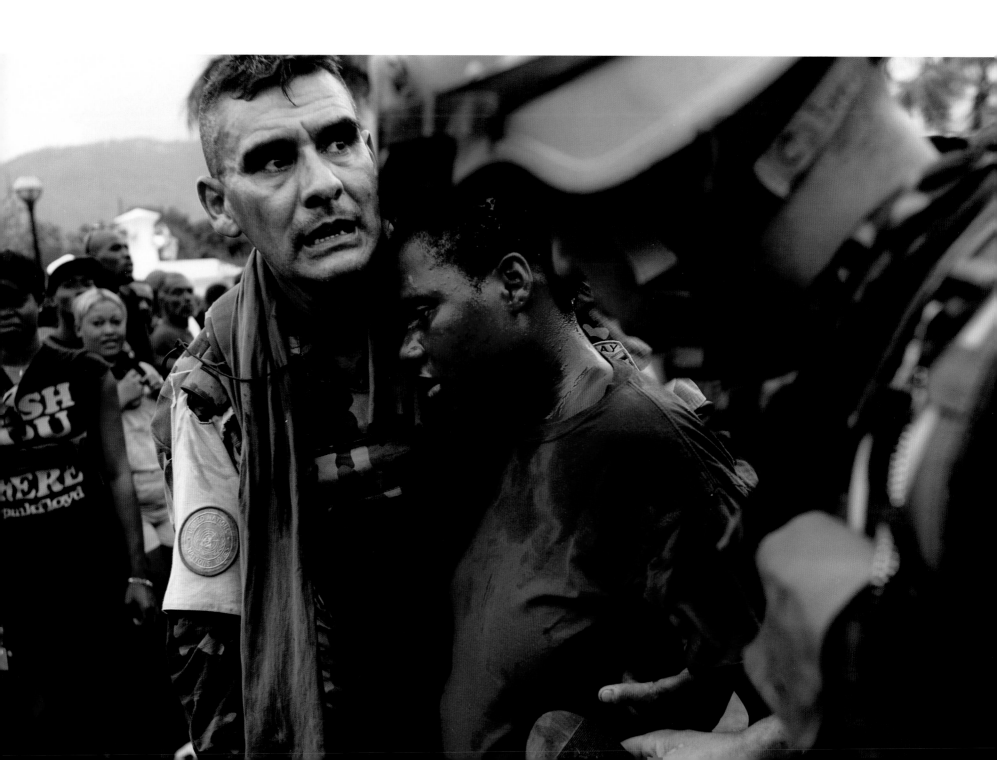

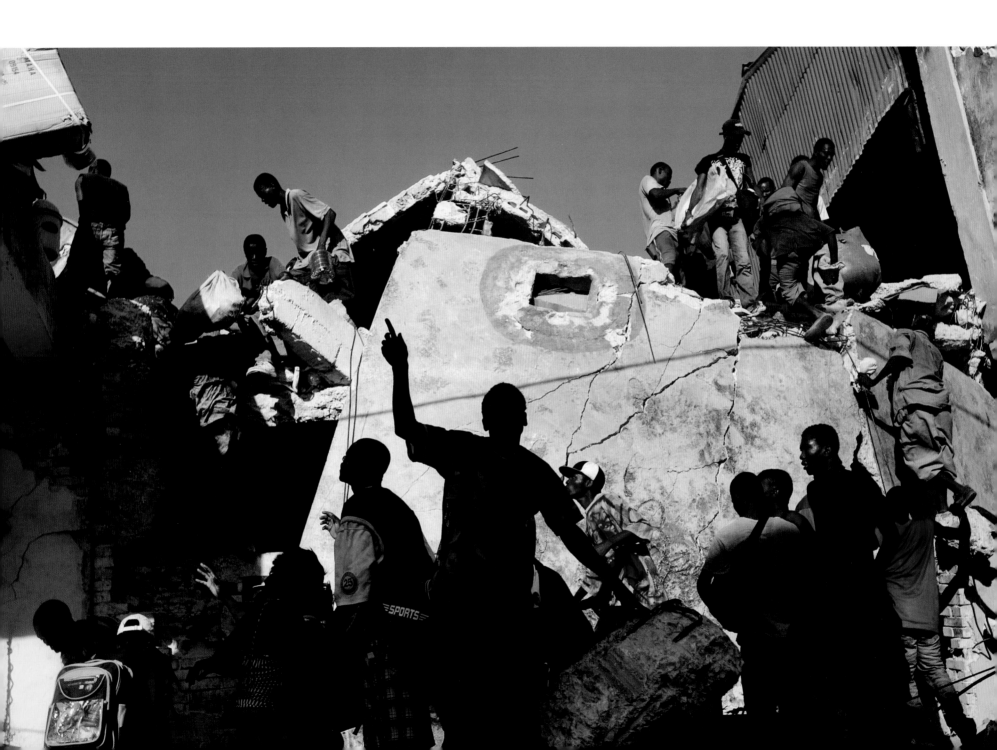

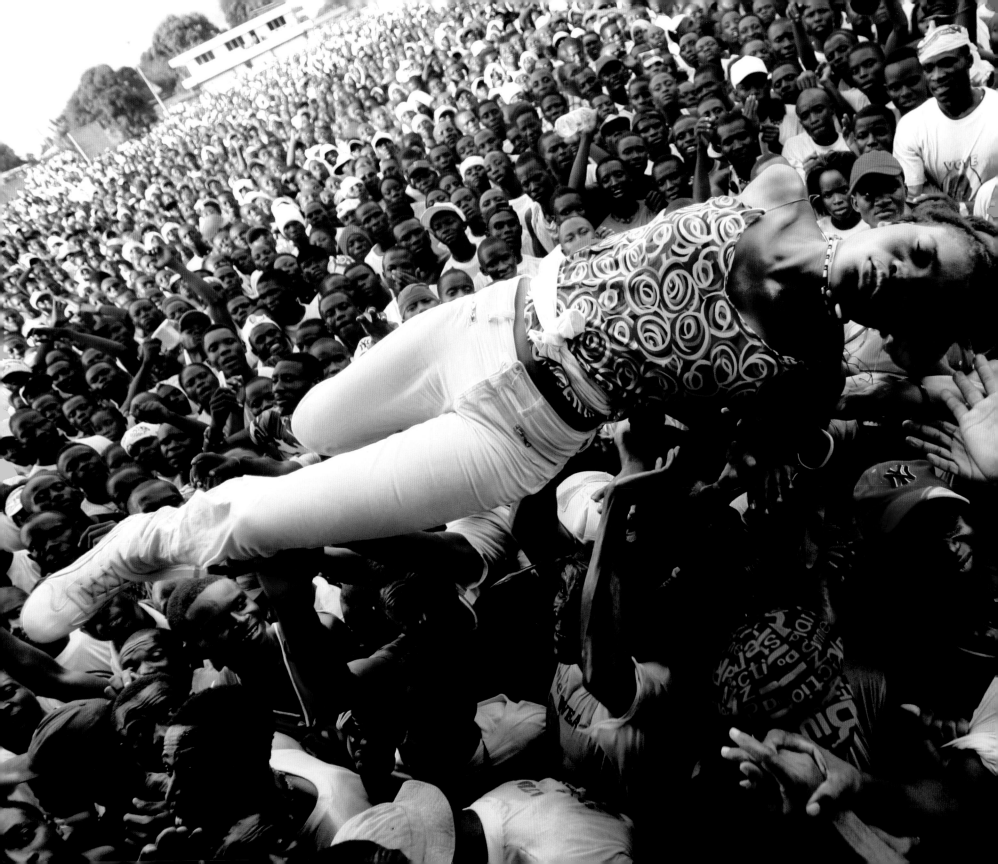

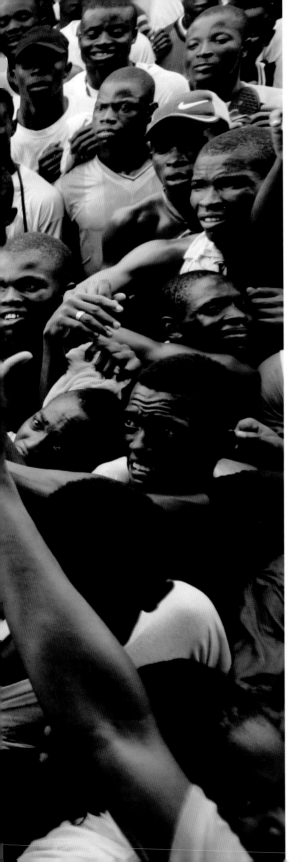

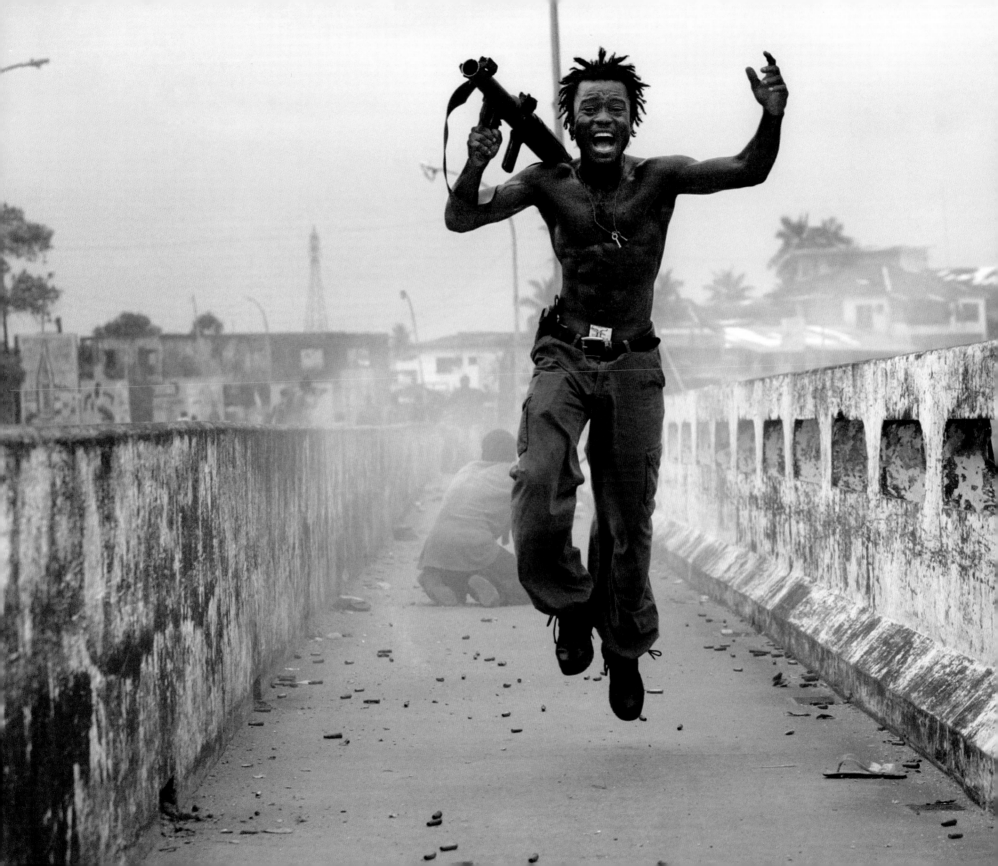

"Liberia in the summer of 2003, during the desperate last month of the civil war, embodied every cliché one hears about battle and armed conflict: terrifying, frenetic, devastating, and horrifying. But that time there were also other things alive — energizing, even life-affirming — a mixture of conflicting emotions that is the reality of war, rather than the usual simple platitudes. Death and life, commingling — a place and time where survival was arbitrary and justice meted out by force of arms, if at all."

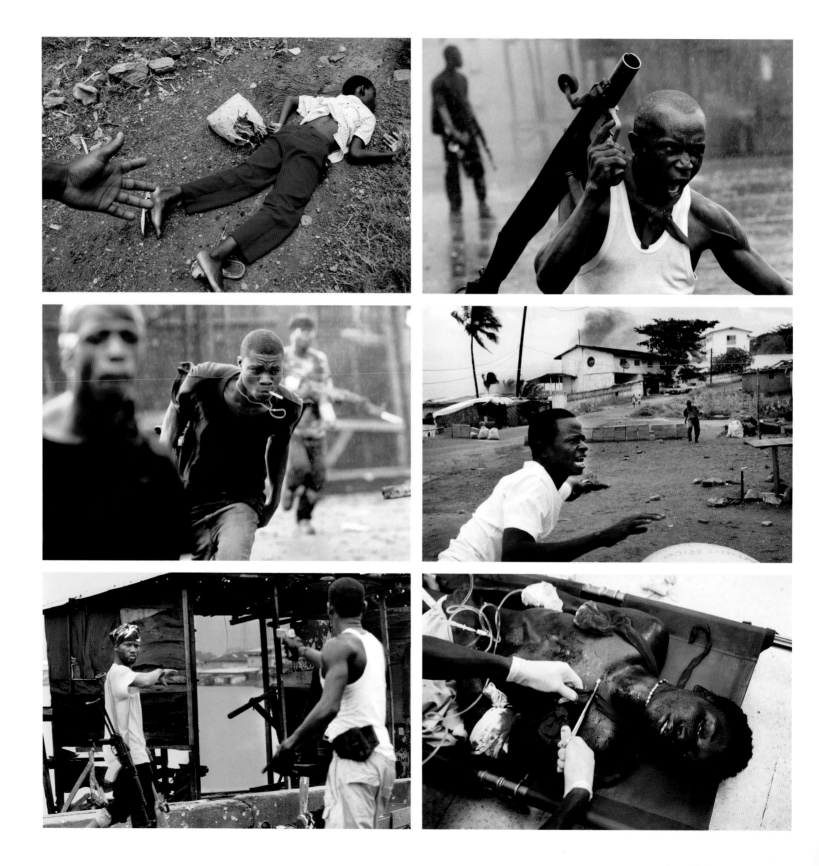

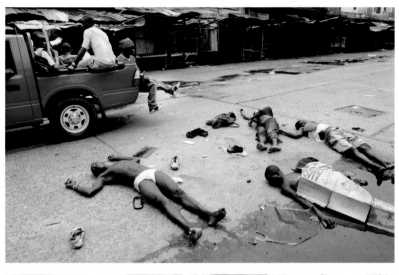
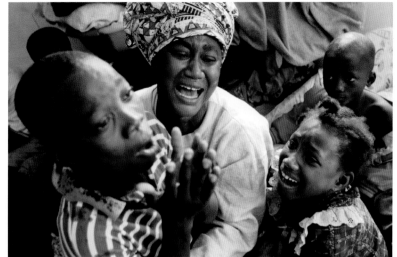
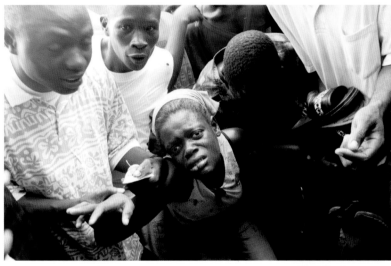
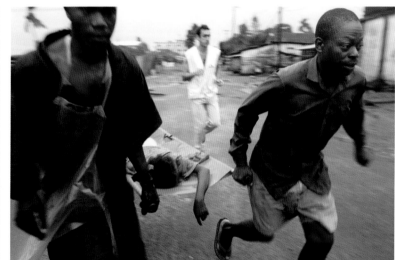
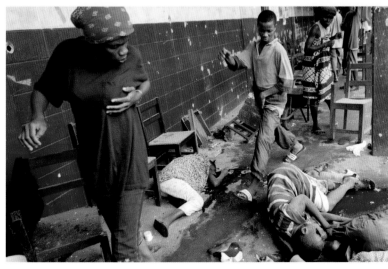
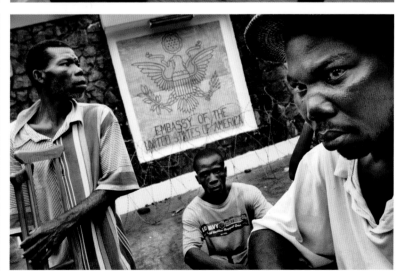

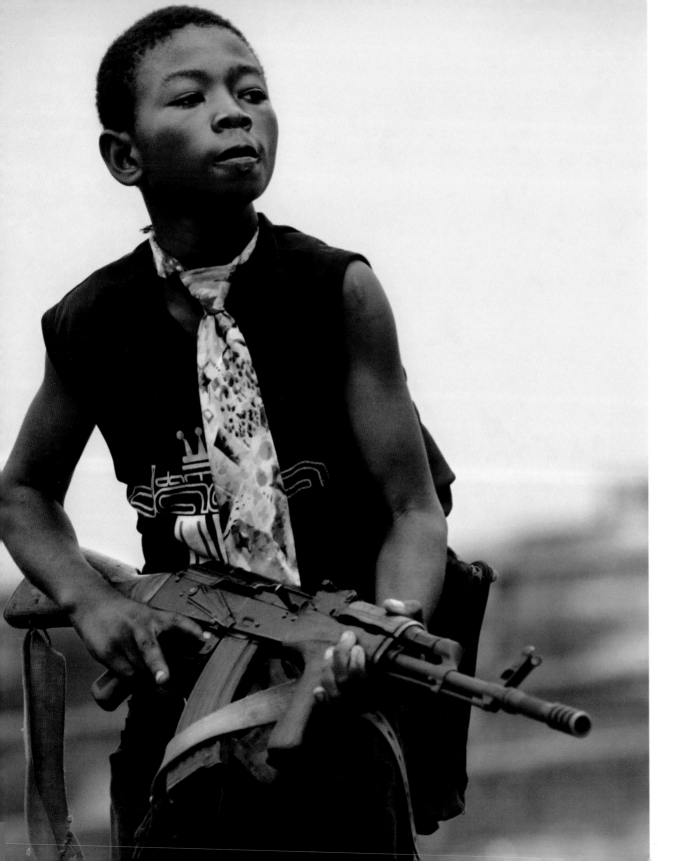

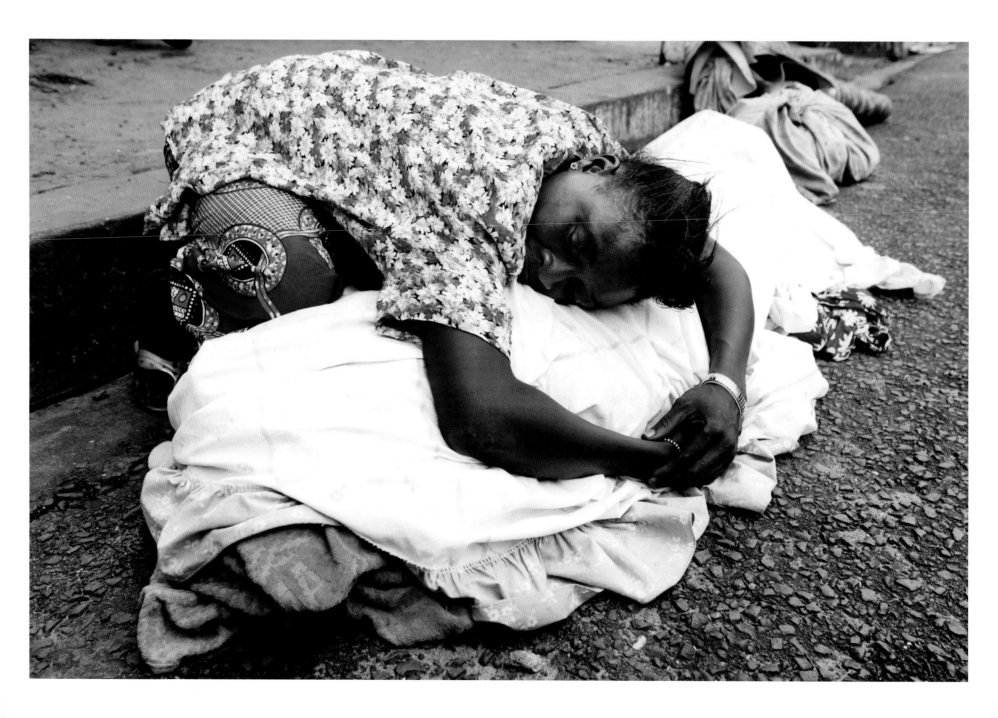

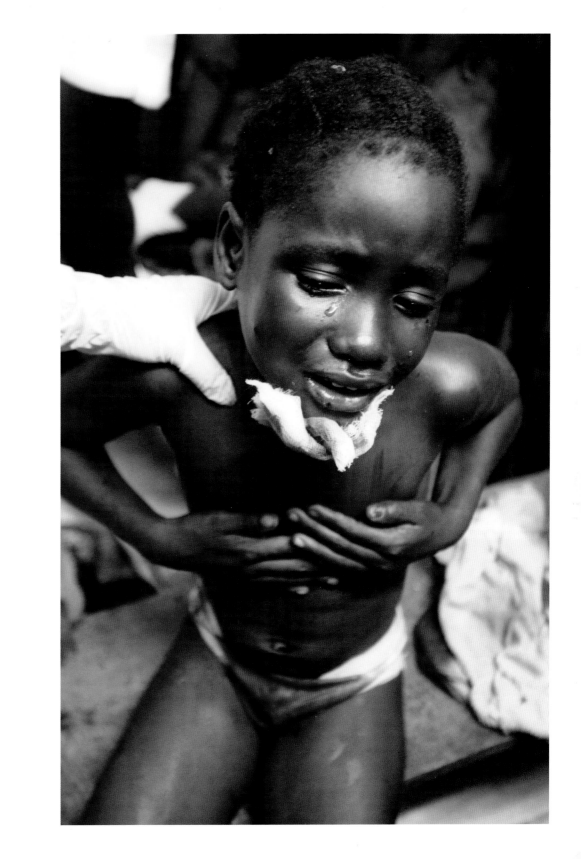

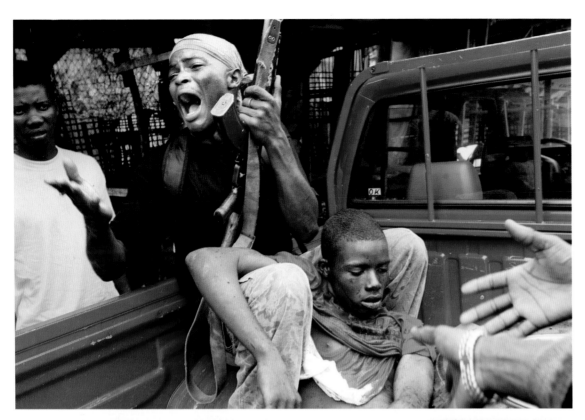

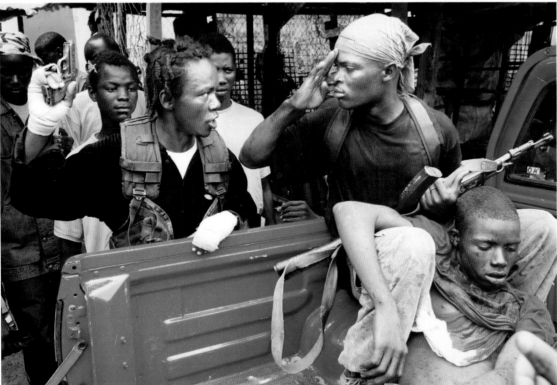

A VERSION OF THIS ARTICLE
WAS ORIGINALLY PUBLISHED
IN THE DIGITAL JOURNALIST,
AUGUST 2003.

Monday was a day of horrors in Monrovia. A massive artillery barrage was unloosed on Liberia's civil war-torn capital, death falling from the sky. Journalists were huddled in the lobby of the press hotel, wondering how to cover the barrage, when the story came to us — a shattering boom, right outside. Everyone ducked.

Eventually I ventured outside the hotel to find a boy, about 10 years old, slowly dying in front of me on the road, his last gasps rasping out, a pool of thick blood spreading from his head. The cassava leaves he had been carrying home to his family lay beside him in the red dirt.

Next, another mortar shell fell, this one landing across the street in a small school compound. Everyone scattered. I ducked inside a concrete guard shack at the gate of the hotel, wondering what I should do. Finally I screwed up enough courage to run the 50 yards to the door of the school. Inside, it was a vision of hell — wailing women and children, crying men, blood, horror, fear. The shell had landed in the middle of an interior courtyard, hitting a woman whose mangled body was now the center of a radiating blast pattern. Wounded and dead bodies lay everywhere.

I took a few photos, but then realized that no one was trying to bring sanity to the situation; the survivors were too dazed to do anything. I was the first outsider to arrive. Usually journalists have little role to play other than documenting and reporting the horrors of war. Aid workers, soldiers, and locals do the actual heavy lifting of saving and feeding. But occasionally we need to act.

"You need to get these people to the MSF clinic down the street," I yelled, to no one in particular, using the French acronym for Doctors Without Borders. "MSF? You know MSF?"

Suddenly I realized that a lot of people might be half-deaf from the blast.

"Look, you two," I shouted to a pair of burly Liberian men standing dazed by a wall, inconsolable but unhurt. "The wounded need to be carried to the MSF clinic. Now!"

They said nothing for a moment — then snapped to focus. "This boy" — I motioned to a child with a searing cut across his head — "and that man there. Come on! Carry them!"

They first moved toward the woman who'd been directly hit, but I stopped them. "Not her; she's dead," I said. "First the living people." One by one, they carried the injured to the MSF clinic about 100 yards away.

"There is still the woman," one man said.

"She's dead, I told you," I said.

He seemed confused. "But look," he said, pointing to her. Astonishingly, the woman who'd been directly hit by the mortar shell and nearly sheared in two was attempting to sit up off the pavement.

INSIDE, IT WAS A VISION OF HELL —
WAILING WOMEN AND CHILDREN, CRYING
MEN, BLOOD, HORROR, FEAR. THE SHELL
HAD LANDED IN THE MIDDLE OF AN
INTERIOR COURTYARD, HITTING A WOMAN
WHOSE MANGLED BODY WAS NOW THE
CENTER OF A RADIATING BLAST PATTERN.

"Good God!" I muttered, and we all ran toward her. She was conscious and moaning. Someone brought over a wheelbarrow, and we picked her up and put her into it. As we took her to the clinic, the wheelbarrow began slowly filling with blood.

Lethargically, I later ambled up to the guard shack in front of the hotel. The Liberian militiaman there showed no sympathy, only scorn. "You see Liberia, white man? You see how we live?" Inside the hotel's lobby, dozens of Liberians and foreign journalists huddled against the walls, like a litter of cowering kittens in a tiny box.

No one, it seems, wants to make the first move to help Liberia, especially not the Americans. U.S. policymakers often trot out the bloody stalemate of Somalia as a "cautionary example" and reason not to intervene. But it's a flawed parallel. Somalia is a lawless land with few ties to the West; seemingly every household there is armed to the teeth and ready to fight. Most Liberians are benign and surprisingly well educated; even refugee children in rags can carefully spell out their names when you ask. And Liberians are generally unarmed and universally weary of war.

In Liberia, I had many versions of this conversation:

"What do you want to happen now in Liberia?" I would ask.

"We want American troops to come and save us."

"If they come, they will probably send a small peacekeeping force."

"They are welcome. But better will be a large number of soldiers."

"How long would you want them to stay?"

"Many years, if they like. We are tired of war. We want occupation. We need help. Even a small number of Americans will command respect."

Not a single person I talked to — from refugees to businessmen to a teenage soldier nervously fingering his Kalashnikov — opposed the idea of having peacekeepers occupy Liberia.

Liberia considers itself an annex of the United States — essentially, the Puerto Rico of West Africa. With the country founded by former American slaves in the 1800s, a significant segment of Liberia's population has American ancestry. Reminders of its history are everywhere. Neighborhoods and counties have names like Virginia, Maryland, New Georgia, and West Point. The government complex is called Capitol Hill. The main hospital is called the JFK Medical Center. A high school is named after Richard Nixon, though I've been too scared to ask anyone exactly why. Even the Liberian flag is a direct knockoff of the U.S. one, so close that when they hang limply they are hard to tell apart. And one common billboard in Liberia shows a small Liberian boy talking with a tall black Uncle Sam: "We've come a long way, Big Brother, but it's still rough! We are suffering!"

In one of the hundreds of refugee camps that have sprouted up along Monrovia's roadsides, since the rebels encircled the city, I met a man slumped in a plastic tent, his only possessions a tin can for cooking and a thin reed mat. We talked about the recent visit of the U.S. assessment team and whether he thought the team would find the evidence it needed to recommend a military intervention. His answer summed up the feelings of almost everyone I met. "We are dying here, every day," he said, tears welling in his eyes. "What more do they need to know?"

It's especially difficult to watch such gruesome devastation every day when you know that a short-term solution is easy. Five hundred U.S. Marines with helicopter support could demolish rebel and government troops alike and secure Monrovia in a matter of days. It's heartbreaking to follow the travails of a multibillion-dollar effort to occupy a clearly reluctant Iraq, while another land, much closer to the United States in its history and culture, literally begs to be occupied.

But for weeks now, no help has come. Meanwhile, Monrovians have to endure hunger from cut-off food supplies, death from archaic diseases like cholera, refugee camps — and also dodge stray bullets. Most feared of all are the mortar barrages that rain down every day, killing anyone unlucky enough to be nearby when they explode. Wariness of these fusillades has already chased out half the foreign press corps.

For two months, the anti-government forces of a group called Liberians United for Reconciliation and Democracy have been waging fierce battles at the edge of town, mobilizing the city's untrained soldiers and militiamen, whose only qualification to fight is that they're old enough to lift a weapon. Some of us have stayed to witness what happens next, wisely or not. Distant politicians may talk doublespeak and advisors may dither, but someone has to be around to show the grim realities of conflict on the ground. Every day that this fighting drags on, dozens more die. No one can claim that we haven't known what's happening.

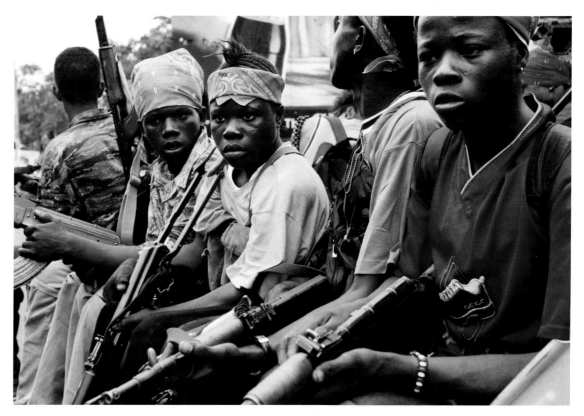
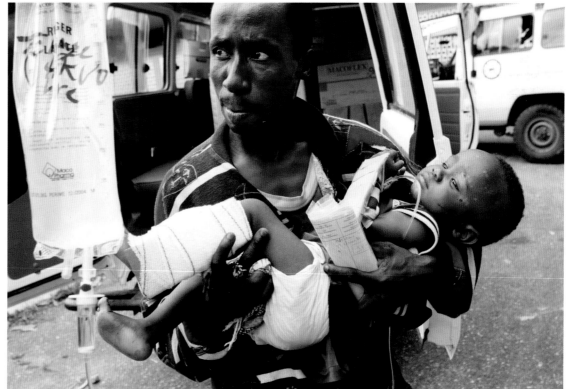

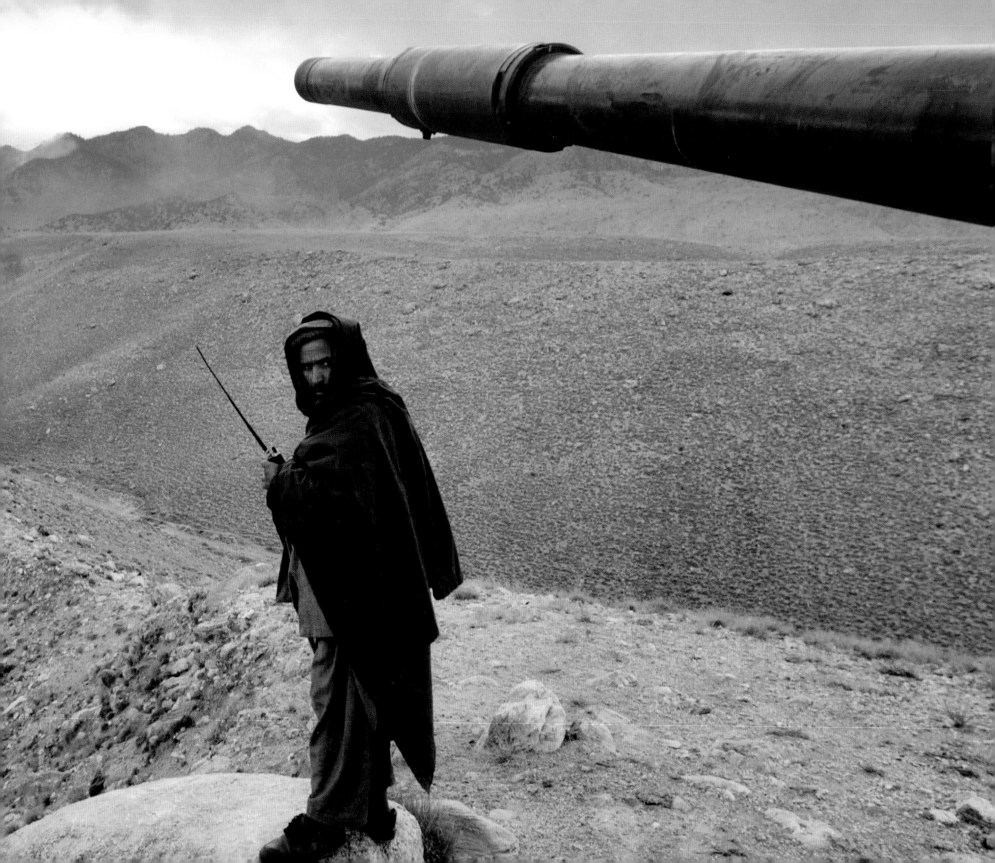

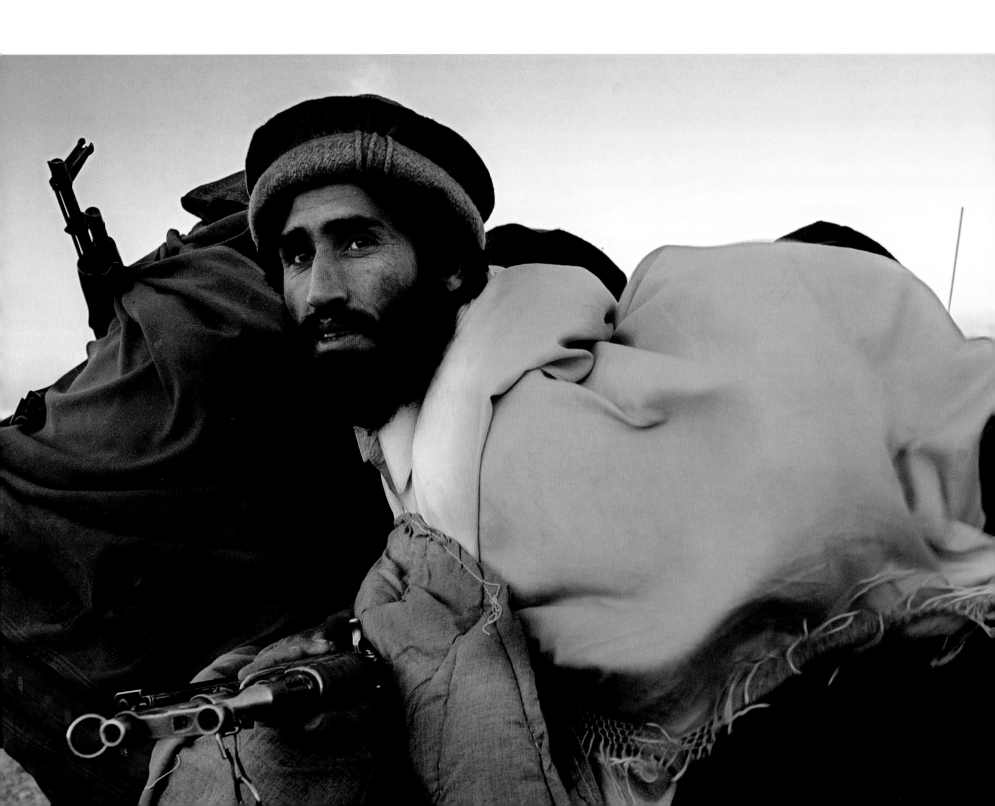

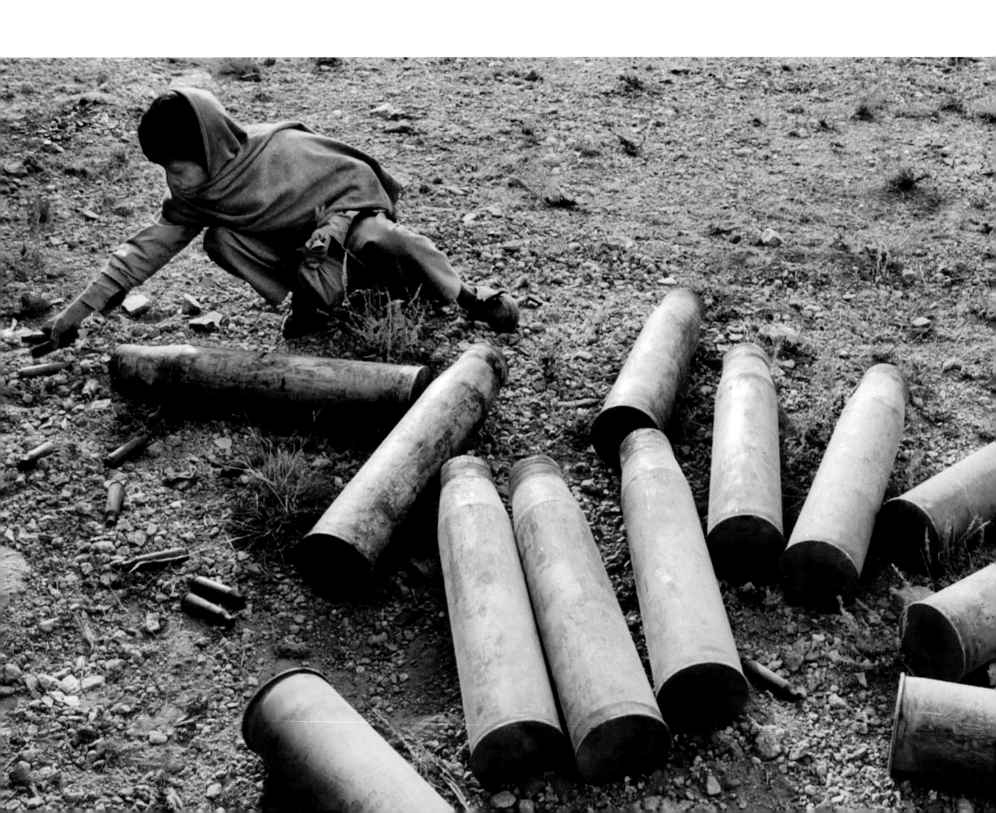

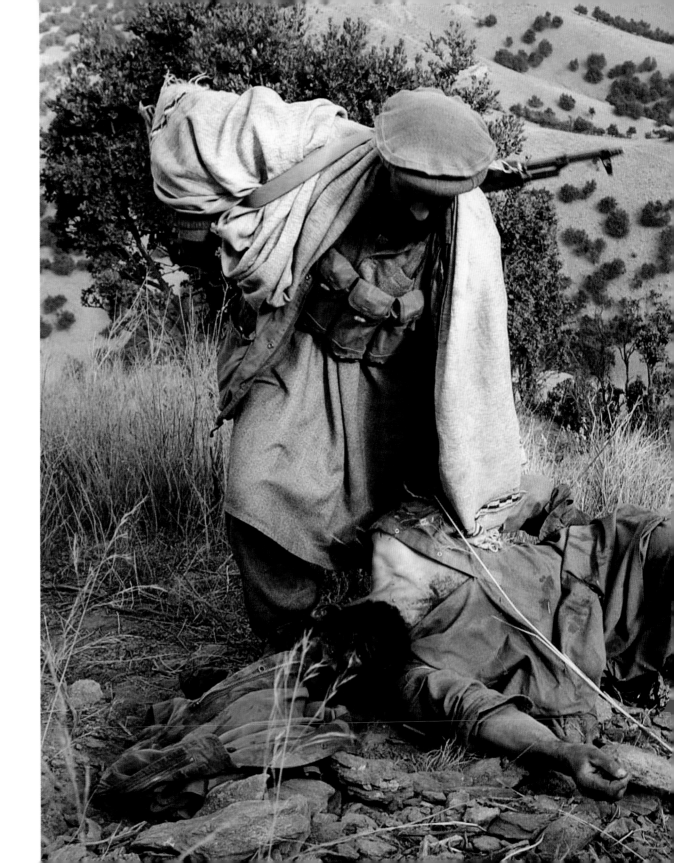

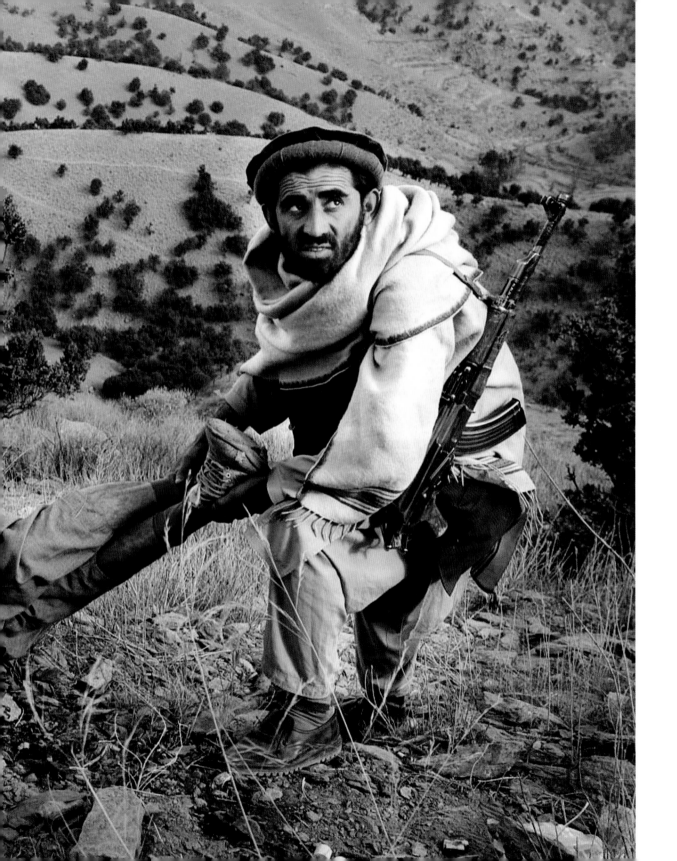

—

A VERSION OF THIS ARTICLE
WAS ORIGINALLY PUBLISHED
IN THE FORT COLLINS
WEEKLY, JAN. 26, 2005.

—

Just another routine foot patrol — a dozen or so men from a U.S. Army platoon carefully walking the dusky streets of Tal Afar after sundown. Having been on so many embedded missions in Iraq, I knew the drill well. Guys spread out over 50 yards or so, walking in separated pairs on either side of the boulevard, guns at the ready, casing out possible threats. Usually little more happens than finding someone out after curfew, patting him down, and then sending him home.

On daylight patrols, sometimes troops will stop to briefly play with Iraqi children or even drink tea. Evening patrols are grimmer. Past the military-imposed curfew, no one is out on the streets of Iraq's cities, and the U.S. troops are edgier and extra-vigilant. One night in January 2005, the streets of Tal Afar were graveyard-quiet as the troops marched along, their bulky silhouettes briefly obscuring the green fluorescent tubing of the town's now-shuttered shops.

You don't hear much about Tal Afar. It's an ethnically mixed town of maybe a few hundred thousand people in northwestern Iraq. The U.S. military is now using the town's impressive historic Ottoman castle as a safe-haven base for themselves and allied Iraqi forces. It's a rough town. A few days ago, the Army unit I was embedded with got caught in an hourlong running gun battle with insurgents here.

At 6 p.m. in winter, Tal Afar isn't quite dark yet. That night, there was just a hint of dark-blue light from the sky. No one was out. As the platoon I was traveling with made its way down a broad boulevard, I could see in the distance a car driving toward us. With all the recent deadly car bombings in Iraq, U.S. soldiers are understandably made nervous by approaching cars. They do not allow private cars to breach the perimeter of their foot patrols, particularly at night.

"We have a car coming," someone called out. The vehicle was about 100 yards away. I doubted whether its driver could see us, a group of darkly camouflaged men in the gloom. That gave me a bad feeling, so I moved over to the side of the road, out of anyone's line of fire.

The car kept driving forward; I could hear its engine whine and then accelerate, instead of slowing down.

"Stop that car!" someone shouted. Someone else fired off warning shots — a staccato measured burst of gunfire. The vehicle was maybe 50 yards away.

Then, perhaps less than a second later, there was a cacophony of gunfire. The car coasted into the intersection, seemingly on its own momentum, and still gunshots were penetrating and slicing it. Finally the shooting stopped. The car drifted listlessly, clearly no longer being steered, and came to a rest against a curb. I stared in shocked silence. The soldiers began to approach it warily.

Then came the sound of crying children from the car. A teenage girl with her head covered soon emerged from the back seat, wailing and gesturing wildly. After her followed an injured boy, who left behind a pool of blood in his seat. More children — six in all — emerged, crying, their faces mottled with blood in long streaks.

"Civilians!" someone shouted, along with a stream of epithets, and the soldiers ran to the car. They carried each child to a nearby sidewalk. By then, it was almost completely dark. Working only by lights mounted on ends of their rifles,

AT 6 P.M. IN WINTER, TAL AFAR ISN'T QUITE DARK YET. THAT NIGHT, THERE WAS JUST A HINT OF DARK-BLUE LIGHT FROM THE SKY. NO ONE WAS OUT. AS THE PLATOON I WAS TRAVELING WITH MADE ITS WAY DOWN A BROAD BOULEVARD, I COULD SEE IN THE DISTANCE A CAR DRIVING TOWARD US...

THEN CAME THE SOUND OF CRYING CHILDREN FROM THE CAR.

an Army medic began assessing the children's injuries, running his hands up and down their bodies, looking for wounds. Incredibly, their injuries were relatively minor: a girl with a cut hand and a boy with a superficial gash in the small of his back — it was bleeding heavily but wasn't life-threatening. The medic began to bind the wound, while the boy crouched beside a wall, his face contorted more in fear than pain.

Now I could see into the bullet-riddled windshield more clearly. Even my hardened nerves started — the man who had been driving was penetrated by so many bullets that his skull had collapsed, leaving his body grotesquely disfigured. Beside him, a woman, dressed in Muslim clothes, also lay dead in the front seat. The soldiers grimly set about placing the two in body bags.

Meanwhile, the children continued to scream, sandwiched between soldiers binding their wounds and others trying to comfort them. The Army's interpreter later told me that this was a Turkoman family and that the teenage girl kept shouting, "Why did they shoot us? We have no weapons! We were just going home!"

Soon we were all headed to the main Tal Afar hospital. It was fairly large and surprisingly well outfitted, with sober-looking doctors in white coats ambling about its sea-green halls. The younger children were carried in by soldiers and by their teenage sister. Only the boy with the gash on his back needed any further medical attention. The Army medic and an Iraqi doctor chatted over his prognosis. "Oh, this will be OK," the Iraqi doctor said in broken English, roughly pulling the skin on the edge of the wound, causing the boy to howl. "We will take care of him fine."

The unit's captain, Thomas Siebold, was adamant that the children be kept inside the waiting room while the body bags, which were waiting outside on gurneys, were brought through the doors to be taken to the morgue. "They've seen enough," he said. "I don't want them seeing any more tonight." I thought of Siebold's office where I'd met him earlier, and the photograph of his smiling 5-year-old daughter filling the entire desktop of his computer.

Within an hour, the convoy's armored vehicles were rumbling back to base. Siebold started writing up a report about what happened. The Army told me it will probably launch a full investigation.

Editor's Note: The surviving boy, Rakan Hassan, was much more grievously wounded than originally diagnosed. A bullet from a soldier's rifle had pierced his spine, paralyzing him. The family was given $7,500 in compensation by the U.S. military, and eventually Rakan was transported to Boston, Mass., for intensive treatment for his wounds in an effort sparked by constituent mail to Sen. John Kerry (D-Mass.) after the public saw Chris Hondros' photos. Rakan eventually was able to walk again and returned to extended family in Iraq. However, he was killed in the ensuing violence in his home country in 2008.

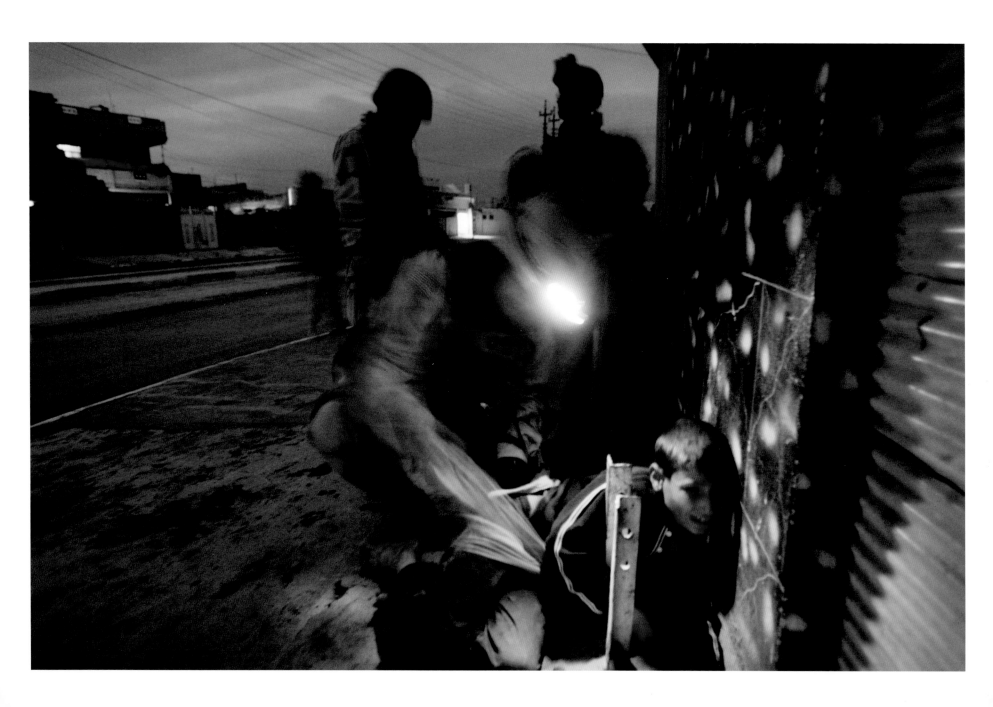

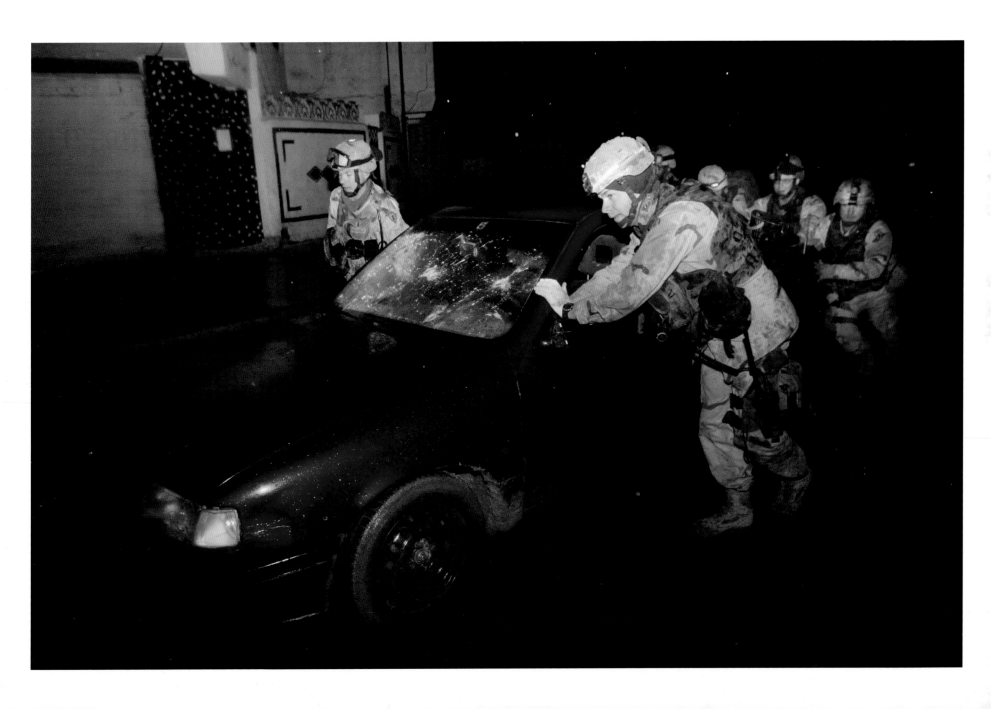

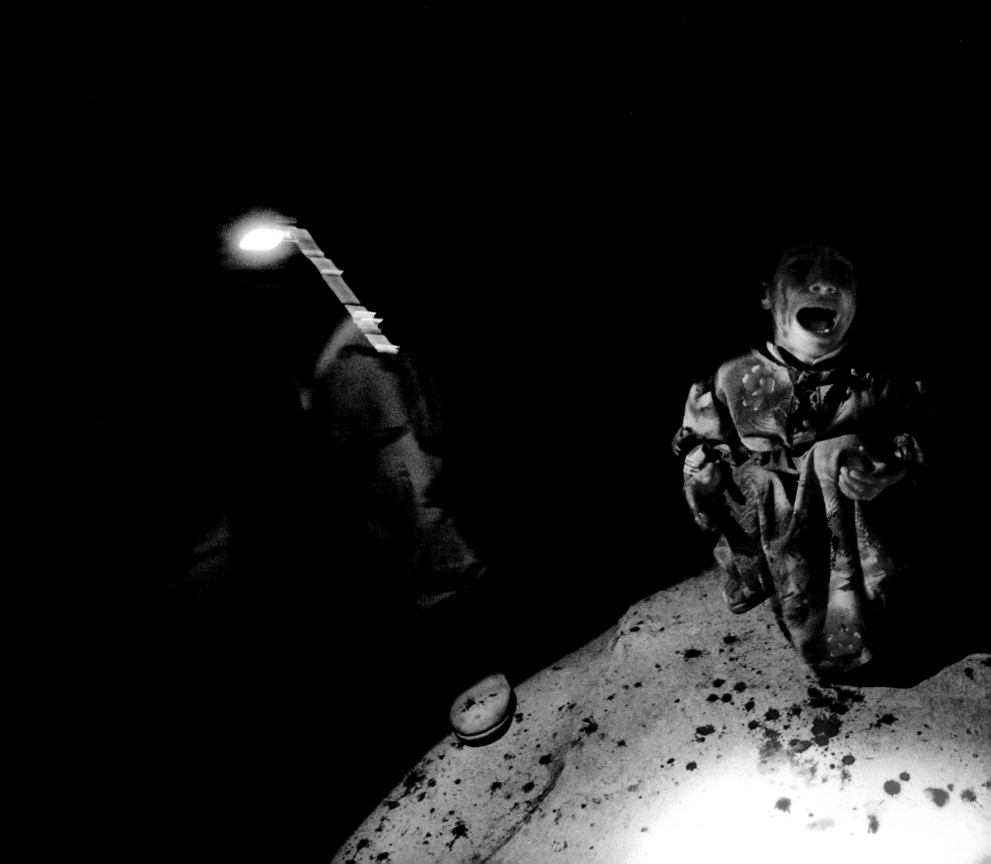

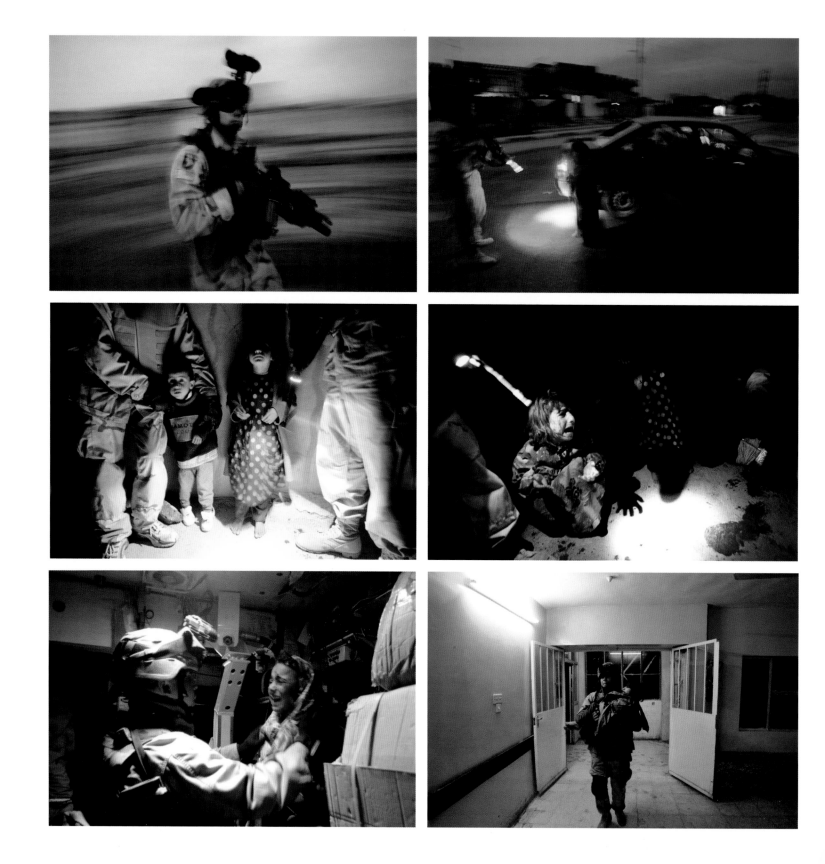

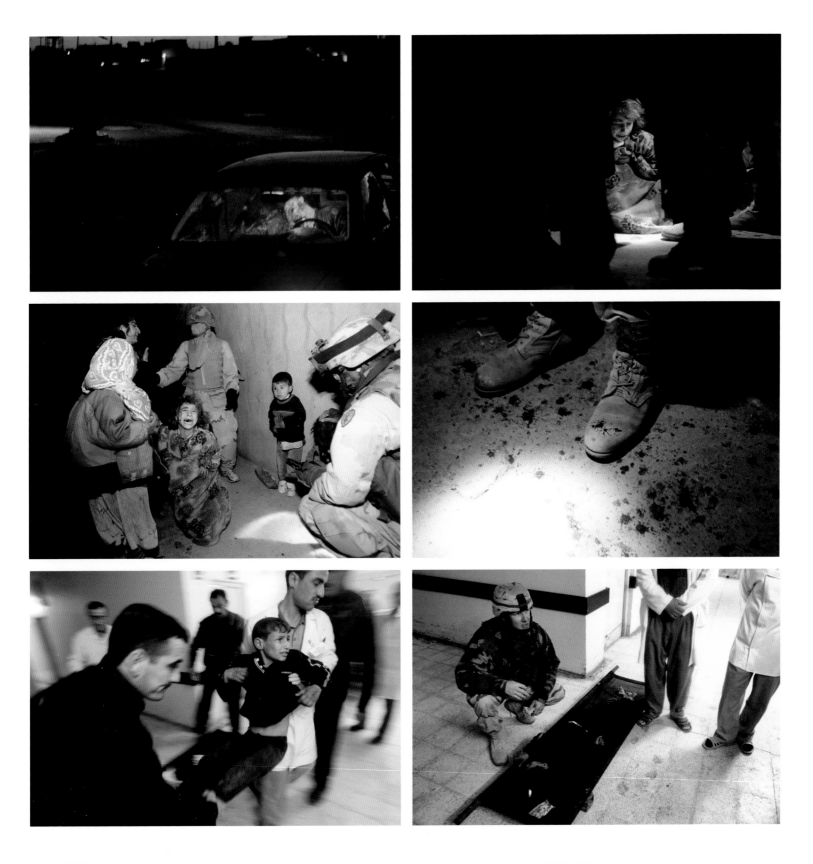

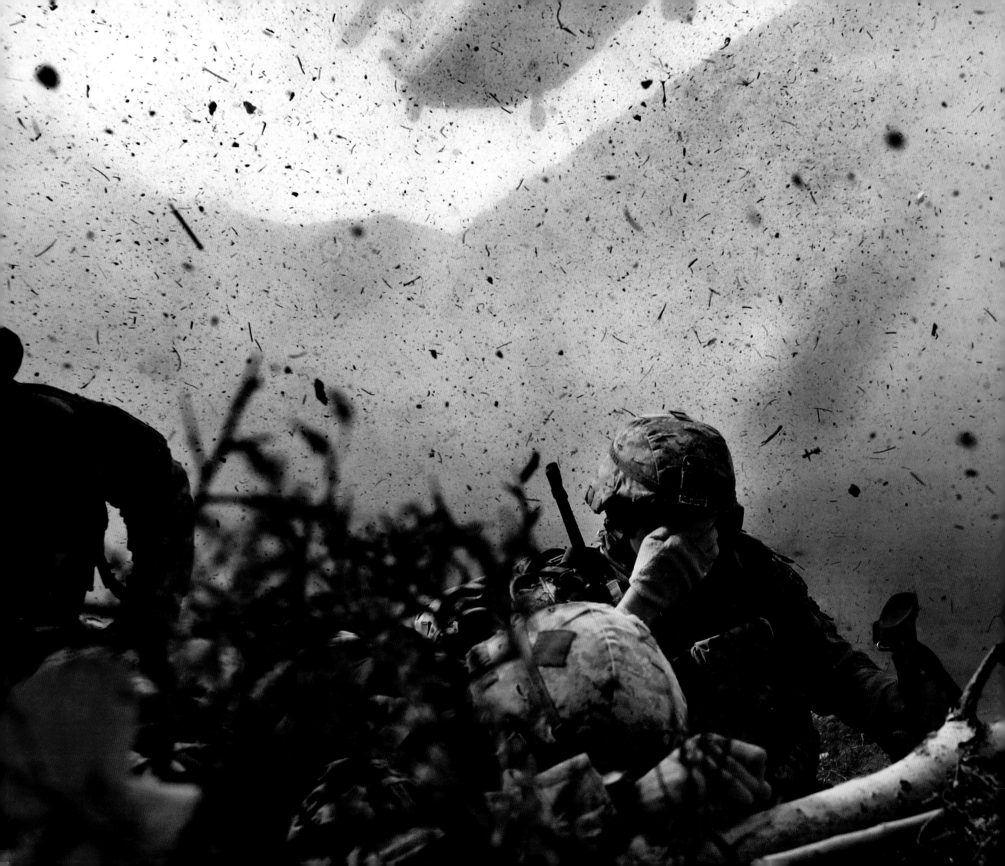

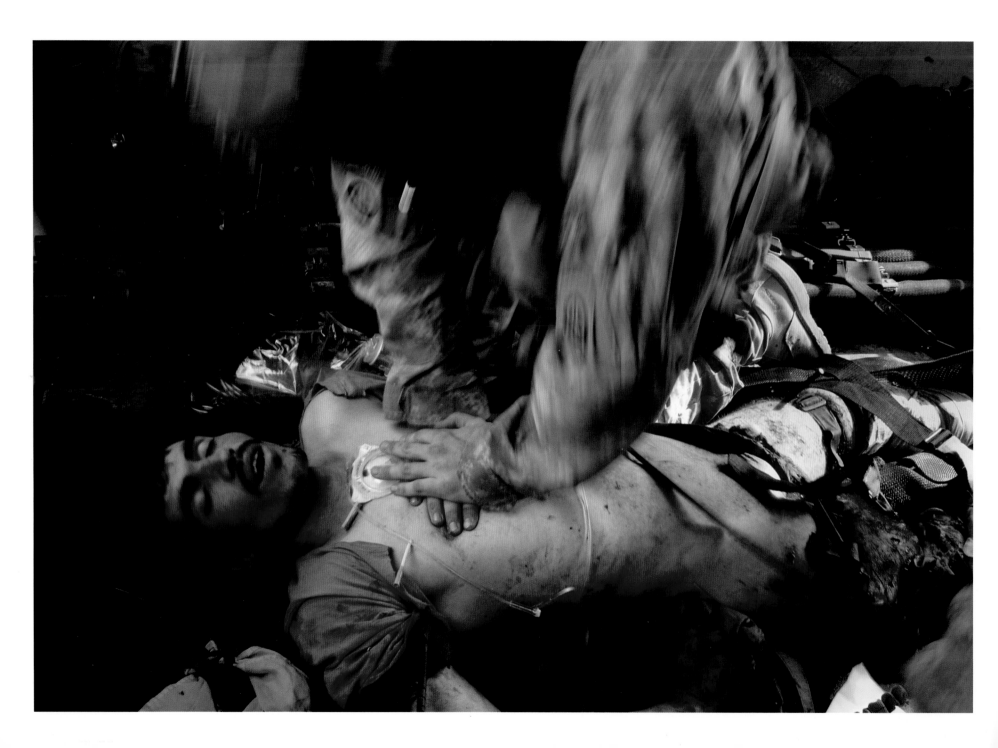

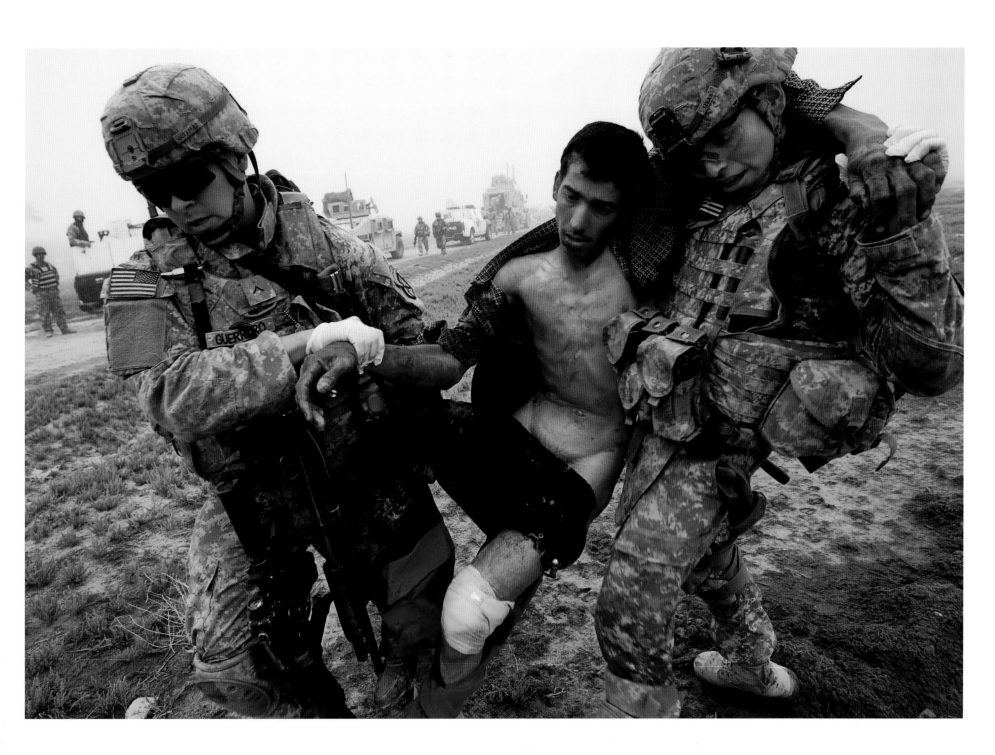

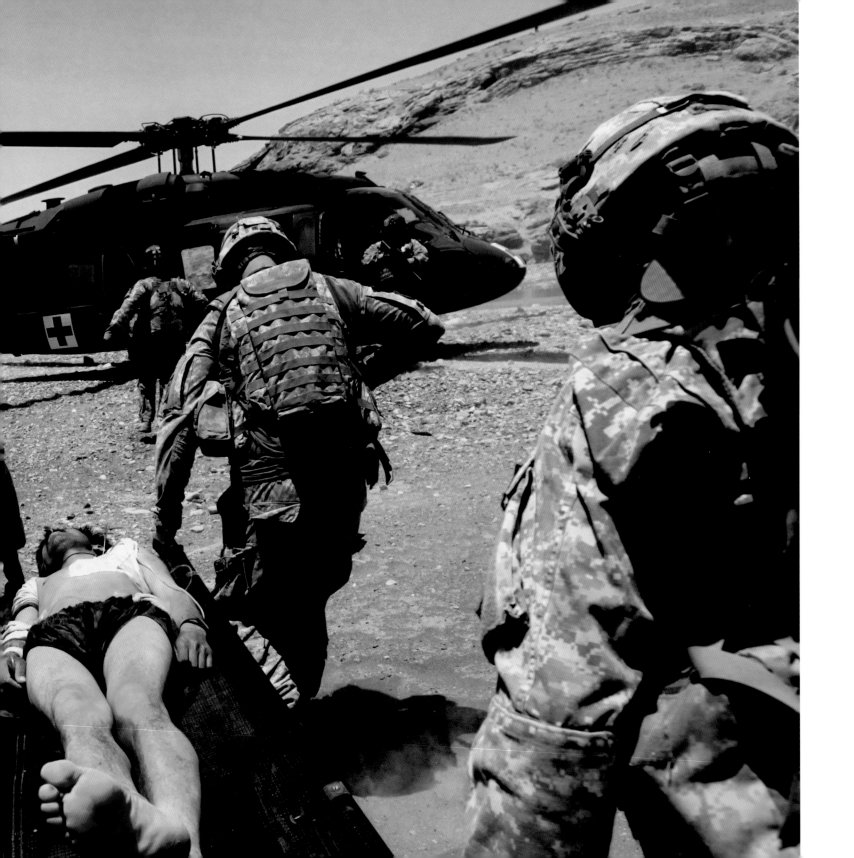

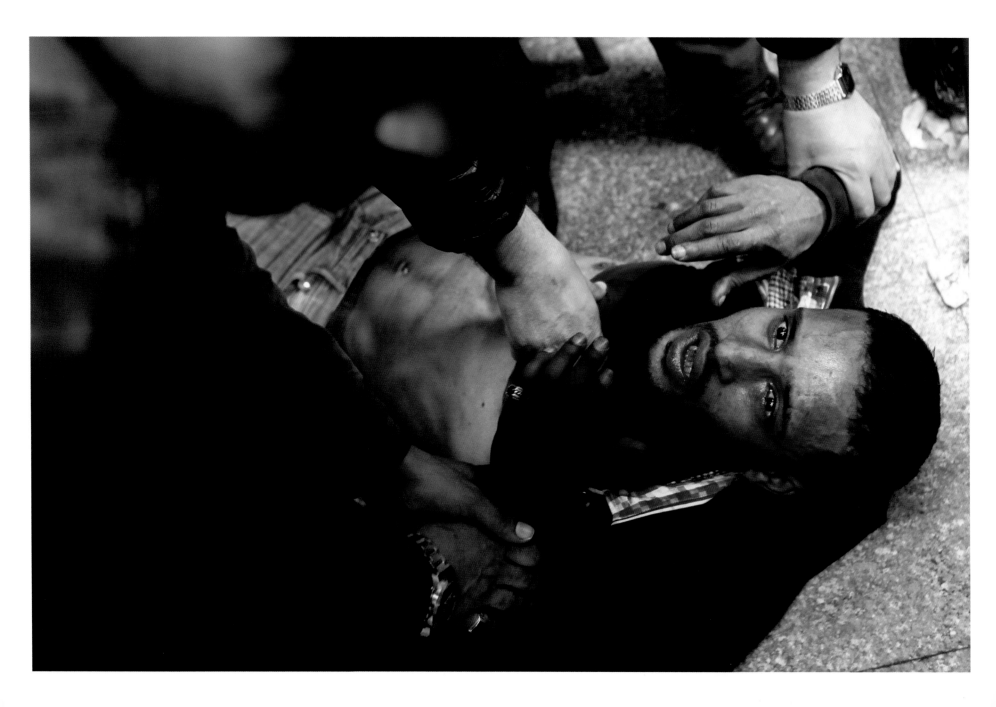

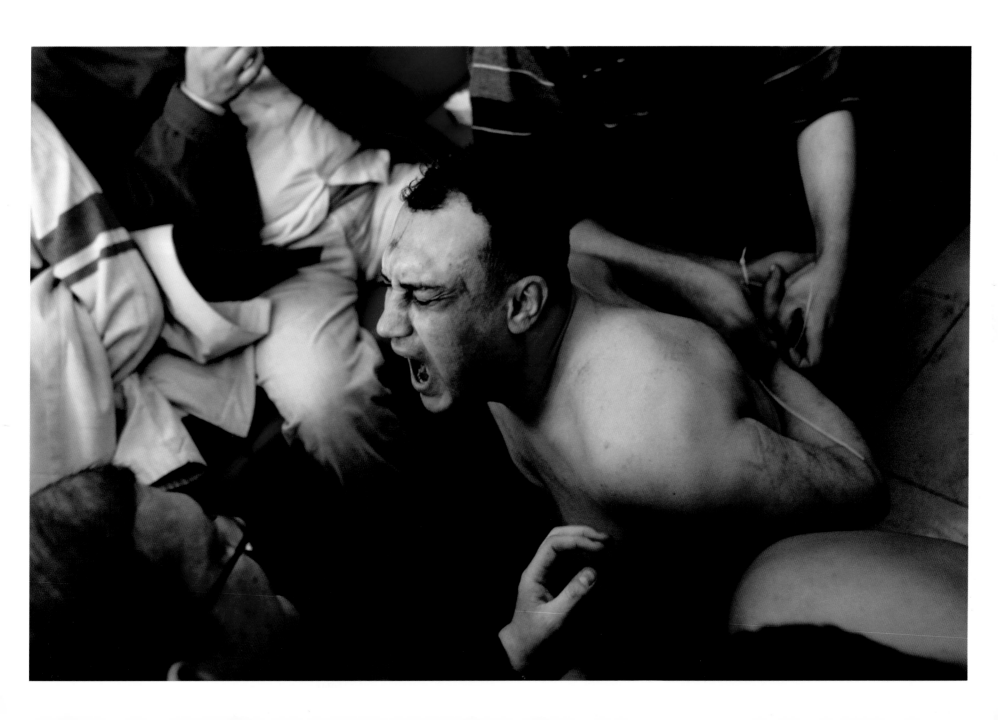

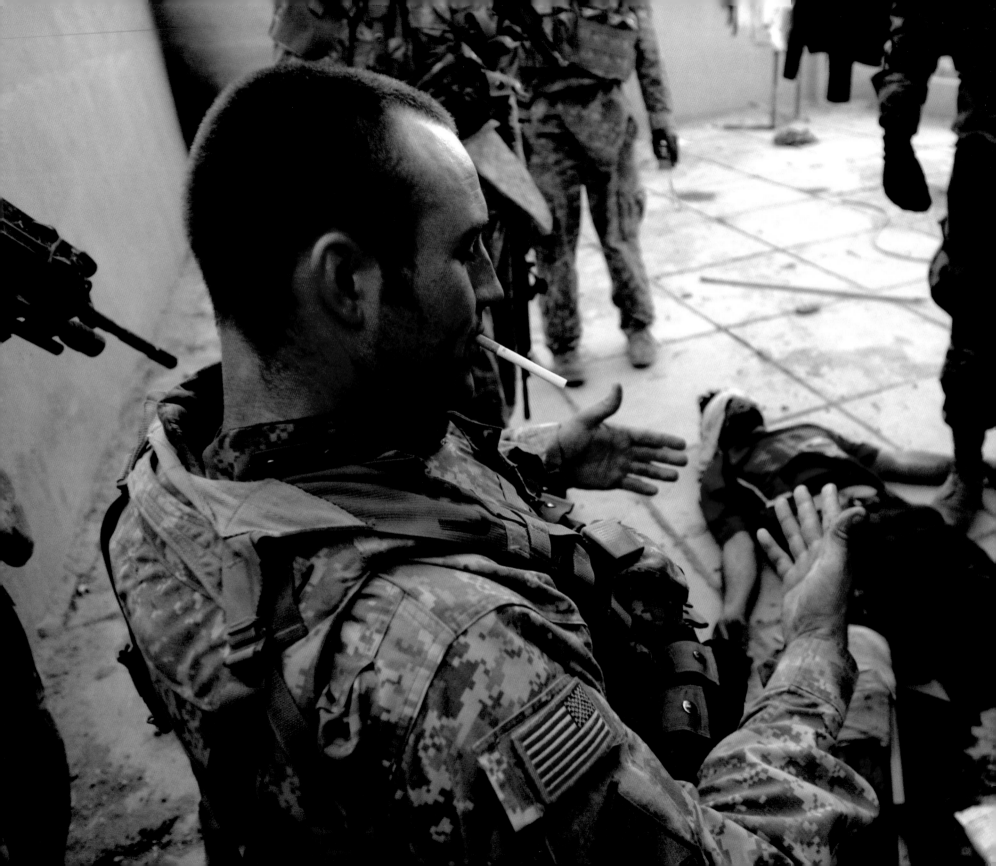

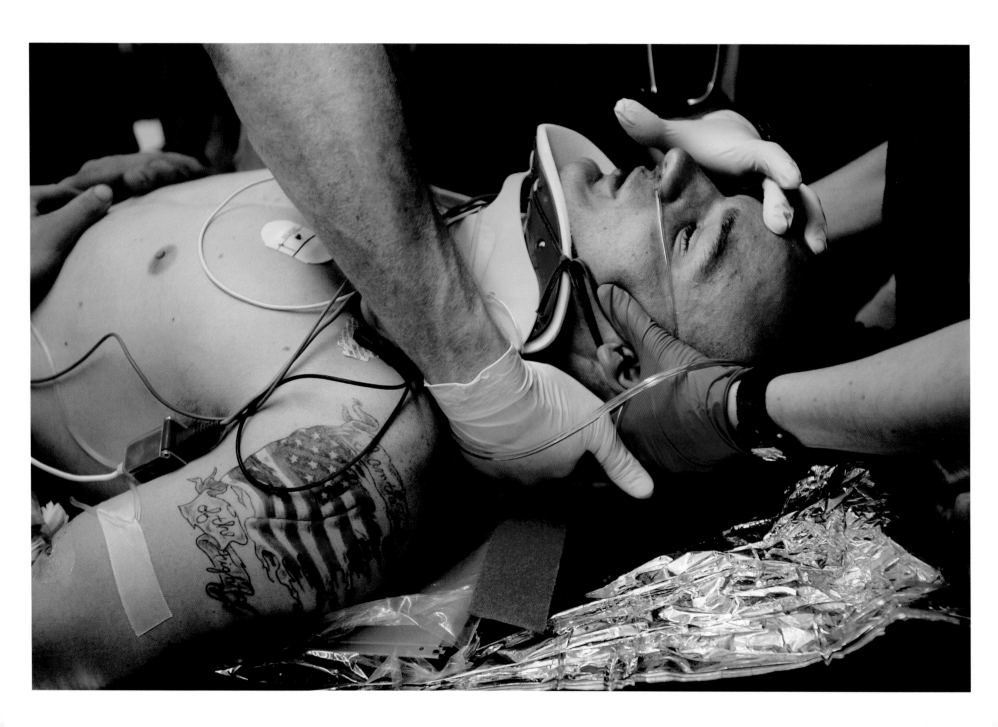

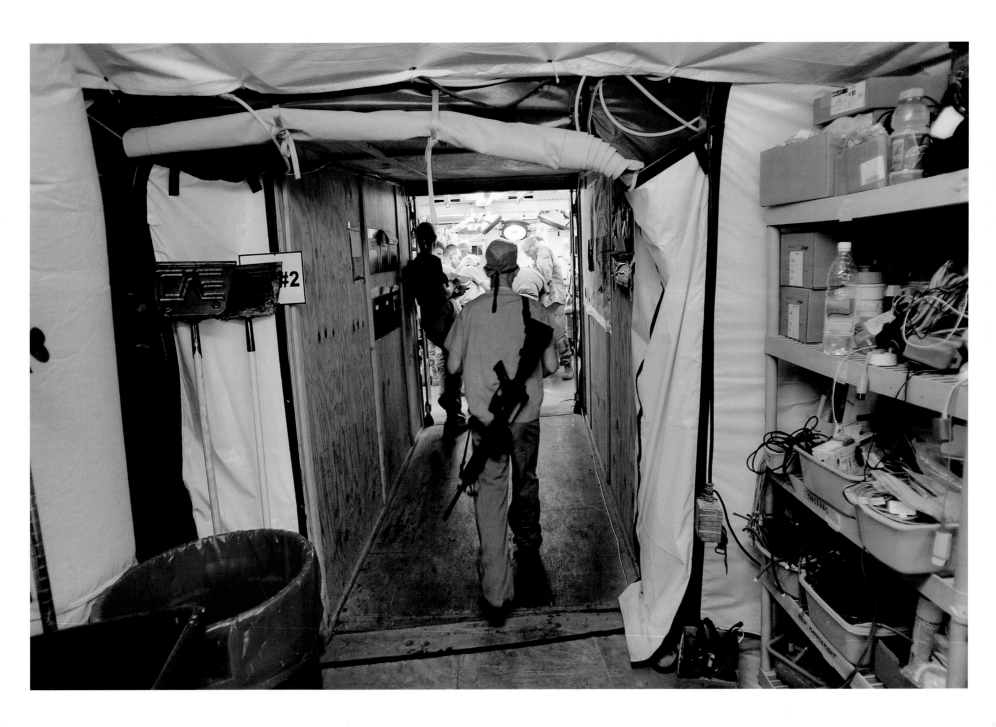

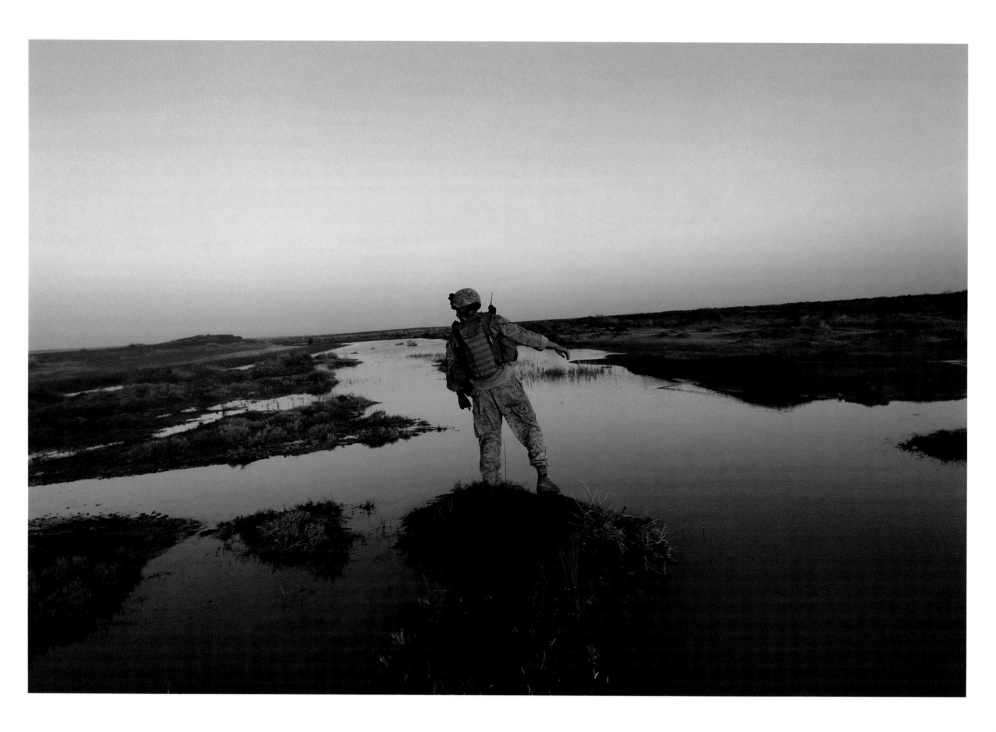

A VERSION OF THIS ARTICLE
WAS ORIGINALLY PUBLISHED
ON THE GETTY IMAGES BLOG,
MARCH 7, 2007.

The memorial ceremony for Staff Sgt. Karl Soto-Pinedo began precisely at 7:30 p.m. The chapel of Forward Operating Base Falcon in Iraq was packed; the pews were full of soldiers, from generals to privates, and more men stood alongside the walls and in the back. The previous week, Soto-Pinedo had been killed by an insurgent's bullet during a routine patrol in Baghdad. He was 22.

Five speakers took their turns at a lectern. One by one, they extolled the virtues of battlefield bravery and Soto-Pinedo's drive and initiative. Raised in Puerto Rico, Soto-Pinedo needed to take an English proficiency course as soon as he joined the Army in October 2002, just out of high school. He was good with people and obviously well liked; a slideshow of snapshots projected on a screen showed him arm to arm with his buddies, many of them now sitting red-eyed in this room. He towered over most of them; his nickname was Big Soto. He'd just been promoted to staff sergeant two months earlier.

After the speakers were finished, an Army chaplain said a prayer. Then a gruff-voiced first sergeant called out a ceremonial last roll call. He called out the name of one of his men; that soldier called back. The sergeant called another man; he also called back instantly. Then the sergeant called out, "Sergeant Soto!"

The room was quiet.
"Staff Sergeant Soto!"
More silence.
"Staff Sergeant Karl Soto-Pinedo!"
Absolute quiet.

Then, piercing the stillness like the sudden shot that felled Soto-Pinedo, three volleys of gunfire sounded from outside the chapel. A trumpeter, also outside, played taps, legato, hushed.

In pairs, the officers in the room approached the memorial stand and saluted in unison. Maj. Gen. Fils, the commander of Soto-Pinedo's 1st Armored Division, reached out and touched the fallen soldier's helmet gently, as if it were a newborn's cheek. More officers followed; many were visibly crying. Then the enlisted men approached, more informally; they stood sometimes six or seven abreast, saluting slowly, not always in sync. Several of them grabbed Soto-Pinedo's dog tags, pulling the chain taut, and prayed or wept or both.

THEN, PIERCING THE STILLNESS
LIKE THE SUDDEN SHOT THAT FELLED
SOTO-PINEDO, THREE VOLLEYS OF
GUNFIRE SOUNDED FROM OUTSIDE THE
CHAPEL. A TRUMPETER, ALSO OUTSIDE,
PLAYED TAPS, LEGATO, HUSHED.

"And the drive through Libya was interesting. The six hours through Egypt to the border is a typical faceless desert, and it's the same in Libya as you cross the spooky no man's land and the frontier itself. But about three hours in … the scenery abruptly becomes lush and verdant, not just in a bit-of-green-right-by-the-river way typical in Arab countries, but a real, mossy, grassy green, extending over hill and dale through to a misty heather in the distance. It stays that way for some hours, but alas, the dream dies down soon enough: an hour or so outside of Benghazi, the green gradually gives way to desert tans and yellows."

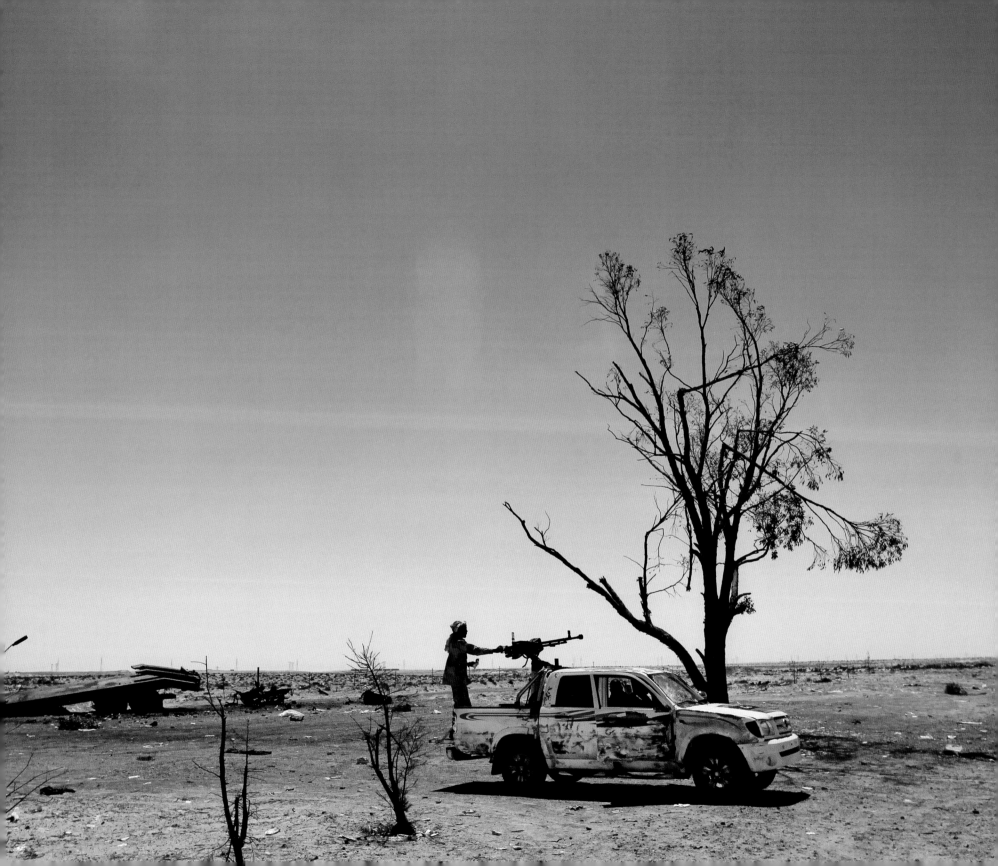

"Then, down the street came charging five or six horses and one camel, and everyone around me was completely beaten. It was an active military camel attack."

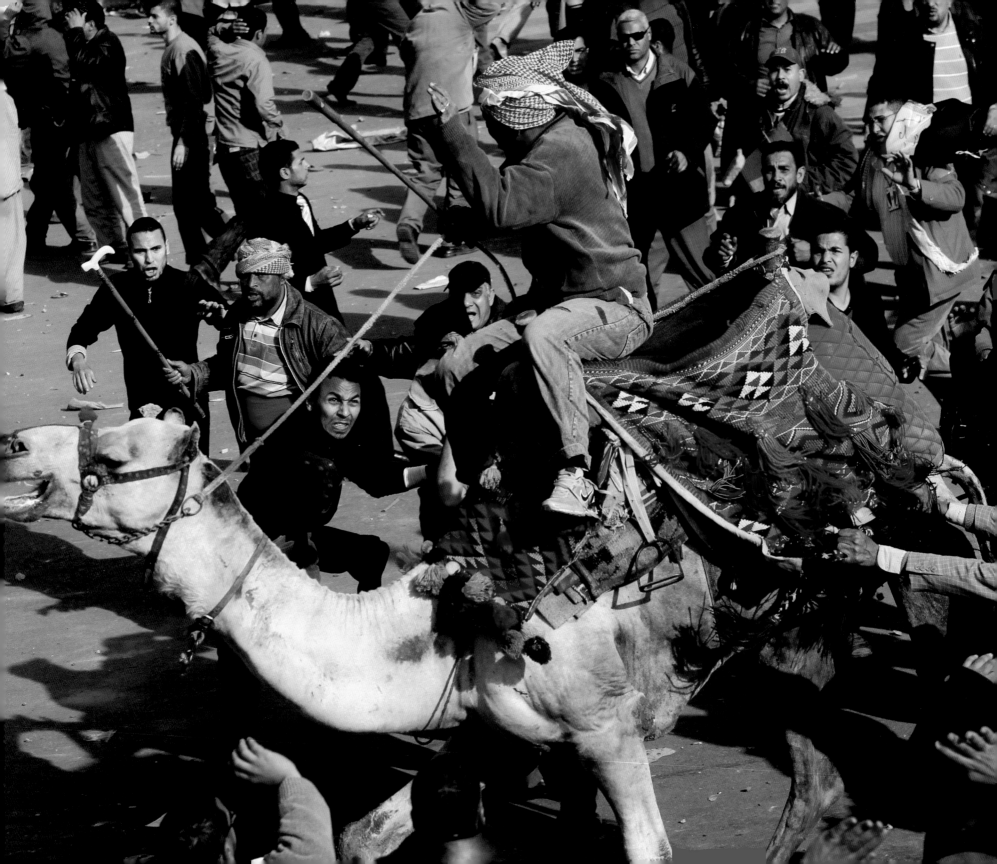

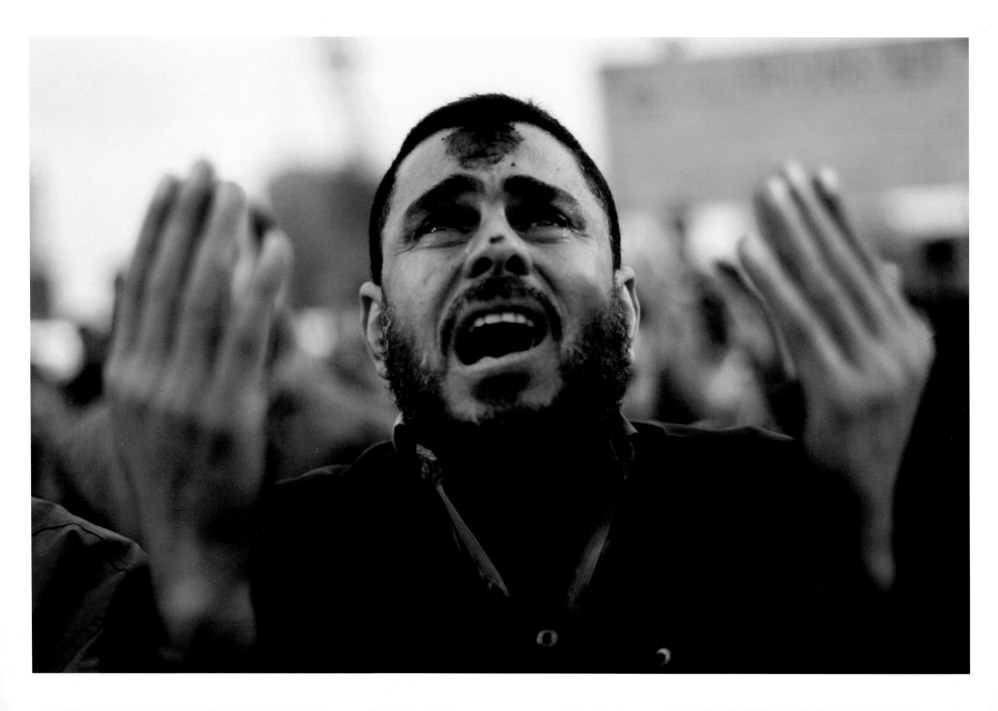

A VERSION OF THIS
INTERVIEW WAS ORIGINALLY
PUBLISHED BY BAGNEWSNOTES,
FEB. 3, 2011.

I had a chance to talk to Getty Images photographer Chris Hondros on the phone from Cairo in the early evening yesterday, several hours after he escaped from the absolute chaos in the central square. Below are his comments.
—Publisher Michael Shaw

"The only way I can describe the situation today is that it was totally old school, just people with rocks, sticks, and fists. It felt almost historical. It was probably more like how the American Revolution was fought. Or a fight in 683 B.C. Just thousands of people battling each other.

"I've seen fighting, but nothing at this scale. The anti-Mubarak people who have had the spotlight for a week were defending the square — it's like the equivalent of having taken over Times Square in New York. The Mubarak faction, which had been in different parts of town, then headed toward the square. Then it was just open season. It was very tribal. Like two rival gangs. It was not organized in any sense more than that. And it played out without the officials intervening. It's absolutely remarkable that there was no intervention at all. And it all comes down to holding that square.

"So the journalists have completely pulled out. Almost all journalists were attacked today — by both sides, especially the pro-Mubarak side. This evening, they're still fighting, with just rocks, sticks, and Molotov cocktails. It's just a few blocks from here. I imagine they'll keep fighting overnight. It all depends if security services intervene, especially the police.

"The craziest thing happened to me today. First rocks started to fly. One grazed my head. Then civilians tried to take my camera and my equipment. I barely escaped into an Egyptian army position, but the soldiers tried to take my memory card. For some reason, they seemed instructed to confiscate them. Barely able to get out of there, I jumped onto a construction trailer adjacent to the square. Then, down the street came charging five or six horses and one camel, and everyone around me was completely beaten. It was an active military camel attack.

"Really, I have no idea where this is going. Everyone is speculating what's going to happen. But if there's one thing I've learned doing war photography, it's never try to anticipate. There are much larger forces at play and we're just along for the ride. It could end tomorrow. Or, today could have been the start of the 2011 Egyptian civil war."

BUT IF THERE'S ONE THING I'VE LEARNED DOING WAR PHOTOGRAPHY, IT'S NEVER TRY TO ANTICIPATE. THERE ARE MUCH LARGER FORCES AT PLAY AND WE'RE JUST ALONG FOR THE RIDE.

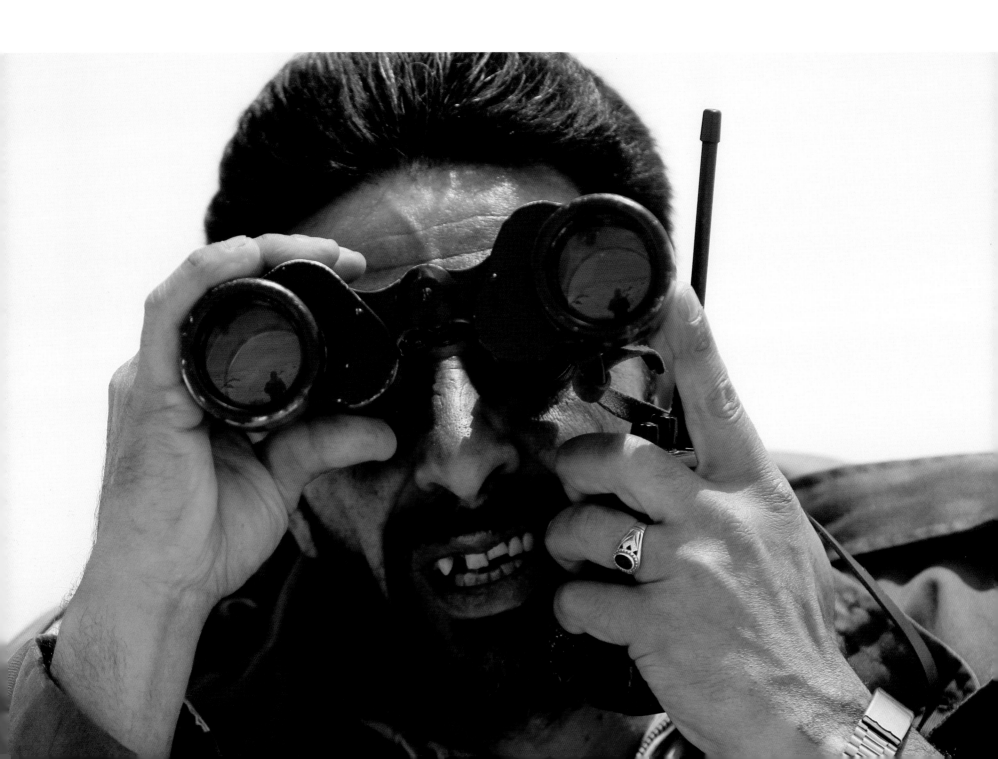

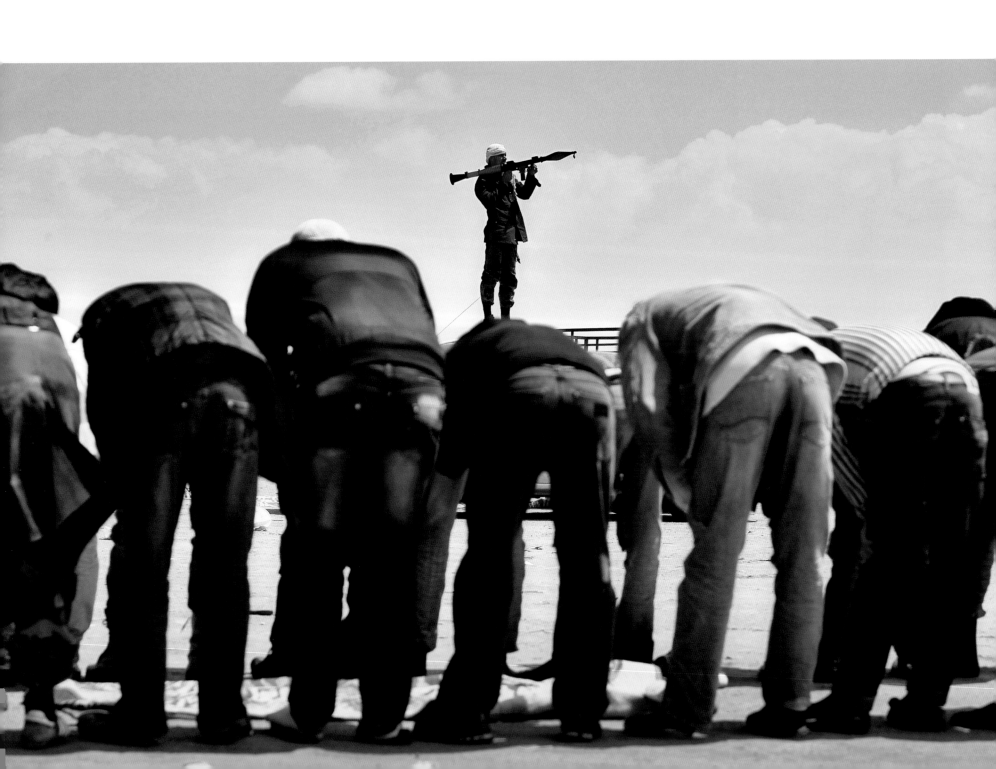

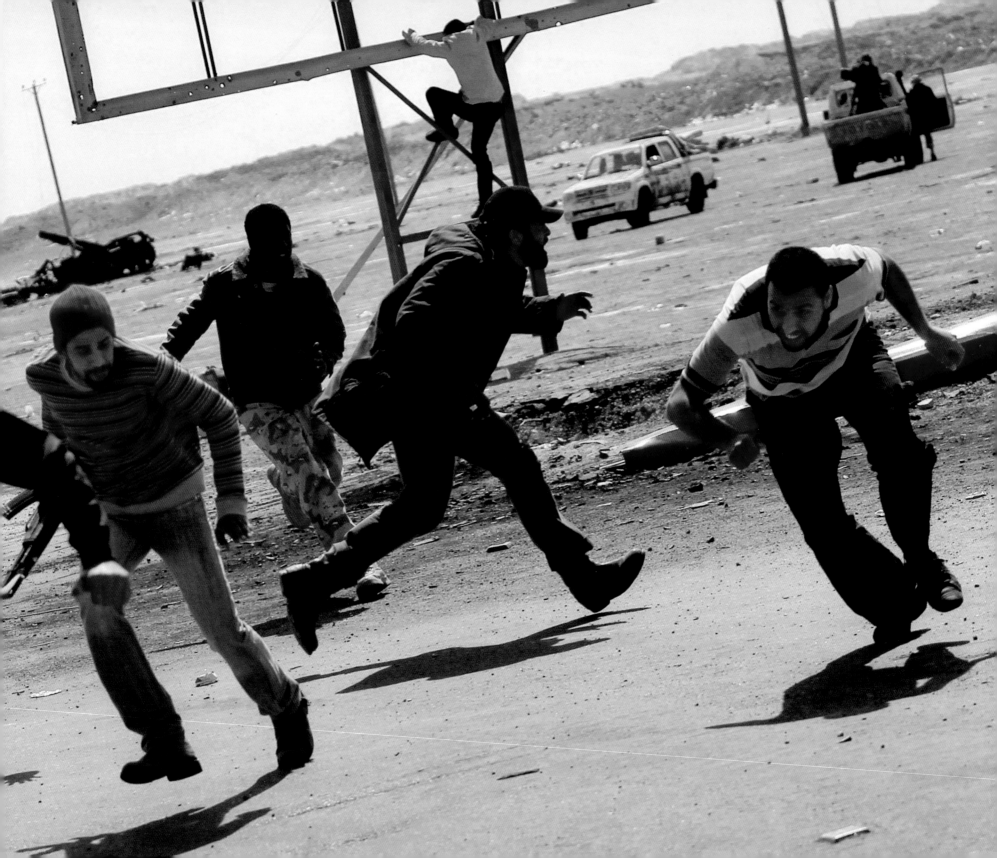

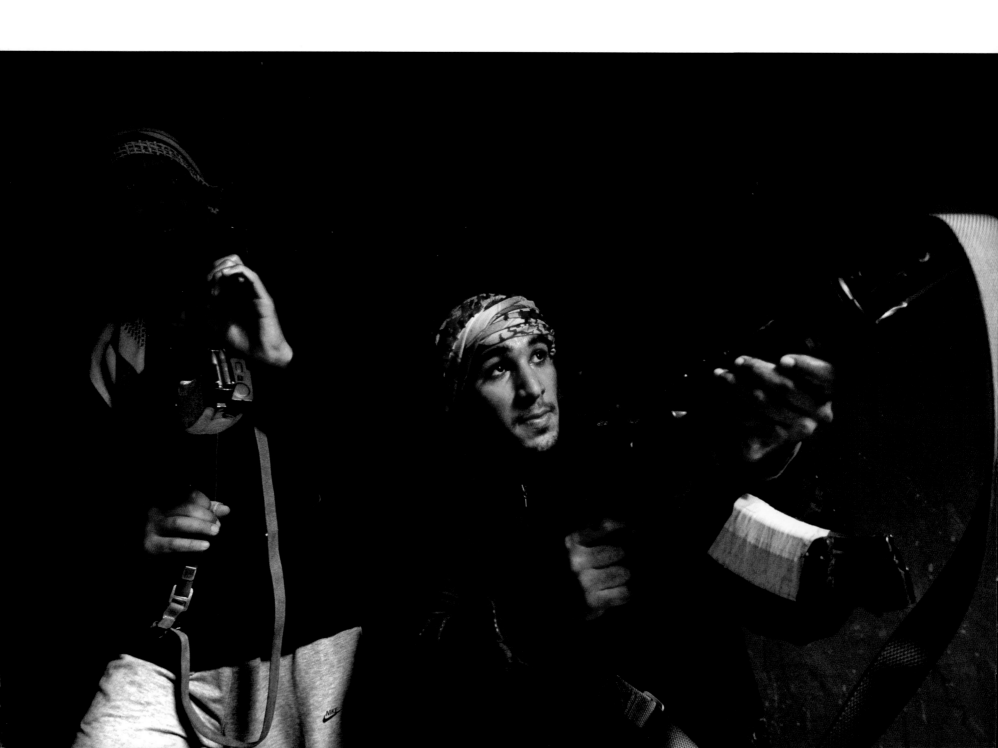

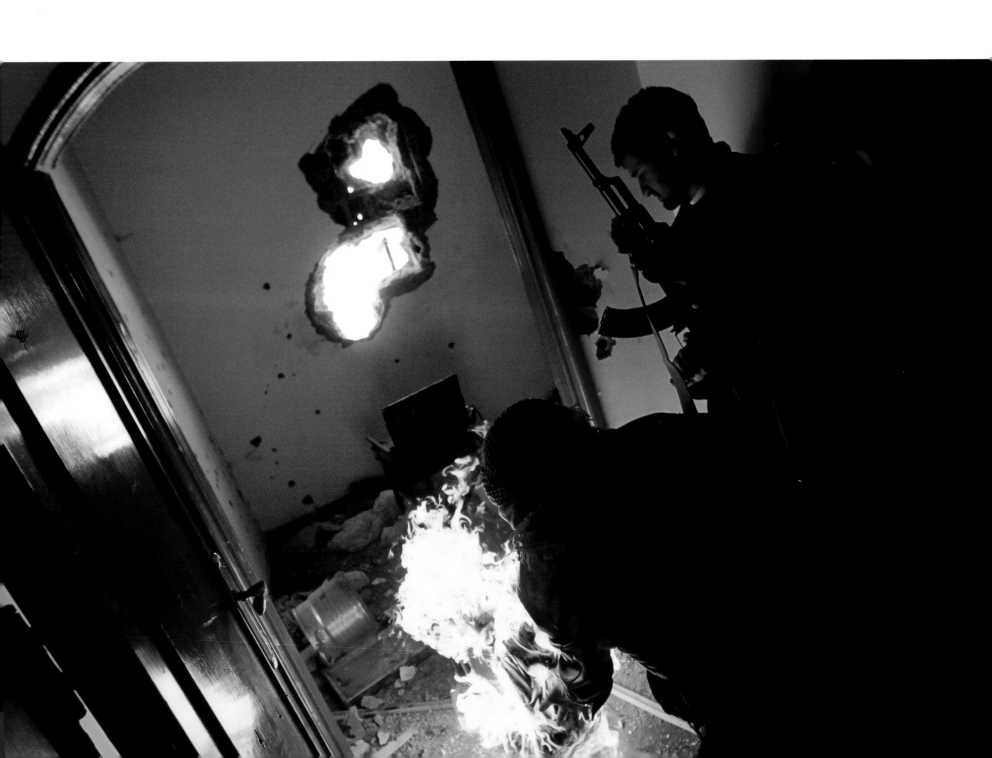

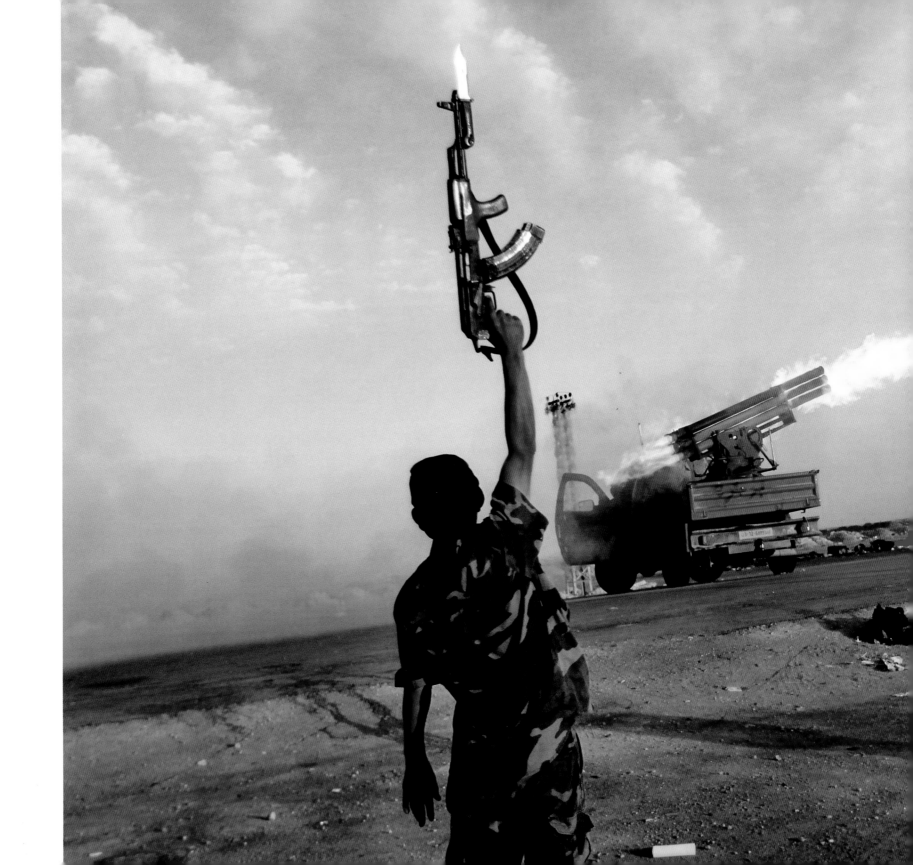

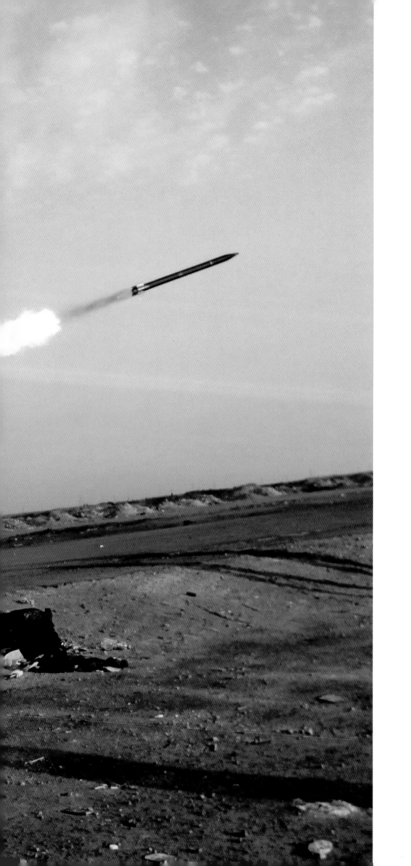

IV.

"Great photography requires
steadiness of hand and heart.
Very often the window to take an
important picture is only open
for a fraction of a second. Waver
or hesitate, even if the world is
crashing down around you, and
the moment will pass."

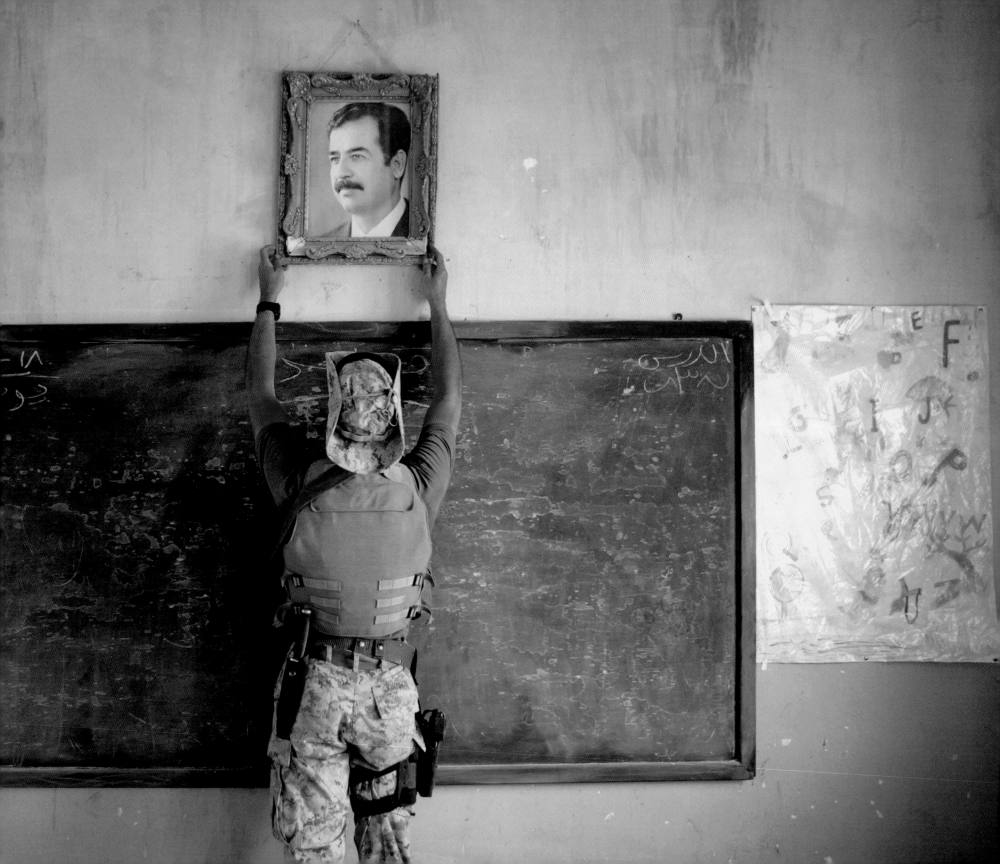

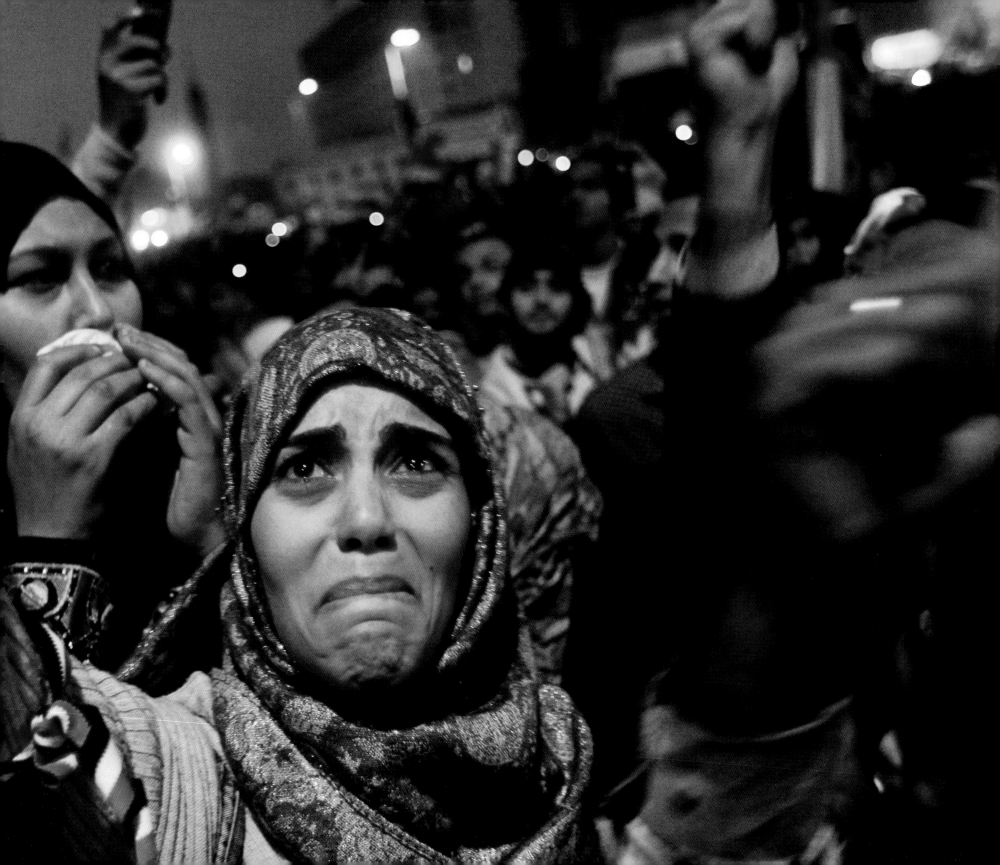

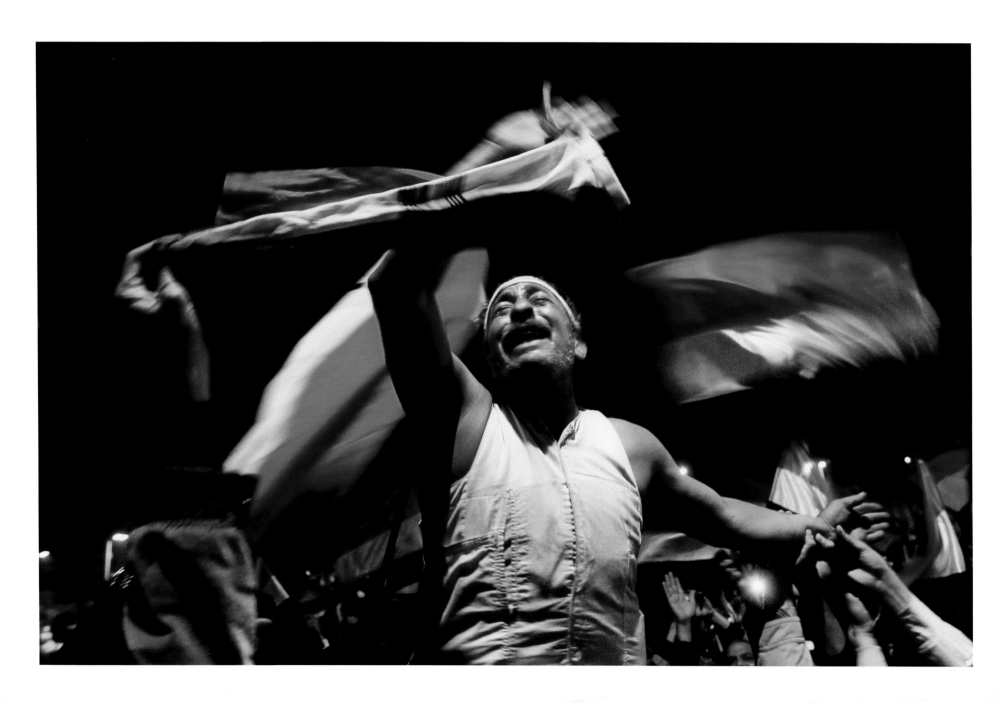

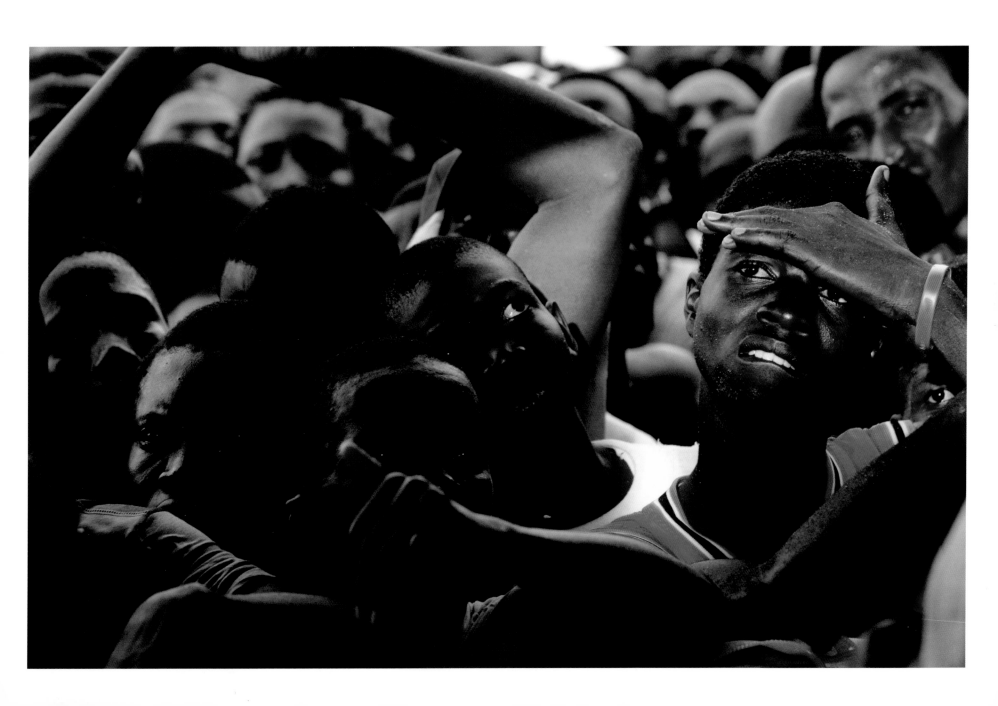

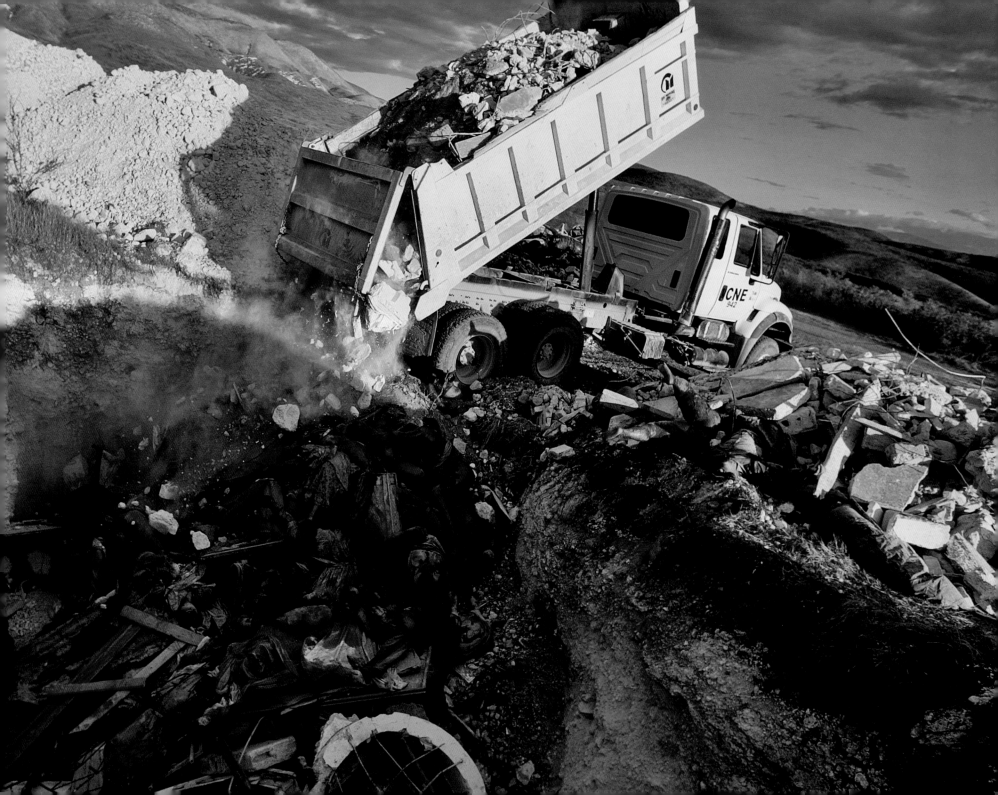

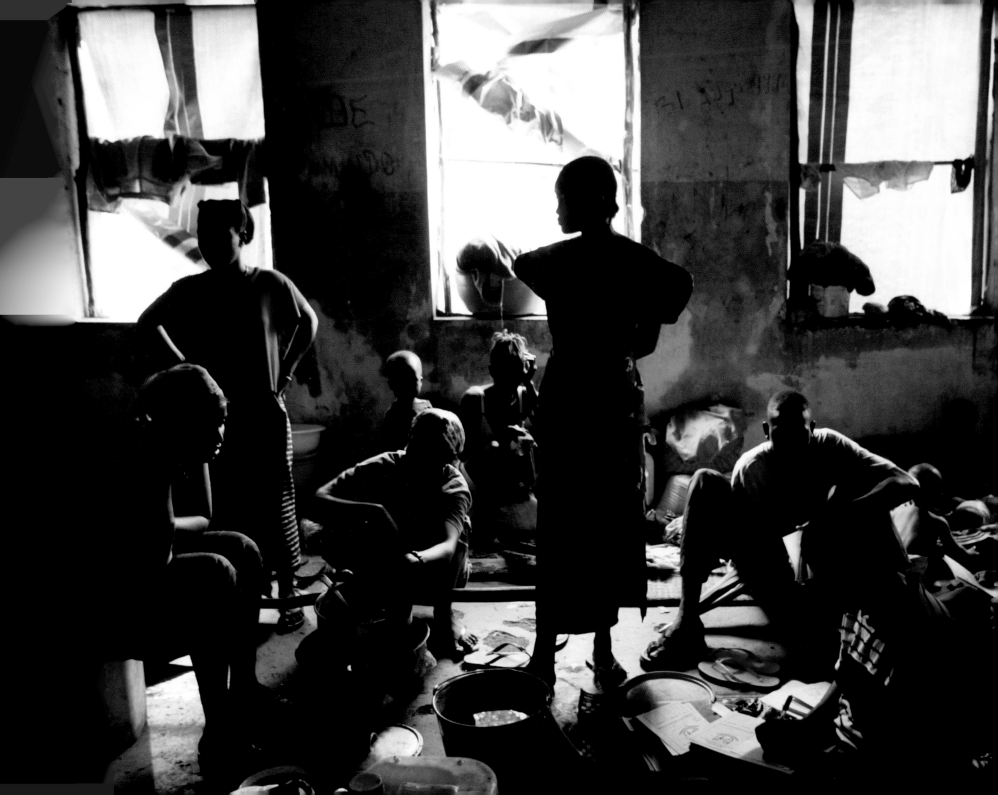

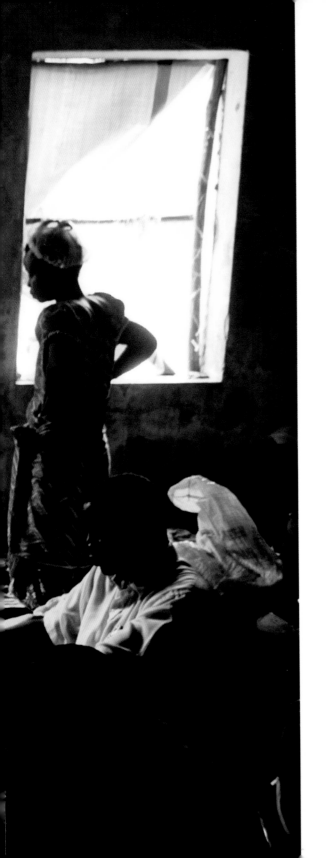

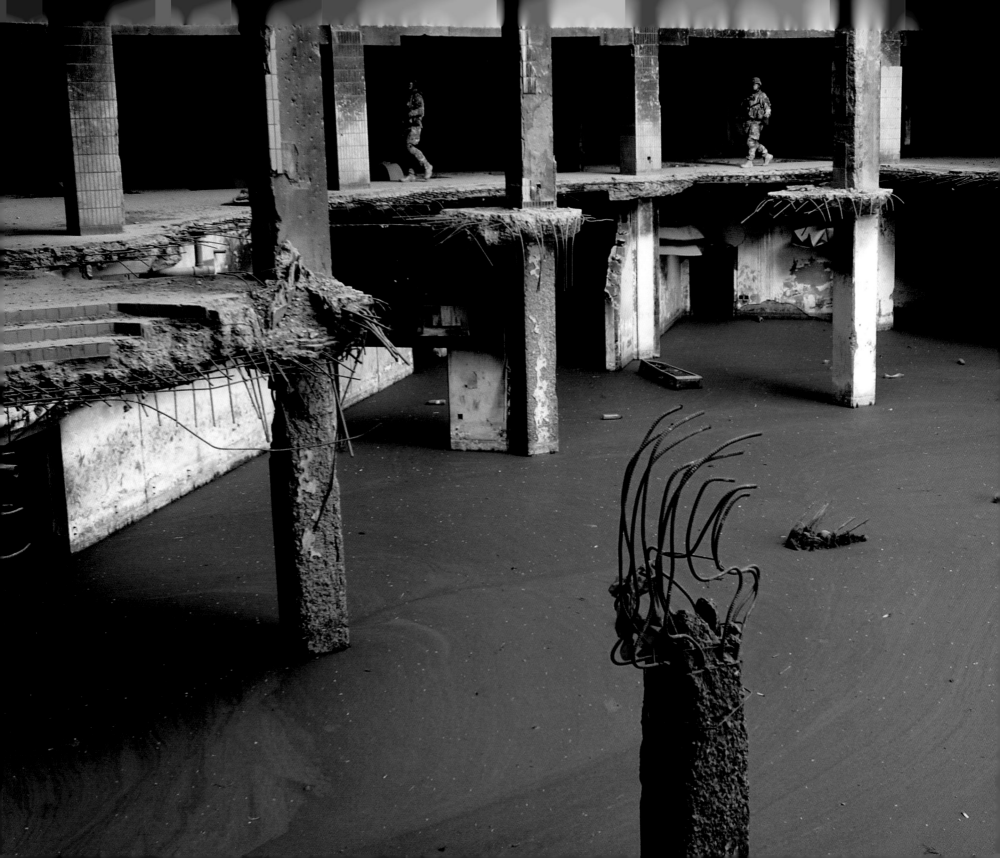

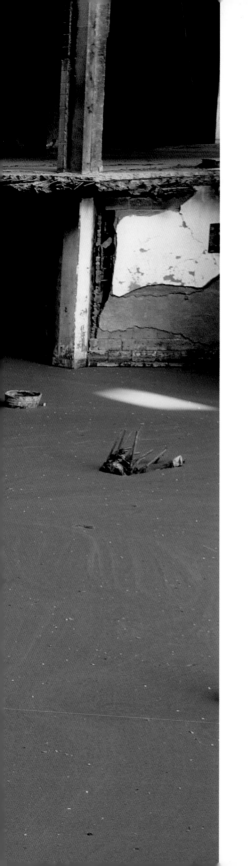

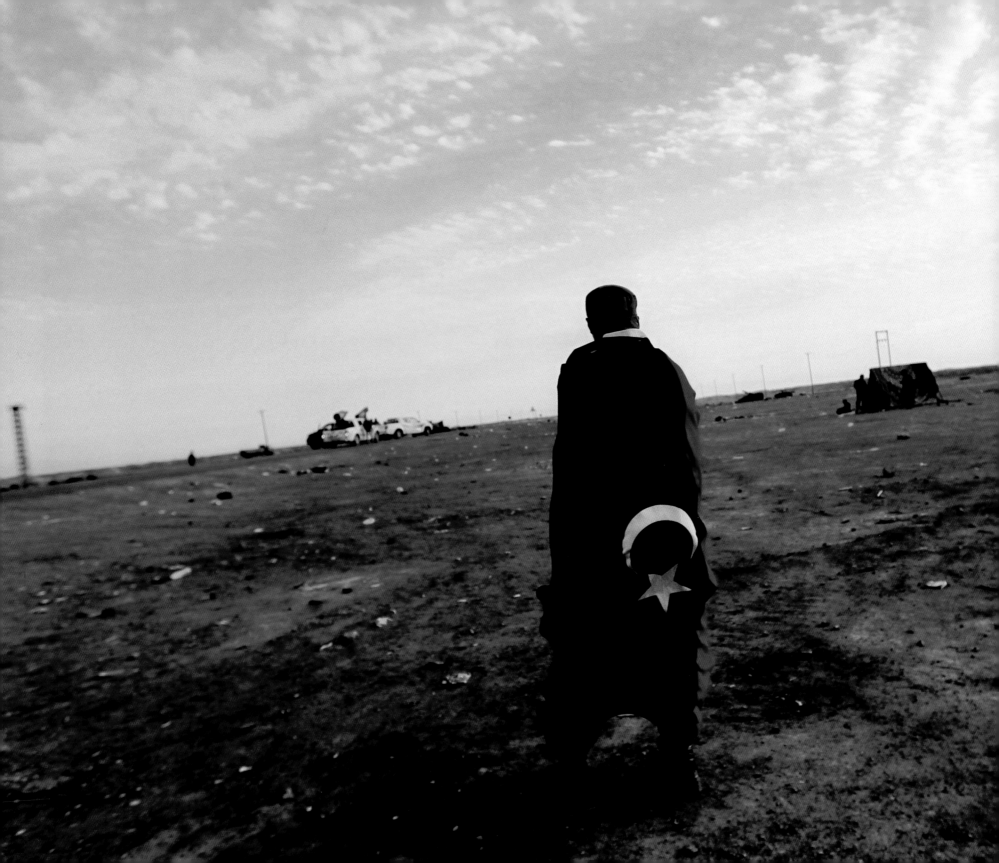

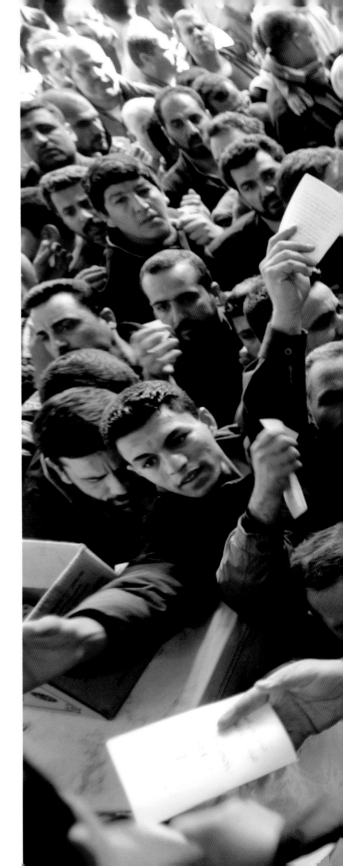

"It was an opportunity that was apparently worth the risk of death, and many Iraqis became giddy with the jubilation of it all, breaking out into spontaneous celebration in the streets around the polling stations, where people waved purple-stained fingers at one another, signs that they'd voted. Something foreign was in the air that was hard to identify, but it finally came to me, amid the excited babble and the ululating of the women, which managed to relegate the occasional gunshot to mere background noise. It was hope."

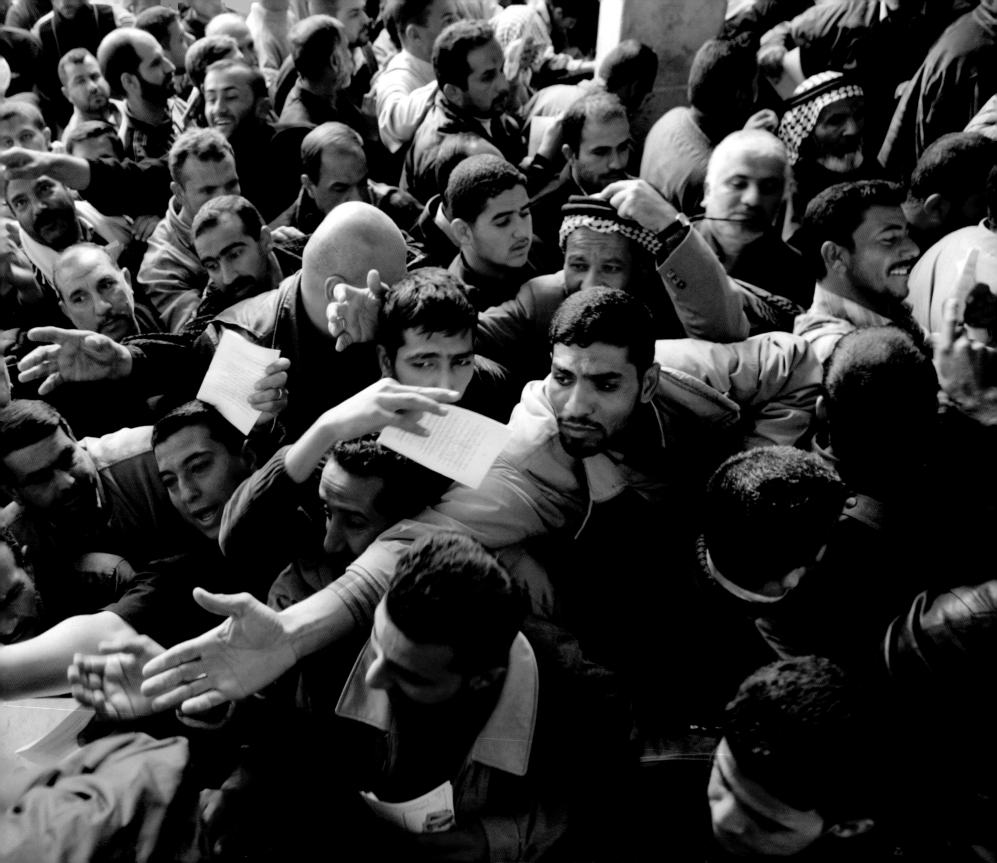

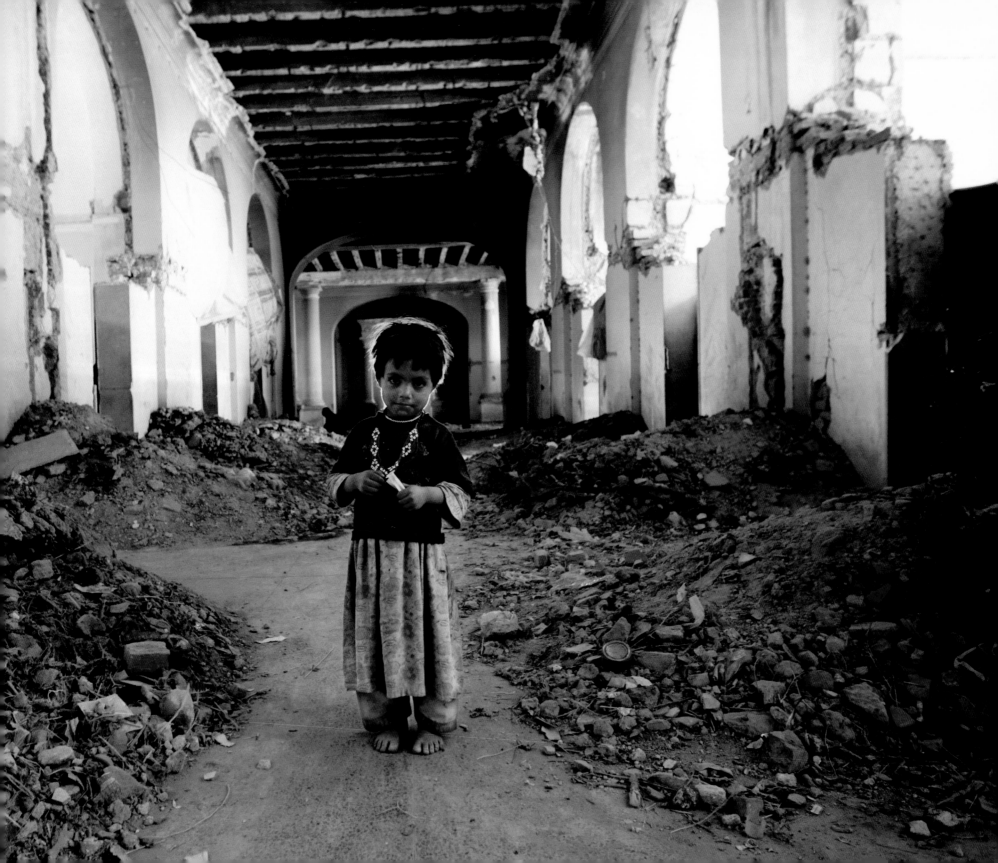

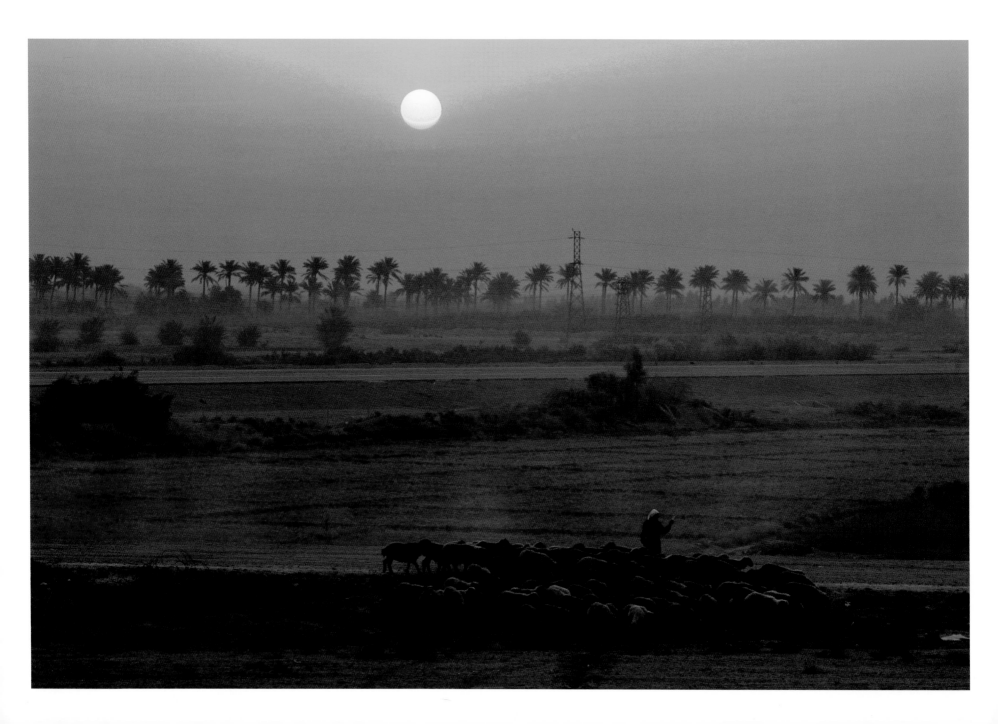

A VERSION OF THIS ARTICLE
WAS ORIGINALLY PUBLISHED
ON THE GETTY IMAGES BLOG,
JULY 10, 2007.

A few evenings ago, I rode in a Black Hawk helicopter over Baghdad in the dead of night. The Army flies dozens of loosely scheduled Black Hawk runs here every day, ferrying troops and sometimes civilians around Baghdad. The trips can be just a few miles, but they save soldiers from the dangerous convoys down bomb-studded roads.

This time, the side door of the helicopter was open; I stared out into the darkness, lost in thought as the rotors beat and the motor whined and I was whipped by the wind. How many helicopters have I been on in Iraq? Hundreds? On how many trips? Ten? Is that right? Ten trips to Iraq so far?

The first trip was at the time of the U.S.-led invasion, in March 2003; that was an ill-fated jaunt in a rented SUV that got shot out from under me, and I abandoned it under fire on the side of an Iraqi highway. The second trip was in November 2003, when things in Baghdad were safe enough to go out for dinner and drinks every night at local restaurants. The third was in June 2004, a trip unfortunately timed to miss everything important that happened in Iraq that year.

Fourth was in January 2005, when I covered the Iraqi election and a horrible checkpoint shooting accident in Tal Afar. Fifth was in June 2005, a hot summer spent with the Marines in Anbar province. Sixth was in February 2006, another less sweaty trip with the Marines.

Seventh, in March 2006, a stint at a U.S. Army hospital in Iraq that seemed straight out of "M*A*S*H." Eighth, in November 2006, a stay in west Baghdad with a brilliant young colonel, and two weeks covering the trial of Saddam Hussein. Ninth, in February 2007, hopping between small firebases around Baghdad, covering the "surge." And now, trip No. 10. Ten trips. And for what?

I STARED OUT INTO THE DARKNESS,
LOST IN THOUGHT AS THE ROTORS
BEAT AND THE MOTOR WHINED AND I
WAS WHIPPED BY THE WIND.

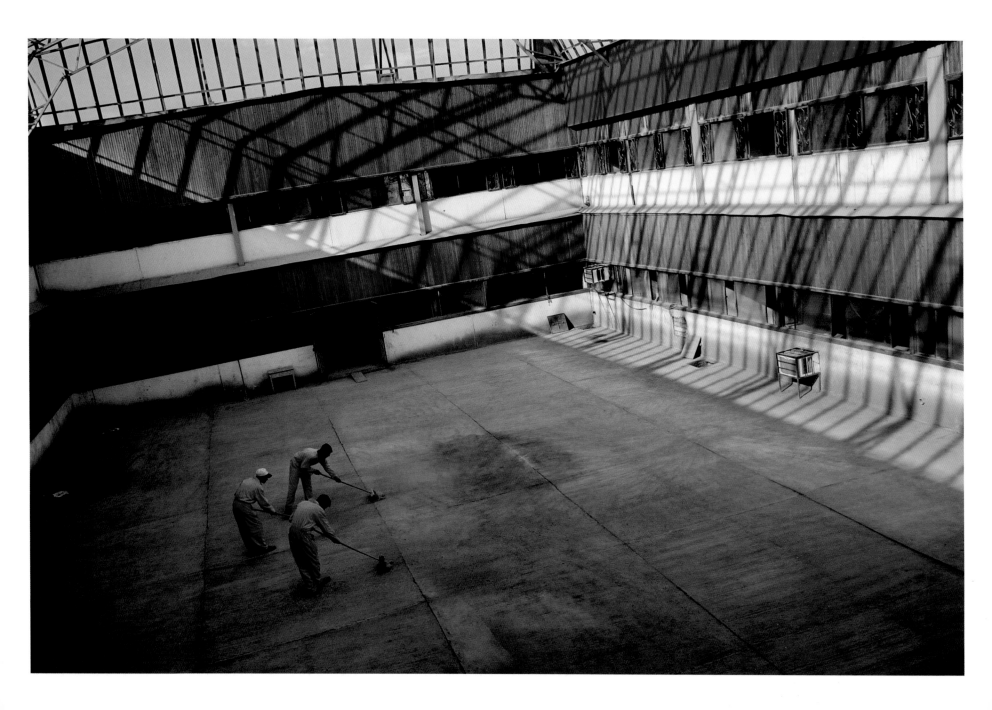

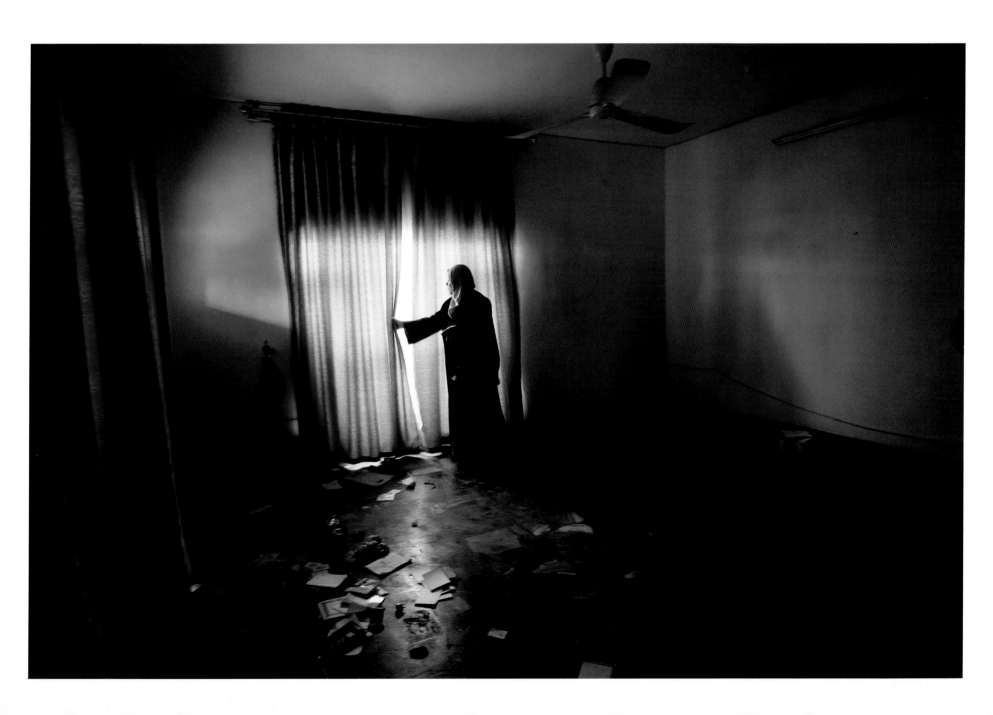

"[O]ne night last week, I was out with the Marines before an offensive in an utterly remote desert of Anbar province, sleeping in the open on the sand, my flak vest spread under me as a pillow. The moon had set and it was ethereally dark and quiet, and I listened to Beethoven's cavatina as I stared up into a black sea sprinkled liberally with the lights of the cosmos. And I felt, for just a moment, that I almost understood why I was there and what it all meant."

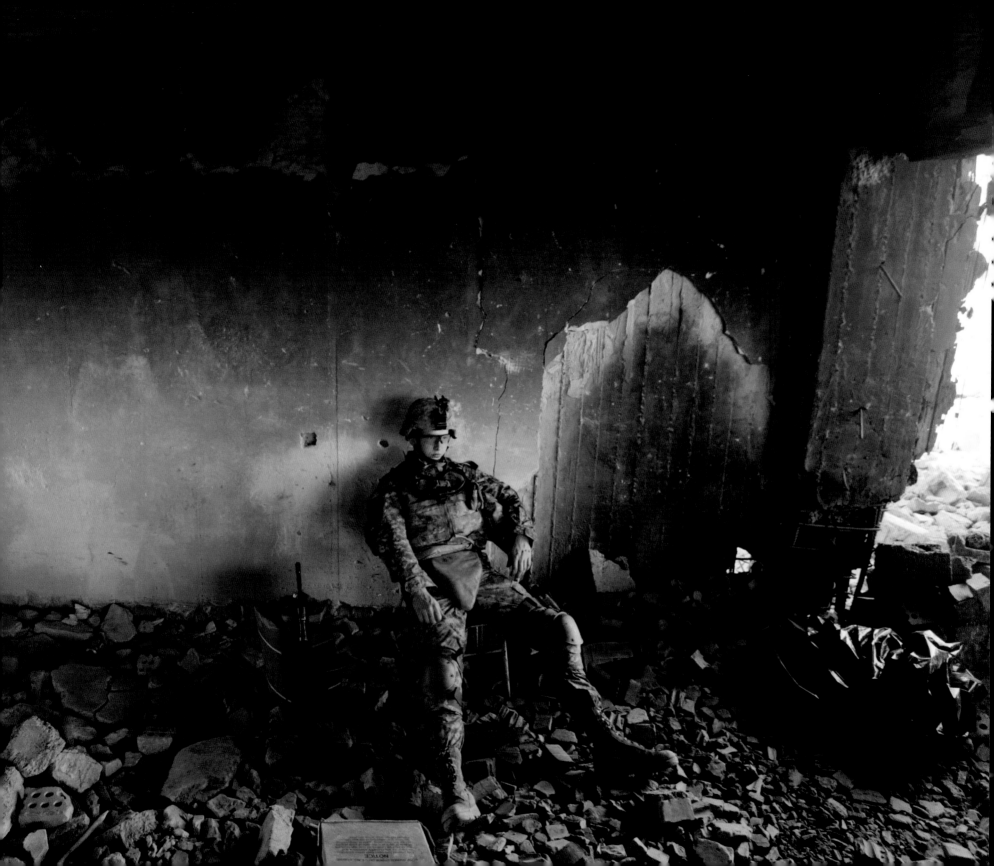

GREG CAMPBELL IS A
JOURNALIST, A BEST-
SELLING AUTHOR, AND A
FRIEND OF CHRIS HONDROS'
SINCE THE AGE OF 14.

As much as Chris Hondros lived on the cutting edge of technology — I have yet to meet anyone whom he didn't persuade to join Facebook long before anyone knew what it was — he was very much a traditionalist in many areas of his life. Pop culture, especially modern music, was largely lost on him. His sport coats all looked 25 years old. The most modern game he enjoyed was chess. And forget the convenience of a Kindle; he preferred to tote his tomes of literature around in the form of heavy, unwieldy *books*.

So it's not much of a surprise that one of the legacies he left behind is one of the most ancient of them all, the art of verbal storytelling. Online memorials to his life and his friendship can only provide so much solace, and it's only when speaking to others and sharing Hondros stories that the real act of grieving, healing, and moving forward takes place.

Almost without realizing it, I've found myself relying on the oral tradition of sharing stories to help fix Chris in my memories and to distill from them the essence of our friendship. I'm amazed at the things he continues to teach me as I experience him anew through the fresh eyes of a friend or colleague. It happens unexpectedly; I'll be speaking to any of a score of Chris' friends, and one of us will laugh at a captured fragment of fleeting memory.

"That reminds me," one of us will say, "did Chris ever tell you of that time..."

The answer is usually, "yeah, but tell me again," and we'll be off, lost in a reverie that could take any number of directions. Even if you've heard the story a hundred times, you never mind hearing it again because part of it will always be new.

But the best is when you can let your mind drift and imagine the story as if Chris were telling it himself. It's not hard to do because all his friends are good storytellers. And we should be. Chris had been training all of us in the craft of storytelling since we met him.

It might seem obvious that a person who'd chosen a career as a photojournalist would be a natural storyteller, but Chris Hondros was an *exceptional* one. He would crinkle his eyes, wiggle forward on his chair, and rub his palms together, flashing a mischievous smile that you couldn't help reflecting yourself, knowing that you were in for a bit of Hondrosian theater.

It was never so much what the story was about than how it was told, an art form that combined the timing of a comedic genius with the untapped talents of a natural thespian. I swear there were times when he was talking in italics, when the punctuation of his speech ran the story through its highs and lows at just the right pace every time. Probably most enchanting was that he could slip into storytelling mode with no notice or preamble, even in the middle of an argument.

Even though most of the stories were about him, they were never really about him. They tended to be illustrative of larger points, whether they took place on a battlefield or in a Walmart; in much the same way as his photos could often speak to deeper truths about shared humanity, so too did the tales he told when no one was in a particular hurry to leave the dinner table or after another bottle of wine had been opened.

One of my favorite Hondros stories takes place in 2003 on a bridge in Monrovia, Liberia, that separated encroaching LURD rebel soldiers on one side from government defenders on the other. Chris and his colleagues had spent days covering this horrific civil war on the government side, photographing child soldiers who brazenly pranced out onto the bridge to fire volleys of ammunition toward their enemies, only to saunter slowly back to cover, as if daring the rebels to take their best shot.

Eventually, even the fighters grew weary of this dangerous back and forth, and one commander suggested to Chris and some of his colleagues that the photographers walk to the other side of the bridge — in the middle of battle — and find out why the LURD rebels were shooting at them.

Naturally the suggestion was dismissed as crazy, at least at first. But — as I heard Chris tell it so many times — the idea nagged at him. "Why not?" he thought. Didn't he have an obligation to tell the other side of the story as well? Why were they fighting? By the time he began looking for material

from which to make a white flag, it was no less crazy of an idea, but it seemed doable. So he and a couple of colleagues shouldered their cameras, waved their crude flags, and stepped onto the bridge, walking into oncoming fire.

Although he gave it the proper dramatic treatment, the enormously dangerous walk from one front line to the other wasn't the point of the story – the point was that when he got to the other side, he found a group of rebels who were just as puzzled as the government soldiers about why the two sides were shooting at each other. For me, the story provided a perfect, personalized coda to the seeming insanity of the Liberian war, as apt as anything that could have been told by Kurt Vonnegut or Joseph Heller. No one knew why they were fighting, but they were determined to continue to the death.

Hondros the storyteller shared this experience with so many people that it has practically become part of the unofficial oral history collection of his life. Every time I hear it retold by a friend or colleague – or sometimes by complete strangers – I pick up different details and emphases, all of which allow me to add more texture and nuance to the event and, as a result, to my memory of Chris.

This is the purpose of storytelling – to refine memories through a variety of perceptions and recollections. The best is when this dynamic interaction between teller and listener reveals subtle new truths, some of which can even rise to the level of messages from Chris that were overlooked in previous tellings.

That happened to me the last time I heard the Liberia story retold, by a mutual friend who hadn't allowed Chris to skip over the part he tended to minimize – the mind-bogglingly complex risk-benefit calculus of choosing to walk, under heavy fire, between two battling forces, unsure of what sort of reception awaited at the end of the bridge.

"He was talking about how terrified he was and about how he thought about turning back many times," our friend recalled. "But then he said, 'You know, I didn't cover all that high school football just to come this far and turn back.'"

It's the sort of thing you can picture Chris saying somewhat flippantly, but it offers a glimpse at the most fundamental gears that drove him forward in everything he did. For better or worse, Chris never found himself anywhere by accident. Every photo, every story, was the result of meticulous and deliberate planning. That was true of individual assignments but also for his career in general.

It's that sort of long-range calculation that made him such an inspiration. Chris was never shy about sharing his advice and his thoughts on how a friend's life should be structured. Yes, it was sometimes infuriating, but no one could ever say that Chris didn't live up to the expectations he set for others. A mere glance at his career and his accomplishments makes it clear that he worked very hard to achieve what he did, but sometimes it was worth saying out loud to everyone in earshot that it didn't come easy. If you want to rise to the top – or in Chris' case, find yourself as one of a very few highly skilled and courageous photographers who can handle the risk and the responsibility of documenting heartbreaking conflicts in ways that may well affect global public sentiment and ongoing foreign-policy decisions – you have to shoot a lot of unglamorous high school football games. And you have to do it well.

There are more abstract ideas to be drawn from his comment, especially when hearing it for the first time after his death. And maybe that's why it struck me the way it has. It's easy, in his absence, to let the motivation and encouragement we found in his friendship die along with him and to wonder who among the survivors can step into the breach and take his place. Anyone who has gone down this path eventually reaches the same destination, even if we don't get there at the same time: There's no one to take his place, except ourselves. That has always been the case.

And if it seems like an impossible task to look toward a future without Chris' advice and encouragement, we can still find the strength in his own words. I'm sure he'd tell everyone he cared about that we didn't come this far – through our grief, in our careers, raising our children – to turn back now.

That's why we tell Hondros stories.

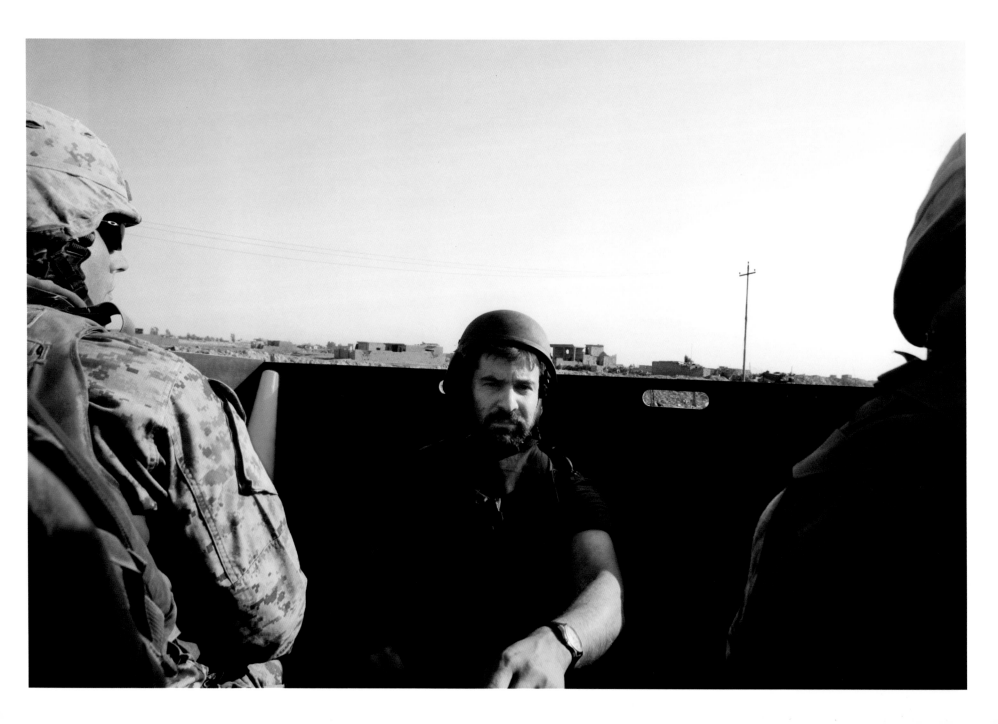

—

Chris Hondros (March 14, 1970 - April 20, 2011) was an American Pulitzer Prize-nominated photojournalist. Born in New York City to Greek and German immigrants, both survivors of World War II, he moved to Fayetteville, North Carolina, as a child. After studying English literature at North Carolina State University and receiving a master's degree from Ohio University's School of Visual Communication, Hondros returned to New York to concentrate on international reporting.

Hondros covered most of the world's major conflicts and disasters since the late 1990s, including work in Kosovo, Afghanistan, the West Bank, Iraq, Liberia, Egypt, and Libya. Hondros was also a frequent lecturer and published essayist on issues of war, and he regularly wrote for the Virginia Quarterly Review, Editor & Publisher, the Digital Journalist, and other news publications.

Hondros, a staff photographer for Getty Images since 2000, was a two-time finalist for the Pulitzer Prize in breaking news photography: in 2004, for his work in Liberia, and posthumously in 2012, for his coverage of the Arab Spring. During his career, he received dozens of awards, among them honors from World Press Photo, the Pictures of the Year International competition, Visa pour l'Image, and the Overseas Press Club, including the John Faber Award for his work in Liberia and the Robert Capa Gold Medal, war photography's highest honor, for his work covering the conflict in Iraq.

His work appeared on the covers of magazines such as Newsweek, Paris Match, and the Economist, and on the front pages of most major newspapers, including the New York Times, the Guardian, the Washington Post, Bild, the Times of London, and the Los Angeles Times.

As a photojournalist working in the world's most difficult and dangerous places, Hondros had the distinctive ability to connect his viewers with people embroiled in far-flung and sometimes obscure conflicts. He recognized the shared humanity among those affected by war, regardless of culture or beliefs, and he was determined to share their challenges to the wider world in the hope of provoking thought, raising awareness, and fostering understanding. One of his many skills was in humanizing world events that are all too often reduced to abstractions that minimize their impact on those involved. Hondros was a witness to their struggles, and his work ensured that they were not forgotten or overlooked.

In addition to photography and writing, Hondros was a self-taught student of classical music. Hondros greatly admired classical music and sought to combine his photographic work with this love. This lead to the creation of Sound + Vision: At War — the first of a series of visual concerts conceived by Hondros. The performances featured images of conflict accompanied by the music of Johann Sebastian Bach.

When not on assignment, Hondros enjoyed hosting historic parties and sharing long lunches and espressos with dear friends around New York City, where he had lived since 2001 and where he met his fiancée, Christina Piaia.

Chris Hondros was killed while on assignment in Misurata, Libya, on April 20, 2011.

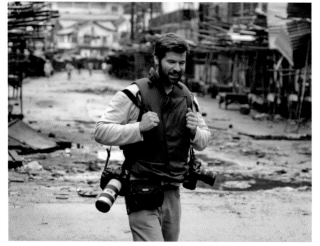

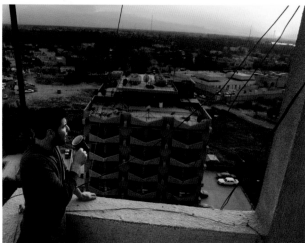

P. 10 Several pages from Chris Hondros' passports are shown including visa stamps from Chris' assignments to Pakistan, Egypt, Afghanistan, Iraq and Liberia. (Photo/Getty Images)

—

PP. 12-13 Iraqis are seen through the dirty window of an American Humvee during a patrol in Khaldiyah, a suburb of Ramadi, Iraq, on Feb. 1, 2006. Khaldiyah, a mostly Sunni town situated between Ramadi and Fallujah, was tense at the time, and the American and Iraqi army patrols that came there were subject to frequent attacks. Khaldiyah was entirely without a police force, as previous attempts to create one were disbanded due to corruption, desertions, and infiltration, as well as destruction of the police headquarters by insurgents.

—

PP. 14-15 A Mandaean Sabian holy man gestures to women to be baptized on July 4, 2004, in Baghdad, Iraq. The Mandaean Sabians are a small, ancient monotheistic religious group with a belief system incorporating many of the elements of Christianity, Judaism, and Islam. Baptism, a crucial aspect of the religion, is performed frequently on all members. Around 100,000 Mandaean Sabians practice worldwide, though most are in Iraq.

—

PP. 16-17 Children in the Nigerian village of Akaraolu play soccer at recess while the nearby Oshie gas flare roars on March 8, 2001. Since 1972, the natural gas flare, a by-product of oil drilling in the Niger River delta, has roared over the village. Natural gas emissions can be harnessed or re-injected into the ground. Flaring is the least expensive. No one under age 30 in the village could remember a time before what they simply call "The Fire" loomed over their village day and night.

—

PP. 18-19 Paratroopers of the 82nd Airborne Division play touch football on the landing zone of a forward U.S. Army base on Oct. 5, 2002, in southeastern Afghanistan. U.S. soldiers were continuing the search for weapons and suspected militants in Afghanistan.

—

P. 22 Marine Lance Cpl. Jillian Masmela of Boston, Massachusetts, suits up for a shift as a female searcher at Entry Control Point 1, a guarded entry into Fallujah, Iraq, on June 25, 2005. According to reports, a suicide car bomber had killed at least four Marines, including at least three women, and wounded 13 Marines, 11 being female, in a military convoy. The Marines were attacked while traveling back to Camp Fallujah after duty at the entry control point into the Iraqi city. The female Marines helped with searches of women Iraqi citizens trying to enter the city.

—

P. 23 Soldiers in the 1st Battalion, 501st Infantry Regiment (1/501) of the 25th Infantry Division file off the ridge of a mountain where they spent the night in a Taliban stronghold area on Oct. 15, 2009, in Paktika province, Afghanistan. Soldiers of the 1/501 scoured the Afghan countryside near the border with Pakistan on a two-day mission into a tense part of the province, an area that American soldiers had not patrolled for over three years. The troops were looking for suspected Taliban weapons stores and hideouts.

—

PP. 24-25 Afghan men in Zhari district, west of Kandahar, Afghanistan, on Oct. 11, 2010, discuss how best to spread dirt atop earthen barriers for a new Afghan police checkpoint as part of a labor program sponsored and paid for by the U.S. Army's 101st Airborne Division. The 1st Battalion, 2nd Brigade of the 101st Airborne was implementing an aggressive labor effort among the mostly agrarian villagers in its area of operations, paying sometimes double the typical daily wage for manual labor in the district. The soldiers, part of the storied "Black Hearts" group of the 101st that won fame on D-Day and in other battles, were spread out in the Taliban-infused badlands west of Kandahar, attempting to sway the hearts and minds of the local populace even as Taliban militants continued their attacks in the restive area.

—

PP. 26-27 A Kurdish schoolgirl walks home from school on March 5, 2003, in Cizre, Turkey. Tensions were high in the Kurdish town, located approximately 15 miles from the border with Iraq. Turkish military activity had increased in the area as well.

—

P. 28 Ali Salem el-Faizani, 10, stands at a street corner while working as a traffic cop on April 15, 2011, in Benghazi, Libya. Schools had been closed throughout eastern Libya for nearly two months due to the ongoing civil conflict; some children like Ali were working to pass the time, in his case finding a job via a Boy Scout-like youth troop that's affiliated with the Benghazi traffic police. "I like directing the cars around," Ali said.

—

P. 29 A young boy poses around bricks he has been stacking at a brick factory on Oct. 24, 2001, outside Peshawar, Pakistan. At the time, aid agencies estimated that around 11 million children from ages 4 to 14 were in the labor force in Pakistan, half of them under age 10.

—

P. 30 Afghan schoolgirls seen through the window of a U.S. Army Humvee wave to a passing American convoy on June 26, 2010, in downtown Herat, Afghanistan. Historic Herat, Afghanistan's third-largest city, was bustling and was considered safe by American and Italian troops tasked with securing the region, who had mostly seen attacks in rural areas of Herat province.

—

P. 31 A man stands on the side of a highway as seen through the window of a U.S. Army Humvee on Oct. 24, 2010, on the outskirts of Herat, Afghanistan. Herat had been spared much of the rampant violence that had engulfed the rural Afghan countryside, though political assassinations and terrorist attacks were not uncommon in the city of over half a million people.

—

P. 32 The shadow of a U.S. Army Humvee is seen through its

window on Feb. 8, 2007, in Baghdad, Iraq. The U.S. military was short more than 4,000 FRAG Kit 5 Humvee armor kits, at the time the latest armor kit, which was designed with flexible materials that help minimize the damage caused by weapons such as "explosively formed penetrators," which were reportedly responsible for 70 percent of U.S. casualties in Iraq at the time.

—

P. 34 (*left to right, top to bottom*)

A. Goats and sheep graze in a field as seen through a window of a U.S. Army Humvee on June 26, 2010, in the village of Deh Moghol, Afghanistan. The 4th Brigade of the U.S. Army's 82nd Airborne Division had been working for nearly a year in Herat province, a historic crossroads near the borders with Iran and Turkmenistan.

B. A man walking the streets is seen through the window of a U.S. Army Humvee on Oct. 24, 2010, in central Herat, Afghanistan.

C. An Iraqi man, seen from a U.S. Army Humvee window, passes by campaign posters on Jan. 20, 2009, in Mussayab, Iraq. Although violence had eased in this war-torn area, soldiers continued to diligently patrol, fearing a dismantling of the fragile peace between area Sunni and Shiite Muslims. Iraq was preparing for Jan. 31 provincial elections to choose over 400 seats for members of ruling councils in 14 of Iraq's 18 provinces.

D. Iraqi children are seen through a window of a U.S. Army Humvee on March 3, 2007, in Baghdad, Iraq. At the time, Humvees were the main vehicle used to transport U.S. troops in Iraq.

E. Men picnicking on a traffic median are seen through the window of a U.S. Army Humvee on Oct. 24, 2010, in central Herat, Afghanistan.

F. Men and boys ride on a vehicle as seen through the window of a U.S. Army Humvee on Oct. 24, 2010, on the outskirts of Herat, Afghanistan.

—

P. 35 (*left to right, top to bottom*)

A. An Afghan man stares back through the window of a U.S. Army Humvee on Oct. 24, 2010, in central Herat, Afghanistan.

B. An Afghan policeman directing traffic is seen through the window of a U.S. Army Humvee on Oct. 24, 2010, in central Herat, Afghanistan.

C. An Afghan man riding a donkey is seen through a U.S. Army Humvee window on June 22, 2010, in the Khushi Khona area of Afghanistan, in Herat province near the border with Turkmenistan. The 82nd Airborne Division, along with Italian NATO troops, had been working nearly a year in this historic area of Afghanistan, dotted with ancient villages and located just north of the cosmopolitan city of Herat.

D. Schoolchildren gathered in front of their school are seen through the window of a U.S. Army Humvee on Nov. 18, 2007, in the Dora neighborhood of Baghdad, Iraq. Dora, a Sunni enclave and once one of Baghdad's most violent neighborhoods for U.S. troops, had been calm recently, freeing U.S. troops to work on civil policing, such as addressing domestic violence and petty crime.

E. A burqa-clad woman boarding a mini-cab is seen through the window of a U.S. Army Humvee on Oct. 24, 2010, in central Herat, Afghanistan.

F. Pedestrians walking on the side of a road are seen through the window of a U.S. Army Humvee on June 26, 2010, in Herat, Afghanistan.

CAPTIONS — SECTION II

PP. 36-37 An Afghan boy stands in a bazaar on March 9, 2010, in Khan Neshin, Afghanistan. U.S. Marines with the 4th Light Armored Reconnaissance Battalion had set up their base inside the earthen walls of an ancient Afghan castle in Khan Neshin, in the southern fringe of Helmand province, and they made outings into the market outside their gates nearly daily to help the local economy and to show goodwill.

—

PP. 38-39 An anti-government protester keeps watch on a rooftop on the edge of Tahrir Square on Feb. 4, 2011, in Cairo, Egypt. Clashes between anti- and pro-government factions in Egypt's central square quieted that day as anti-government protesters called for a "Day of Departure" and renewed demands for Egyptian President Hosni Mubarak to step down.

—

PP. 40-41 A soldier in the U.S. 82nd Airborne Division turns away from a landing Black Hawk helicopter on Oct. 3, 2002, at a forward U.S. Army base at an undisclosed location in southeastern Afghanistan.

—

PP. 44-45 Fearful women and children watch paratroopers of the 1st Battalion, 504th Parachute Infantry Regiment of the 82nd Airborne Division raid their house, a suspected militant compound, on Nov. 26, 2003, in Nassar el al Salaam, Iraq. The overnight raid netted two men suspected of militant activities against American forces.

—

P. 46 Two Iraqi girls watch Staff Sgt. Nick Gibson of the 2nd Battalion, 12th Infantry Regiment of the 2nd Infantry Division on June 21, 2007, as the unit was canvassing the tense Dora neighborhood of Baghdad, Iraq. U.S. soldiers patrolled the area almost daily in an effort to get to know the residents and find insurgents.

—

P. 47 A member of the Iraqi Intervention Force covers a street, while a resident waits, during a patrol on June 13, 2005, in downtown Fallujah, Iraq. The Iraqi Intervention Force, a part of the Iraqi army, was formed as a multiethnic offensive force designed to react and deploy to all parts of Iraq.

—

PP. 48-49

left: U.S. Marines of the Force Reconnaissance attachment to the 24th Marine Expeditionary Unit interrogate an Iraqi prisoner on April 12, 2003, in central Iraq, north of Nasiriyah. The prisoner and two others were picked up while fleeing from the Marines and trying to discard military uniforms and IDs. Force Recon is the Marines' equivalent of Special Forces — Marines tasked with reconnaissance and other sensitive

missions in small groups.

center: A Marine Arabic interpreter of the Force Recon attachment to the 24th Marine Expeditionary Unit prepares to interrogate an Iraqi prisoner on April 12, 2003, in central Iraq, north of Nasiriyah. The prisoner was one of the three who were picked up while fleeing from the Marines.

right: The three Iraqi soldiers who had been picked up while fleeing sit bound and hooded, waiting to be interrogated by Marines of the Force Recon attachment to the 24th Marine Expeditionary Unit on April 12, 2003, in central Iraq, north of Nasiriyah.

—

P. 50 A Shiite boy pastes up campaign posters for the United Iraqi Alliance in the ethnically mixed Baladiyat neighborhood in Baghdad, Iraq, on Jan. 7, 2005. The United Iraqi Alliance, a coalition of various ethnicities with predominantly Shiite backing, ended up leading the elections that took place Jan. 30 despite concerns about the security of four of Iraq's 18 provinces.

—

PP. 52-53 A detained man, with the weapons allegedly found with him, waits to be photographed by U.S. Marines for processing on June 24, 2005, near Fallujah, Iraq. Marines in the 3rd Battalion, 4th Marines had launched a midnight raid in the rural suburbs of Fallujah and detained 19 men, the Marines said.

—

P. 54 Marines of the 3rd Battalion, 4th Marines process a detained man on June 24, 2005, near Fallujah, Iraq.

—

P. 55 Under headlights and the light of the moon, a U.S. soldier of the 2nd Battalion, 23rd Infantry Regiment of the 2nd Infantry Division out of Fort Lewis, Washington, lowers a concrete wall into place between Sunni and Shiite areas of the Dora neighborhood of Baghdad, Iraq, during the early hours of July 4, 2007. The soldiers built the wall at night in order to avoid attacks, though attacks against them occurred at night as well. The U.S. Army hoped the wall, nearly 2 miles long, would disrupt insurgent activities and prevent sniping attacks between the neighborhood areas.

—

P. 56

top: A soldier of the U.S. Army's 1st Battalion, 5th Cavalry Regiment stands guard on July 12, 2007, in a bus at a large bus depot in the tense Amiriyah neighborhood of Baghdad, Iraq. The 1-5 Cav conducted a raid with Iraqi army soldiers and the "Amiriyah Freedom Fighters," a group of former insurgents who later allied with the U.S. forces in the neighborhood. At the time, Amiriyah was one of Baghdad's most dangerous neighborhoods, claiming the lives of 14 U.S. soldiers in the month of May 2007 alone.

bottom: A rebel fighter moves through a hole punched in a wall near the front-line fighting on Tripoli Street in downtown Misurata, Libya, on April 18, 2011. Tripoli Street had been Misurata's posh main avenue for shops and expensive apartments, but weeks of house-to-house battles between forces loyal to Libyan ruler Moammar Gadhafi and rebels left

it in ruins. As the Libyan uprising entered its third month, fighting continued between Libyan government forces that had surrounded the city and anti-government rebels ensconced there.

—

P. 57

top: An ethnic Albanian in the Kosovo Liberation Army watches a Serbian troop convoy in February 1999 in Kosovo. Ethnic Albanians in Kosovo formed a ragtag guerrilla army in response to persecution by the controlling Serbian military. *bottom*: U.S. soldiers with the 1st Battalion, 5th Infantry Stryker Brigade Combat Team of the 25th Infantry Division, along with a masked Iraqi police officer (right, background), conduct a foot patrol on Jan. 16, 2005, in Tal Afar, Iraq. Iraqi police usually wore masks to hide their identities, in order to prevent insurgents from attacking them or their families.

—

P. 58 U.S. Marine Lance Cpl. Shawn Spicher, from Hemet, California, is reflected in a mirror at his field base on June 26, 2005, in Fallujah, Iraq. Spicher, 21, with the 3rd Battalion, 4th Marines, participated in combat in Fallujah and elsewhere during his two tours in Iraq and learned "that this life can be over in an instant." Marines with the 3rd Battalion, 4th Marines have had a storied history in Iraq, which includes being the U.S. troops who famously pulled down the statue of Saddam Hussein in Baghdad and leading the first assault on Fallujah in April 2004.

—

P. 59 A soldier in the 1st Battalion, 5th Cavalry Regiment of the U.S. Army sleeps on July 13, 2007, on a cot in a crude hallway in a Saddam-era fortified concrete bunker that was being converted to an Army field post in the tense Amiriyah neighborhood of Baghdad, Iraq. Insurgents who had recently been in control of Amiriyah had attempted to destroy the bunker and an adjacent building with explosives and burning tires, but the Army was able to salvage the compound and afterward occupy it.

—

P. 60 Mohammed, 7, stands near his family's mud-brick home on June 3, 2010, in Walakhan, a village south of Kandahar, Afghanistan. Tiny Walakhan, which at the time had perhaps 300 ethnic Pashtuns, is typical of many agrarian hamlets in the Pashtun belt in southern Afghanistan, where traditional farmers grow crops and raise families in ways they have for centuries. Walakhan and surrounding Dand district lie on crucial access routes to nearby Kandahar, and American soldiers had been occupying a forward operating base nearby to keep order in the restive region ahead of a push to place Kandahar under full Afghan government control.

—

P. 61 Halawasha, an Afghan Pashtun girl, holds her badly burned young sister Shokria as soldiers in the U.S. Army's 101st Airborne Division pass by on Oct. 12, 2010, in the tiny village of Now Ruzi, west of Kandahar, Afghanistan. The soldiers were on a routine patrol when they came across Shokria, who had third-degree burns over both forearms from a household accident with scalding milk five days earlier. The

only medical attention the wounds had received was swathing in dirty cloth, leaving her vulnerable to dying at any time due to infection. Army medics dressed the burns and began working with local Afghan military personnel to have the girl driven to a hospital in nearby Kandahar.

—

PP. 62-63 Detained men sit, bound and blindfolded, under the light of the moon after being detained by U.S. Marines of the 3rd Battalion, 4th Marines on June 24, 2005, near Fallujah, Iraq.

—

P. 64 United Nations peacekeepers from Uruguay tend to a pregnant Haitian woman who had lost consciousness in a massive crowd during a rice distribution for earthquake-displaced Haitians in front of the National Palace on Jan. 25, 2010, in Port-au-Prince, Haiti. Life in Haiti was transitioning to a new normal nearly two weeks after the powerful Jan. 12 earthquake that delivered historic damage and death to Port-au-Prince.

—

P. 65 Haitians climb on the rubble of a damaged shop during a mob looting spree on Jan. 17, 2010, in the downtown business district of Port-au-Prince, Haiti. Sporadic looting happened that day in the aftermath of the historic Jan. 12 earthquake that devastated the capital, prompting Haitian police to break up crowds with gunfire that killed at least one man.

—

PP. 66-67 An unconscious woman is carried by supporters of Liberian presidential candidate George Weah after she fell ill from heat during a rally on Oct. 8, 2005, in Monrovia, Liberia. Hundreds of thousands of people attended the rally for Weah, a former international soccer star, on a brutally hot day, with many reportedly collapsing from the heat.

CAPTIONS — SECTION III

PP. 68-69 Joseph Duo, a Liberian militia commander loyal to the government, exults after firing a rocket-propelled grenade at rebel forces at a key strategic bridge on July 20, 2003, in Monrovia, Liberia. Government forces succeeded in forcing back rebel fighters in fierce fighting on the edge of Monrovia's city center.

—

P. 70 (*left to right, top to bottom*)
A. The body of schoolchild Lasana Harding lies on a dirt path about two minutes after he was killed by a mortar shell on July 21, 2003, in Monrovia, Liberia. Fighting in the Liberian capital intensified that day as some 60 people were killed when mortars, believed to be fired by rebel troops, pounded the city.
B. A soldier loyal to the government shouts out a battle call after firing a rocket-propelled grenade at rebel forces on July 23, 2003, at a key front-line bridge in Monrovia, Liberia. At the time, clashes continued in the Liberian capital, despite a call for a cease-fire by the leaders of the LURD rebel group.
C. Government militia soldiers duck from incoming rebel fire on July 25, 2003, at a key bridge in Monrovia, Liberia. The standoff at Monrovia's bridges continued that day, as government forces and rebel troops battled for control of the

Liberian capital.
D. Liberians scatter in fear as a mortar shell explodes near them (background) on July 21, 2003, in Monrovia, Liberia.
E. A government loyalist commander (right) orders a soldier at gunpoint to the front lines during fighting on Aug. 2, 2003, in Monrovia, Liberia. Government forces succeeded in pushing back rebel forces from the edge of Monrovia after 11 days of fierce fighting for the Liberian capital.
F. A doctor at the JFK Medical Center cuts off the bloody shirt of a government soldier who was injured in fighting on July 20, 2003, in Monrovia, Liberia.

—

P. 71 (*left to right, top to bottom*)
A. Government loyalist soldiers riding in a pickup truck pass the bodies of alleged looters near front-line positions on Aug. 2, 2003, in Monrovia, Liberia.
B. Relatives of refugees who had been killed minutes before by mortar shells grieve on July 21, 2003, while they huddle in their makeshift refugee camp at a small school in Monrovia, Liberia.
C. A woman who was beaten by soldiers is carried on July 19, 2003, near front-line positions just outside Monrovia, Liberia. In an unexpected move, rebels attacked the capital that afternoon.
D. Aid workers with Doctors Without Borders rush an injured girl to a clinic minutes after a shelling attack on July 25, 2003, in Monrovia, Liberia. A fresh round of shelling terrorized Monrovia early that morning, as government forces and rebel troops battled for control of the Liberian capital.
E. Shocked Liberians walk through the remains of shelling victims at a high school, where hundreds of refugees had been living, minutes after they were killed on July 25, 2003, in Monrovia, Liberia.
F. Disabled men sit in the street in front of the U.S. Embassy in Monrovia, Liberia, on July 23, 2003. A group of institutionalized disabled Liberians protested for food and water in front of the embassy, as the humanitarian crisis deepened.

—

PP. 72-73 A child militia soldier loyal to the government walks away from firing while another taunts enemies on July 30, 2003, in Monrovia, Liberia. Sporadic clashes continued between government forces and rebel fighters in the fight for control of Monrovia.

—

P. 74 A woman grieves over the body of a relative on July 26, 2003, outside a church in Monrovia, Liberia. Sporadic shelling had continued overnight in Monrovia, hitting a church that housed dozens of families and killing at least three people.

—

P. 75 A young child whose chest was injured by shrapnel from mortar shells gets medical attention in a crude medical tent in the Greystone refugee camp near the U.S. Embassy in Monrovia, Liberia, on July 21, 2003.

—

P. 76

top: A government loyalist soldier grieves as a comrade dies of

wounds suffered during a battle near front-line positions in Monrovia, Liberia, on Aug. 2, 2003.

bottom: A government loyalist commander (left) orders the soldier to stop grieving his comrade after the comrade died of the wounds.

—

P. 79

top: Liberian child soldiers loyal to the government sit silently before charging at a strategic bridge position on July 20, 2003, in Monrovia, Liberia.

bottom: A Liberian man carries an injured baby out of the back of an ambulance at a hospital in Monrovia, Liberia, on July 25, 2003.

—

PP. 80-81 An anti-Taliban commander on Dec. 10, 2001, looks over the area where al-Qaeda fighters were hiding and engaging his troops in the Tora Bora area of Afghanistan. Anti-Taliban soldiers were bombing and fighting al-Qaeda fighters in an attempt to oust the estimated 2,000 soldiers loyal to Osama bin Laden who were holed up in caves in the rugged countryside.

—

P. 82 A mujahideen fighter braces himself against a fierce wind on Dec. 18, 2001, in the Tora Bora area of Afghanistan. With the al-Qaeda soldiers routed out of their mountain strongholds, mujahideen soldiers had begun to pull out, while American officials searched the area for signs of al-Qaeda leader Osama bin Laden.

—

P. 83 A young boy picks through used shell casings from a tank on Dec. 10, 2001, in the hills overlooking the Tora Bora area of Afghanistan.

—

PP. 84-85 Anti-Taliban soldiers carry off the body of an al-Qaeda soldier they had just killed in battle on Dec. 11, 2001, in the Tora Bora area of Afghanistan. At the time, anti-Taliban forces had made more gains against entrenched al-Qaeda forces, prompting talks of a cease-fire and possible surrender by Osama bin Laden's terrorist organization.

—

P. 88 Rakan Hassan, 11, an Iraqi boy, is treated for a wound on his back after U.S. soldiers with the 1st Brigade, 25th Infantry Division killed his parents when their car unwittingly approached soldiers, despite warning shots, during the soldiers' dusk patrol on Jan. 18, 2005, in Tal Afar, Iraq. Six children in the car survived.

Rakan was treated by a medic seconds after being accidentally shot in the restive northern Iraqi city. The incident was widely publicized and ultimately led to Rakan's treatment in Boston, Massachusetts. With nerve damage to his abdomen and spine, doctors thought Rakan might never walk again, but an intensive physical therapy regimen brought back the use of his legs so that he could walk with assistance. Rakan returned to Iraq in January 2006. He died at age 14 in June 2008, when a bomb exploded at his family's home.

—

P. 89 U.S. soldiers push the Hassan family car after they fired at the vehicle when it failed to stop and unwittingly came toward soldiers on Jan. 18, 2005, in Tal Afar, Iraq.

—

PP. 90-91 Samar Hassan, 5, screams after her parents were killed by U.S. soldiers on Jan. 18, 2005, in Tal Afar, Iraq. The troops fired on the Hassan family car when it unwittingly approached them during their dusk patrol in the tense northern Iraqi town. Parents Hussein and Kamila Hassan were killed instantly, and son Rakan, 11, was seriously wounded in the back.

—

P. 92 (*left to right, top to bottom*)

A. A U.S. soldier with the 1st Brigade, 25th Infantry Division walks the streets during a dusk patrol on Jan. 18, 2005, in Tal Afar, Iraq.

B. U.S. soldiers approach the Hassan family car immediately after they fired on the vehicle on Jan. 18, 2005, in Tal Afar, Iraq. They fired on the car after it failed to stop and unwittingly came toward soldiers, despite warning shots. Parents Hussein and Kamila Hassan were killed instantly, and son Rakan was seriously wounded in the back. Five other children survived.

C. Two children from the Hassan family car are held by U.S. soldiers after their parents were killed.

D. Samar Hassan, 5, one of the children in the vehicle, screams after her parents were killed.

E. One of the Hassan daughters screams while a soldier checks her for wounds after her parents were killed.

F. Rakan Hassan, 11, is carried into the hospital after being shot by U.S. soldiers.

—

P. 93 (*left to right, top to bottom*)

A. A U.S. soldier looks at the body of Hussein Hassan after troops fired on the car carrying his family on Jan. 18, 2005, in Tal Afar, Iraq.

B. Samar Hassan, 5, one of the children in the Hassan family car, sits at the feet of U.S. soldiers after her parents were killed in the shooting.

C. Children from the Hassan family cry after their parents were killed.

D. The boots of a U.S. soldier are spattered with blood after U.S. troops fired on the Hassan family car.

E. Rakan Hassan, 11, is carried by hospital staff after being accidentally shot by U.S. soldiers when they fired on the Hassan family car.

F. Rakan lies paralyzed on a stretcher while a U.S. medic kneels over him after he was shot.

—

PP. 94-95 U.S. Army soldiers in the 1st Battalion, 501st Infantry Regiment (1/501) of the 25th Infantry Division shield their eyes from the powerful rotor wash of a Chinook cargo helicopter as they are picked up from a mission on Oct. 15, 2009, in Paktika province, Afghanistan. Soldiers of the 1/501 scoured the Afghan countryside near the border with Pakistan for suspected Taliban weapons stores and hideouts on a two-day mission into an area that American soldiers had not patrolled for over three years.

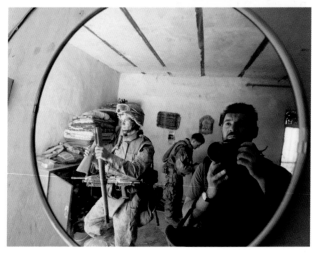

P. 96 An American medic in the 82nd Combat Aviation Brigade gives CPR to a grievously wounded Afghan National Army soldier in a medevac helicopter on Nov. 1, 2009, in Kandahar province, Afghanistan. The soldier, who later died of his injuries, had stepped on a land mine planted by insurgents, severely wounding his legs. Medevac medics, crew chiefs, and pilots fly at a moment's notice into the war zone in Afghanistan, quickly retrieving wounded Western and Afghan troops from the battlefield.

—

P. 97 In the orange fog of an Iraqi sandstorm, Pfc. Joshua Guerrero (left) and Pvt. Aaron Livas, U.S. troops of the 2nd Battalion, 30th Infantry Regiment of the 10th Mountain Division, carry a wounded Iraqi man who started running from their platoon during a routine morning patrol and was shot on May 16, 2008, in Baghdad, Iraq. When the patrol encountered a group of three men digging in an area of frequent insurgent mortar activity, the man started to run and was shot in the leg. He was immediately treated by the U.S. medic traveling with the platoon and transported to the nearest U.S. base for medical care, and he was expected to recover. The other two men were arrested and later released.

—

PP. 98-99 Paratroopers in the U.S. Army's 82nd Airborne Division carry a seriously wounded Afghan civilian to an Army medevac helicopter on June 21, 2010, in Khushi Khona, Afghanistan, in the northern reaches of Herat province near the border with Turkmenistan. Eight local Afghan men aboard a truck, returning from a routine trip to buy sheep, struck a powerful buried explosive along a route frequented by the U.S. Army's 82nd Airborne Division, which was nearby. Five of the men were killed instantly; the three others, gravely wounded, were treated by 82nd Airborne medics on the scene and were then flown out by medevac helicopter.

—

P. 100 A captured Egyptian man suspected of being in the government security forces is roughly handled by anti-government protesters in Tahrir Square in Cairo, Egypt, on Feb. 3, 2011. Anti-government Egyptian leaders captured dozens of Egyptians they alleged were government police or intelligence officers who were trying to blend in with anti-government protesters. The standoff between factions for and against Egyptian President Hosni Mubarak in the capital's central square continued after a day and night of violence in which hundreds were injured in clashes.

—

P. 101 A captured Egyptian whom anti-government protesters alleged was a member of the Egyptian government security forces screams as his handcuffs are adjusted at an ad hoc anti-government command center in Cairo, Egypt, on Feb. 3, 2011. Anti-government Egyptian leaders questioned the man and several other suspected security officers who were captured near Tahrir Square, while allegedly trying to blend in with anti-government protesters.

—

PP. 102-103 U.S. Army Sgt. Sergej Mithaud of El Paso, Texas,

from the 1st Cavalry Division, Charlie Company, 2-12, smokes after treating a suspected Iraqi Shiite insurgent they had shot earlier and tracked by his blood trail on Feb. 8, 2007, in the Ghazaliya neighborhood of Baghdad, Iraq. Troops followed the blood trail to a hiding suspected insurgent, allegedly with the Shiite Mahdi Army.

—

P. 104 Army Spc. Allan Beck, injured in a vehicle accident, has his neck stabilized in the emergency room at Balad Air Force Theater Hospital (BAFT) on March 18, 2006, in Balad, Iraq. At the time, the BAFT, a simple double row of tents and plywood, was the busiest military hospital in Iraq, seeing hundreds of patients a month from all over Iraq, both military and civilian.

—

P. 105 Maj. Hans Bakken, a U.S. Army neurosurgeon from Decorah, Iowa, enters a surgical ward with his unloaded rifle on his back on March 16, 2006, in Balad, Iraq.

—

P. 106 A U.S. Marine attached to the 4th Light Armored Reconnaissance Battalion gingerly steps across a muddy creek while on a mission on March 13, 2010, near Khan Neshin, in southern Helmand province, Afghanistan. The southernmost troops in Afghanistan, the Marines at Khan Neshin were using the earthen walls of the ancient castle there as a base from which to monitor activity in what was a hotbed of smuggling and insurgency near Afghanistan's southern border with Pakistan.

—

PP. 108-109 Rebel fighters hold a position ahead of a rumored Libyan army advance on April 11, 2011, in the desert between the crucial towns of Ajdabiya and Brega, Libya. Rebels continued to hold the strategic town of Ajdabiya a day after NATO air power struck nearby army troops loyal to Libyan ruler Moammar Gadhafi.

—

PP. 110-111 A supporter of embattled Egyptian President Hosni Mubarak rides a camel through the melee during a clash between pro-Mubarak and anti-government protesters in Tahrir Square in Cairo, Egypt, on Feb. 2, 2011. The previous day, Mubarak had announced that he would not run for another term in office but would stay in power until elections later that year. Thousands of supporters of Egypt's longtime president and opponents of the regime then clashed the next day in Tahrir Square, throwing rocks and fighting with improvised weapons.

—

P. 112 An anti-government protester cries during Islamic prayers in Tahrir Square in Cairo, Egypt, at sundown on Jan. 30, 2011. Cairo remained in a state of flux, and marchers continued to protest in the streets and defy curfew, demanding the resignation of Egyptian President Hosni Mubarak. The day before, as Mubarak struggled to regain control after five days of protests, he appointed Omar Suleiman as vice president. At the time, the death toll stood at 100, and up to 2,000 people were thought to have been injured during the clashes, which started Jan. 25. Overnight it

was reported that thousands of inmates from the Wadi Natrun prison had escaped and that Egyptians were forming vigilante groups in order to protect their homes.

—

P. 114 A Libyan rebel commander looks through binoculars as he talks on a radio near front-line positions outside Brega, Libya, on April 6, 2011. Rebel militias fighting against Libyan government loyalist soldiers continued their standoff in the eastern Libyan desert that day, regaining ground toward a key oil port while anxiously awaiting further NATO airstrikes in their quest to unseat longtime Libyan ruler Moammar Gadhafi.

—

P. 115 Libyan rebels pray while a comrade stands with a rocket-propelled grenade launcher on the western edge of Ajdabiya, Libya, on April 8, 2011. Rebels skirmished with Libyan loyalist troops that day, taking close mortar fire at strategic Ajdabiya's western edge as they tried to stop advances by the troops loyal to ruler Moammar Gadhafi.

—

PP. 116-117 Libyan rebels scatter as mortars fired by Libyan army troops crash down nearby on April 8, 2011, in Ajdabiya, Libya.

—

P. 118 Rebel fighters carefully move into a building where they had trapped government loyalist troops during street fighting on Tripoli Street in downtown Misurata, Libya, on April 20, 2011. Rebel forces assaulted the downtown positions of troops loyal to Libyan strongman Moammar Gadhafi that day, briefly forcing them back over a key bridge and trapping several in a building. With rebel troops surrounding the building, the loyalist troops fired on the rebels from upper-floor positions instead of surrendering.

—

P. 119 A Libyan rebel fighter rolls a burning tire into a room containing ensconced government loyalist troops who were firing on rebel forces during house-to-house fighting on Tripoli Street in downtown Misurata, Libya, on April 20, 2011.

—

PP. 120-121 A rebel fighter celebrates as his comrades fire a rocket barrage toward the positions of troops loyal to Libyan ruler Moammar Gadhafi on April 14, 2011, west of Ajdabiya, Libya. Rebels exchanged artillery and rocket fire with loyalist troops west of Ajdabiya that day as the conflict engulfing Libya continued.

CAPTIONS — SECTION IV

PP. 122-123 A U.S. Marine pulls down a picture of Saddam Hussein at a school on April 16, 2003, in Kut, Iraq. A combination team from the Marines, Army, and Special Forces went to schools and other facilities in Kut looking for weapons caches and unexploded bombs in preparation for removing and neutralizing them.

—

PP. 124-125 A woman cries in Tahrir Square in Cairo, Egypt, on Feb. 11, 2011, after it was announced that Egyptian President Hosni Mubarak was giving up power. After 18 days

of widespread protests, Mubarak, who by then had left Cairo for his home in the Egyptian resort town of Sharm el-Sheikh, announced that he was stepping down.

—

P. 126 An anti-government protester reacts before Egyptian President Hosni Mubarak was to make a statement on Feb. 10, 2011, in Cairo, Egypt. Mubarak made a statement in which he refused to step down, defying expectations that he was preparing to resign.

—

P. 127 A supporter of Liberian presidential candidate George Weah shields his eyes from the late afternoon sun during a rally on Oct. 8, 2005, in Monrovia, Liberia. Hundreds of thousands of people attended the rally for Weah, a former international soccer star, on a brutally hot day, with many reportedly collapsing from the heat.

—

PP. 128-129 A truck in Titanyen, Haiti, on Jan. 16, 2010, dumps rubble into a pit full of the dead from the country's devastating Jan. 12 earthquake. Officials, overwhelmed by the thousands of dead from the magnitude-7.0 earthquake, had resorted to burying the corpses without ceremony in hastily dug pits in a rural area outside Port-au-Prince, the capital.

—

PP. 130-131 Refugees on July 15, 2003, crowd into a Masonic temple that had been converted into a camp in Monrovia, Liberia. Hundreds of thousands of Liberians had converged on the capital as they fled from fighting in the country's civil war, which had been raging for most of the past 13 years. At the time, the United States was weighing sending troops to the war-torn West African country, but only on the condition that President Charles Taylor step down and leave.

—

PP. 132-133 A platoon from the 3rd Squadron, 89th Cavalry Regiment of the 10th Mountain Division enters a bombed-out former shopping mall on May 11, 2008, in east Baghdad, Iraq. The building, which had long since been looted and now stood flooded with 10 feet of brackish algae-slimed water, afforded a commanding view of the surrounding neighborhood. Soldiers often climbed to the mall's crumbling roof to inspect the area for any use by insurgents.

—

PP. 134-135 A youth draped in the flag used by the Libyan rebellion walks on April 14, 2011, west of Ajdabiya, Libya. Rebels exchanged artillery and rocket fire with loyalist troops west of Ajdabiya that day as the conflict engulfing Libya continued.

—

PP. 136-137 Shiite Iraqi men crush in to get election pamphlets from the United Iraqi Alliance, a coalition of various Shiite political and religious parties, as they are handed out at Buratha Mosque on Dec. 31, 2004, in Baghdad, Iraq. With a national election planned for the following month, Shiite clerics were encouraging their followers to vote, giving firebrand sermons urging followers to participate in the election and handing out campaign pamphlets at mosques.

—

PP. 138-139 An Afghan girl stands in the ruins of Darul Aman Palace on Oct. 21, 2010, on the outskirts of Kabul, Afghanistan. A group of Afghan Kuchi tribal nomads had settled into the palace several months earlier, under the protection of Afghan paramilitary police that used the ruins as a makeshift patrol base, after the nomads were driven from a nearby area in Kabul during a bout of ethnic riots that summer. The massive palace was built in the early 1920s as part of a modernizing push by Afghanistan's ruler at the time, but religious conservatives stymied the effort and the grandiose palace fell into disuse and later was shelled into ruins by warlords during the Afghan civil war of the early 1990s.

—

P. 140 A shepherd tends to his flock as the sun rises on June 15, 2005, near Saqlawiyah, Iraq.

—

P. 142 Workers sweep the huge interior courtyard of the Children's Memorial School in the Dora neighborhood of Baghdad, Iraq, on Nov. 17, 2007. The school was set up in the late 1980s by Saddam Hussein's government to commemorate the deaths of dozens of Baghdad schoolchildren who were killed by an Iranian missile in an incident during the Iran-Iraq War. It had been closed for months after being severely damaged in fighting between insurgents and U.S. forces, but was being repaired with American money and was slated to reopen in the next few months. Dora, a Sunni enclave and once one of Baghdad's most violent neighborhoods for U.S. troops, had recently been calm as U.S. forces had helped form local Sunni armed groups as part of a neighborhood security force.

—

P. 143 A Sunni woman on Feb. 15, 2007, looks over her looted house that she and her family were forced out of due to Shiite threats. She and her family were able to return only with a U.S. Army escort, to look for what few possessions were left. At the time, houses like this one, in the multiethnic neighborhood of Ghazaliya in Baghdad, Iraq, were commonly ethnically cleansed through intimidation by Shiite militants who cleared out the Sunni occupants in preparation for moving in Shiite families. Ghazaliya, formerly a mixed Sunni-Shiite neighborhood, had become mostly Shiite as Shiite militias had forced area Sunnis out of their homes.

—

PP. 144-145 Pfc. Daniel Sims of Clemson, South Carolina, and the 1st Battalion, 5th Cavalry Regiment of the U.S. Army, sits during watch duties on July 13, 2007, in a partially destroyed building that was being converted into an Army field post in the tense Amiriyah neighborhood of Baghdad, Iraq. Insurgents who had been in control of Amiriyah until recently had attempted to destroy this building and an adjacent bunker with explosives and burning tires, but the Army was able to salvage the compound and then occupy it.

—

P. 150 Chris Hondros embedded with the 2nd Marine Expeditionary Force in Fallujah, Iraq, on June 25, 2005. (Photo by Phillip Robertson)

—

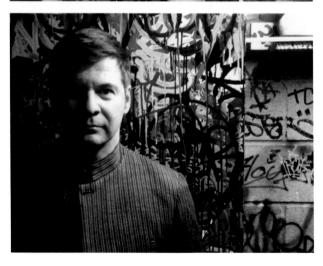

P. 152 (*top to bottom*)
Chris Hondros walks through the streets of Monrovia, Liberia, on Aug. 3, 2003, while on assignment covering the Liberian civil war. (Photo by Nic Bothma/EPA)

Chris Hondros (right) peers out a helicopter door on March 25, 2003, with photographer Luc Delahaye after they were forced to land in southern Iraq due to a sandstorm. (Photo by Timothy Fadek/Redux Pictures)

Chris Hondros stands on the balcony of the Getty Images Iraq bureau at the Hamra hotel in Baghdad, Iraq, on May 30, 2007. (Photo by Régis Le Sommier)
—
P. 155 (*top to bottom*)
Chris Hondros and his fiancée, Christina Piaia, pose for a self-portrait amid the pyramids of Giza, Egypt, on Chris' 41st birthday on March 14, 2011.

Chris Hondros poses for a portrait in his apartment in Brooklyn, New York, on Oct. 20, 2008. (Photo by Jeff Swensen)

Chris Hondros photographs as U.S. Marines with the 1st Battalion, 6th Marines search a home for contraband during Operation Dagger on June 18, 2005, in Anbar province, Iraq.
—
P. 156 (*top to bottom*)
Chris Hondros looks through a window overlooking Tahrir Square on Feb. 5, 2011, in Cairo, Egypt, while covering the Egpytian uprising during the Arab Spring. (Photo by Scout Tufankjian)

Chris Hondros removes his wading boots on Sept. 7, 2005, after photographing the aftermath of Hurricane Katrina in New Orleans, Louisiana. (Photo by Barbara Davidson)

Chris Hondros sits atop a mine-resistant, ambush-protected military vehicle near Khan Neshin, Helmand province, Afghanistan, on his 40th birthday, on March 14, 2010. (Photo by Régis Le Sommier)
—
P. 158 (*top to bottom*)
Chris Hondros celebrates with his mother, Inge Hondros, on April 21, 2004, in New York, N.Y., after the Overseas Press Club awarded him the John Faber Award for best photographic reporting from abroad in newspapers and wire services for his coverage of the Liberian civil war. (Photo by Mish Whalen)

Chris Hondros poses for a photo with his father, also named Chris, on May 9, 1998, before leaving the family home in Fayetteville, N.C. (Photo courtesy of the Hondros family collection)

Chris Hondros poses for a portrait on April 15, 2010, in Brooklyn, New York. (Photo by Todd Heisler)
—

—

This book would not have been possible without the unfaltering support of so many who have kept Chris' vision and voice close to their hearts.

A warm note of thanks to our friends and colleagues at Getty Images, including Craig Peters, Adrian Murrell, John Lapham, Eric Rachlis, Hugh Pinney, Aidan Sullivan, Jason Camhi, Nina Schoen, Lizanne Vaughan, Yoko Miyashita, Peggy Willett, Colleen McCabe, Travis Lindquist, Preston Rescigno, and most especially Jonathan Klein, whose belief in Chris and his work long precedes the publication of this book. We note a special appreciation to Getty Images for donating its proceeds from the sales of this book to the Chris Hondros Fund.

We are greatly indebted to Pierce Wright and Mario Tama, without whom this book could not have been realized. Pierce's support and keen observations helped complete the look and feel of this book; and Mario, whose commitment began at *Testament*'s infancy, has since given tireless time, love, and talent to see it come to fruition. Without Mario's guidance and wisdom, the book would not have measured up to Chris' vision.

The editors are very appreciative of Chris' friends and colleagues for their time, crucial insight, and consummate advice given throughout the photo-editing process and beyond: Todd Heisler, Jeff Swensen, Lauren Steel, Brent Stirton, Lisa Maree Williams, Andreas Gebhard, Beth Keiser, Elodie Mailliet, John Moore, and Daniel Berehulak.

Christina Larson, whose knowledge of Chris' writings proved essential to making this book happen, stepped in wholeheartedly and made the texts shine, keeping Chris' voice and style ever present. And Preeti Aroon's sharpness and steadfast guidance brought the writing to completion.

The editors are ever grateful to Jonathan Klein, Régis Le Sommier, and Greg Campbell for their captivatingly personal and telling essays about Chris.

Thank you to Chris' fellow journalist colleagues and friends who contributed photographs of Chris from New York and far-flung places around the world: Nic Bothma, Barbara Davidson, Timothy Fadek, Todd Heisler, Régis Le Sommier, Phillip Robertson, Jeff Swensen, Scout Tufankjian, and Mish Whalen. We are grateful for their generous spirit.

We sincerely thank the following publications for graciously granting permission to reprint Chris' writing: BagNewsNotes, the Digital Journalist, the Fort Collins Weekly, the Raleigh Hatchet, and the Virginia Quarterly Review.

Thank you to Michael Kamber, Stephen Ferry, and Robert Nickelsberg, who generously shared their knowledge of book publishing with the editors. Their advice was invaluable.

We thank Craig Cohen, Will Luckman, and the powerHouse Books' team for their patient support and dedication to this very important project.

Thank you to David Heasty of Triboro Design, who oversaw *Testament*'s design from its inception and provided patient advice to the editors throughout the creative process. Megan Parker made Chris' photos look their very best, and she did so with professional calm and dedication.

We want to acknowledge and thank the Getty Images U.S. news staff photographers — Win McNamee, Andrew Burton, John Moore, Scott Olson, Spencer Platt, Joe Raedle, Chip Somodevilla, Justin Sullivan, Mario Tama, Mark Wilson, and Alex Wong — for their camaraderie and friendship, and for carrying on with the important work that made Chris proud to be a member of their ranks.

Thank you to Mrs. Inge Hondros for her unyielding support of this project and for encouraging our work during both the good and the trying times.

—

In April 2011, the Chris Hondros Fund was created to honor two-time Pulitzer Prize finalist and photojournalist Chris Hondros, who was killed on assignment in Misurata, Libya. The Fund seeks to continue and preserve Hondros' distinctive ability to bring shared human experiences into the public eye. To this end, the Fund supports and advances the work of photojournalists and emerging photojournalists who espouse Hondros' vision and educates the public about the work of photojournalists as they tirelessly document our world.

To learn more about the Chris Hondros Fund or to support our work, please visit www.chrishondrosfund.org.

**CHRIS
HONDROS
FUND**